Truth may seem, but cannot be:
Beauty brag, but 'tis not she;
Truth and beauty buried be.

To this urn let those repair
That are either true or fair;
For these dead birds sigh a prayer.

Bacon

J. Hallett Hyatt, Sc

Thomas Gainsborough

THOMAS
GAINSBOROUGH

BY

LORD RONALD SUTHERLAND GOWER, F.S.A.

LONDON

GEORGE BELL AND SONS

CHISWICK PRESS : CHARLES WHITTINGHAM AND
TOOKS COURT, CHANCERY LANE, LONDON.

PREFACE

AN art critic has said that no great painting can be described, and that it is not in the province of words to give an idea of colour. This, in a certain measure, is true, but since works of the highest art—whether a building such as the Parthenon, or the Taj Mahal, or the Alhambra, or statues like the Venus of Milo and the Olympian Hermes—may be brought before the mental vision by words, why also may not such consummate creations of the brush as Raffaele's *School of Athens*, or Leonardo's *Last Supper*, or Michael Angelo's frescoes on the ceiling of the Sistine Chapel?

On a lower level words do not entirely fail to convey the impression of a fine portrait or a landscape painting, although the most elementary photographic reproduction of such portrait or landscape will give a better idea than pages written by a Ruskin or a Fromentin.

With the help of the illustrations, which are numerous, I hope this little book will make Gainsborough's art more familiar to those who may not have had an opportunity of seeing a collection of his works. I can only advise those who have not studied his paintings in our own National Gallery to do so. Let them pass a few moments, at least, before that wonderful half-length portrait of Mrs. Siddons, and when they have studied it sufficiently let them turn to that other half-length portrait of the Parish Clerk of Bradford-on-Avon, old Edward Orpin. If portraits do not attract, let them look at the same painter's landscapes in the Gallery; at the *Market Cart, The Watering Place*, or that picture of a forest called

Gainsborough's Forest, which out-Hobbemas Hobbema's greatest efforts. What poetry there is in all these, what truth to Nature. How full of light and fresh country air are these views of Suffolk lanes and pastures, and the woods with their summer foliage, and the great rolling clouds above.

No one need go beyond the walls of our National Gallery to study the Suffolk painter at his best Never was an artist more endowed with a sense of the beauty of Nature, both in things animate and in scenery: it would be hard to say which he more excelled in painting. Even in his lifetime Sir Joshua Reynolds gave it as his opinion that Gainsborough was the greatest landscape painter of his day. Time has endorsed this opinion. In some respects Gainsborough was the most delightful portrait painter also, not only of his day, but that the world has ever had.

To His Royal Highness the Duke of Cambridge I am indebted for his kind permission to reproduce his picture of Anne Luttrell, Duchess of Cumberland, and I have also to thank the following owners of sketches and pictures by Gainsborough for their kindness in allowing me to use their treasures as illustrations : the Duke of Portland, the Duke of Sutherland, the Duke of Rutland, the Duke of Buccleuch, the Duke of Westminster, the Duke of Newcastle, Earl Amherst, Earl Stanhope, Lady Wantage, Earl Spencer, Lord Rothschild, the Earl of Northbrook, the Earl of Carlisle, Lady Annaly, the Earl of Leicester, Lord Tweedmouth, Miss Alice de Rothschild, the Rev. E. Gardiner, Mr. Lionel Phillips, Mr. James Orrock, Mr. Arthur Kay, Mr. Henry Pfungst, Mr. Alfred de Rothschild, Mr. A. Sanderson, and Mr. F. Leyborne Popham.

CONTENTS

CHAPTER PAGE

 LIST OF ILLUSTRATIONS ix

 I. INTRODUCTORY 1

 II. SUDBURY 10

III. IPSWICH 23

IV. BATH 37

 V. LONDON 69

VI. THE ILLUSTRATIONS 108

 INDEX 129

LIST OF ILLUSTRATIONS

PAGE

THOMAS GAINSBOROUGH (*Photogravure Plate*)

(*Frontispiece*)

MRS. SIDDONS *National Gallery* 4

ALEXANDER, DUKE OF HAMILTON

Collection of Miss Alice de Rothschild 6

LANDSCAPE IN BLACK AND WHITE CHALK

Collection of Arthur Kay, Esq. 8

DRAWING IN CHALK AND WASH ON YELLOW PAPER

Collection of Arthur Kay, Esq. 8

PORTRAIT OF GAINSBOROUGH, FROM A DRAWING

Collection of Lord Ronald Sutherland Gower 10

THOMAS GAINSBOROUGH *Collection of the Earl of Leicester* 12

GAINSBOROUGH'S BIRTHPLACE, SUDBURY 1727, FROM THE
VIEW BY G. C. FINDEN 14

GAINSBOROUGH'S BIRTHPLACE, SUDBURY, FROM A PHOTO-
GRAPH 14

GARDEN FRONT OF GAINSBOROUGH'S BIRTHPLACE, SUDBURY 16

JACK PEARTREE, FROM A SKETCH AFTER THE ORIGINAL LIFE-
SIZE OIL PAINTING *Christ Church Museum, Ipswich* 16

THE OLD GRAMMAR SCHOOL, SUDBURY, 1700, FROM A PRINT 18

LADY EDEN *Collection of Charles Wertheimer, Esq.* 20

DRAWING FOR "THE SHRIMP GIRLS"

Collection of Arthur Kay, Esq. 22

MRS. MEARS *Collection of Alfred de Rothschild, Esq.* 24

NANCY PARSONS *Collection of Charles Wertheimer, Esq.* 26

MRS. GAINSBOROUGH 28

LANDSCAPE WITH SHEEP AND HORSES

Collection of Henry Pfungst, Esq. 30

ix

PAGE

LANDSCAPE *Collection of Henry Pfungst, Esq.* 30

GAINSBOROUGH'S TWO DAUGHTERS

 Collection of the Rev. E. Gardiner 32

THE TWO DAUGHTERS OF THE ARTIST

 Collection of Charles Wertheimer, Esq. 32

H.R.H. THE DUKE OF CUMBERLAND, FROM THE UNFINISHED
 PORTRAIT

 Collection of H.M. the King, Windsor Castle 34

QUEEN CHARLOTTE, FROM THE ENGRAVING BY GAINS-
 BOROUGH DUPONT OF THE PICTURE AT BUCKINGHAM
 PALACE 36

LORD ARCHIBALD HAMILTON

 Collection of Miss Alice de Rothschild 38

GAINSBOROUGH'S HOUSE IN BATH, 24, THE CIRCUS 40

GREAT CORNARD WOOD, FROM THE MEZZOTINT 42

MR. OZIER *Collection of James Orrock, Esq.* 44

DAVID GARRICK *Town Hall, Stratford-on-Avon* 46

DAVID GARRICK *Christ Church, Oxford* 46

GENERAL WOLFE *Collection of James Orrock, Esq.* 48

LORD FREDERICK CAMPBELL

 Collection of the Duke of Argyll 50

LANDSCAPE *Collection of Lionel Phillips, Esq.* 52

LANDSCAPE *Formerly in the possession of*

 Lord Ronald Sutherland Gower 54

LANDSCAPE *Collection of the Duke of Sutherland* 56

THE HARVEST WAGGON *Collection of Lord Tweedmouth* 58

THE TWO MISS LINLEYS (MRS. SHERIDAN AND MRS.
 TICKELL *Dulwich Gallery* 60

SAMUEL LINLEY, R.N. *Dulwich Gallery* 60

MRS. SHERIDAN *Collection of Lord Rothschild* 62

MRS. SHERIDAN *Collection of Charles Wertheimer, Esq.* 62

THE HONOURABLE GEORGIANA SPENCER, AFTERWARDS
 DUCHESS OF DEVONSHIRE *Collection of Earl Spencer* 64

THE DUCHESS OF DEVONSHIRE, FROM THE OIL SKETCH IN
 MONOCHROME IN THE POSSESSION OF LADY ANNALY 66

PAGE

GEORGIANA, DUCHESS OF DEVONSHIRE, FROM THE LITHO-
GRAPH BY LORD RONALD SUTHERLAND GOWER 66

GEORGIANA, DUCHESS OF DEVONSHIRE
Collection of Earl Spencer 66

STUDY *Collection of Henry Pfungst, Esq.* 68

STUDY FOR A PORTRAIT GROUP
Collection of Henry Pfungst, Esq. 68

SKETCH *Collection of Henry Pfungst, Esq.* 68

SCHOMBERG HOUSE, GAINSBOROUGH'S RESIDENCE IN PALL
MALL 70

THE WOODCUTTERS *Collection of Arthur Kay, Esq.* 72

THE HON. MRS. GRAHAM
National Portrait Gallery of Scotland 74

THE HOUSEMAID, FROM THE ORIGINAL DRAWING
Collection of the Earl of Northbrook 74

THE HOUSEMAID, FROM THE LITHOGRAPH BY RICHARD
LANE, AFTER THE ORIGINAL DRAWING IN THE POSSES-
SION OF THE EARL OF NORTHBROOK 74

THE HOUSEMAID *Castle Howard* 76

PRINCESS MARIE, DUCHESS OF GLOUCESTER (*Photogravure
Plate*) 76

MASTER BUTTALL (THE BLUE BOY)
Collection of the Duke of Westminster 78

THE DUCHESS OF CUMBERLAND
Collection of H.M. the King, Windsor Castle 80

ANNE LUTTRELL, DUCHESS OF CUMBERLAND
Collection of H.R.H. the Duke of Cambridge, K.G. 80

QUEEN CHARLOTTE
Collection of H.M. the King, Windsor Castle 82

GEORGE III. *Collection of H.M. the King, Windsor Castle* 82

GEORGE, PRINCE OF WALES
Collection of H.M. the King, Windsor Castle 82

GEORGE, PRINCE OF WALES
Collection of Miss Alice de Rothschild 82

CHARLES FREDERICK ABEL 84

PAGE

COTTAGE CHILDREN. FROM THE MEZZOTINT BY H.
 BIRCHE 86
LANDSCAPE. FROM AN ETCHING ON PEWTER
 Collection of the Rev. E. Gardiner 86
GIRL AND PIGS. FROM THE MEZZOTINT BY W. DICKENSON 88
THE WOODCUTTER'S HOME
 Collection of the Duke of Rutland 90
COLONEL ST. LEGER *Collection of Miss Alice de Rothschild* 92
DRAWING FOR ONE OF GAINSBOROUGH'S TRANSPARENCIES
 IN BLACK CHALK ON GRAY-WASHED PAPER
 Collection of Arthur Kay, Esq. 94
THE ROYAL PRINCESSES (DAUGHTERS OF GEORGE III.)
 Collection of H.M. the King 96
MRS. ROBINSON AS PERDITA *Wallace Gallery* 98
THE HON. WELBORE ELLIS (LORD MENDIP)
 Christ Church, Oxford 100
PORTRAIT STUDY OF A YOUNG GIRL, PROBABLY DAUGHTER
 OF THE ARTIST *Collection of the Rev. E. Gardiner* 102
LADY MULGRAVE (*Photogravure Plate*) 102
LETTER FROM GAINSBOROUGH TO REYNOLDS. IN THE
 POSSESSION OF THE COUNCIL OF THE ROYAL ACADEMY 104
MRS. MOODEY AND HER CHILDREN *Dulwich Gallery* 106
MRS. FITZHERBERT *Collection of A. Sanderson, Esq.* 108
LORD LEICESTER *Holkham Hall* 110
GIRL AT A WINDOW *Collection of the Duke of Sutherland* 110
ROBERT, VISCOUNT BELGRAVE
 Collection of the Duke of Westminster 110
GRACE DALRYMPLE, MRS. ELLIOTT
 Collection of the Duke of Portland 112
MUSIDORA BATHING HER FEET *National Gallery* 112
STUDY OF A DOG. IN COLOURED CHALK
 Collection of Henry Pfungst, Esq. 112
MRS. LEYBORNE *Collection of F. Leyborne Popham, Esq.* 114
HENRY, THIRD DUKE OF BUCCLEUCH
 Collection of the Duke of Buccleuch 114

PAGE

WILLIAM PITT *Collection of Earl Amherst* 114

SKETCH OF THE PICTURE OF "THE MORNING WALK"—
SQUIRE HALLETT AND HIS WIFE
Original picture in collection of Lord Rothschild
Sketch in collection of H. Pfungst, Esq. 114

ORPIN, PARISH CLERK OF BRADFORD, WILTS
National Gallery 116

GAINSBOROUGH'S NEPHEW
Collection of the Rev. E. Gardiner 116

MRS. FREER *Collection of James Orrock, Esq.* 116

SIR JOHN SKINNER (CHIEF BARON)
Christ Church, Oxford 116

AN IDYLL. *Collection of Lord Ronald Sutherland Gower* 118

AN IDYLL. FROM THE MEZZOTINT 118

LARGE DRAWING IN COLOURED CHALKS AND WASH
Collection of Arthur Kay, Esq. 118

CHALK DRAWING *Collection of Arthur Kay, Esq.* 118

HENRIETTA, COUNTESS GROSVENOR
Collection of the Duke of Westminster 120

ANNA, COUNTESS OF LINCOLN
Collection of the Duke of Newcastle 120

PHILIP, FOURTH EARL OF CHESTERFIELD
Collection of Earl Stanhope 120

MARIA, LADY EARDLEY, AND HER DAUGHTER, AFTER-
WARDS LADY SAYE AND SELE
Collection of Lady Wantage 120

THE DUKE AND DUCHESS OF CUMBERLAND
Collection of H.M. the King, Buckingham Palace 122

HEN AND CHICKENS. FROM A SKETCH DONE IN ONE HOUR
Collection of the Rev. E. Gardiner 122

MISS SUKEY TREVELYAN
Collection of Sir G. O. Trevelyan 124

LADY SHEFFIELD *Collection of Miss Alice de Rothschild* 126

EARL FITZWILLIAM *Fitzwilliam Library, Cambridge* 126

THOMAS GAINSBOROUGH

CHAPTER I

INTRODUCTORY

IT is inevitable to compare Gainsborough with Reynolds, but the comparison is unprofitable, since, although both painted the portraits of the same generation, they were distinctly different in style and feeling. When compared with the output of Reynolds, who for some years painted over a hundred portraits a year, Gainsborough's total of not many over three hundred seems small. But whilst Reynolds had many pupils and assistants, Gainsborough had no assistants, and only a very few pupils. At no period of his life did Gainsborough emulate the industry which enabled the President to create a world of portraits. Gainsborough also lacked Reynolds's confidence of touch, his psychological grip and marvellous variety. Sir Joshua's portraits of Lord Heathfield, of Laurence Sterne, and of Mrs. Siddons as the Muse of Tragedy, are the very greatest portraits any English painter has created ; unapproachable in dignity, intellect and force. But in delineating the grace and sweetness of womanhood Gainsborough claims an equal place with his great rival, and as a painter of landscape he stands on a far higher level.

It is to Gainsborough's credit that he never attempted the so-called "grand style" in painting as did Romney with such doubtful success; in that province Reynolds holds the highest rank of the artists of his day. Gainsborough in some respects was like a child; and this gives his character a certain attraction. He probably never opened a book for the sake of study or information, I doubt whether he ever read a play of Shakespeare's or a dozen lines of Milton. When not at work he would pass hours with his friends, playing some musical instrument or listening to their performances. A man is judged by his friends, and whilst Reynolds loved to be in the society of Burke or Johnson, Gainsborough liked those better who could play upon the fiddle or the flute; to hear music pleased him more than to hear great minds discuss great subjects.

It has been truly said by the German art critic, Richard Muther, that, "what with Reynolds was sought out and understood, was felt by Gainsborough; whence the former is always good and correct, where Gainsborough is unfortunate and often faulty, but in his best pictures with a charm to which those of the President of the Academy never attained . . . but what distinguishes him from Reynolds, and gives him a character of greater originality, is just his naïve independence of the ancients, to which he was led by the difference in his method of study."

Yes, whereas Gainsborough had his study and painting-room on the green lawns and by the sedgy streams of Suffolk, and among the woods and valleys of Somerset, Reynolds had his among the works of the great Italian masters, and in the churches of the Netherlands. The one was contented to paint the natural beauties of his native land, the land he loved so well that he never cared

to leave it, not even to cross the Channel; the other, after visiting Italy in his early years, was for ever striving to walk in the giant footsteps of that Titan in Art, Michael Angelo, whose works were always in his mind and whose name was for ever on his lips—whom he almost worshipped as the greatest genius of all time. The only "old master" (yet for ever young) whom Gainsborough thoroughly appreciated, and the only one whose works he cared to copy and to imitate in his own portraits, was Vandyck. Some of that master's works he had seen in the great houses of this country, then the only art galleries in England, and it was whilst visiting Lord Pembroke at Wilton that he made copies of some of the finest works by the great Fleming that exist in this country. As to the great masters of Italian painting, I doubt whether Gainsborough thought it worth his while to see their works in Italy, and his enthusiasm for Michael Angelo and the School of the Carracci was probably as little as the admiration of Reynolds and the others was intense. It will be seen how little he cared for what he called " the long-nosed Greeks." " If we were in a room and Sir Joshua Reynolds walked in we should receive him with all deference; but if Gainsborough were to appear we would greet him as an old friend, clasp his hand, and wish to embrace him." Thus a devoted lover of art and a devoted admirer of England's greatest painters describes his feelings towards the two great painters.

There is but one other great painter who combined landscape painting and portraiture with an equal amount of success as did the subject of the following memoir. But besides being the greatest of portraitists and landscape painters, Rembrandt, the highest genius among all Northern artists, was also the greatest in his religious

and *genre* subjects, subjects which Gainsborough never attempted.

Whether Gainsborough ever had an opportunity of seeing one of Watteau's paintings is doubtful, but in some respects he may be compared to that delightful artist. Take that exquisite picture by him of the ladies walking in the Park at St. James's, does it not recall the graceful brilliancy of the author of *Le Départ pour la Cythère;* or again the group of the Duke and Duchess of Cumberland, where the pair are sauntering in the chequered shade of a stately garden. Here again Watteau's delicate brushwork and diaphanous tone seem to have been invoked with an equal amount of grace and refinement; all the joy of life is there, and all the glamour of the summer sky above, and cool sylvan glades beneath, which give so much value to the *fêtes champêtres* of the works of the Valenciennes painter. But whilst Watteau created a purely imaginary world, Gainsborough painted what he saw, only gilding it with the gold of his genius. The same may be said of Gainsborough's landscapes of Suffolk and Wiltshire in which he has introduced a peasantry whose beauty could never have existed—cottagers and their children, grouped around their doors or seated in their waggons quite as beautiful as his fair dames and gallants who flutter in the Mall, or walk in palace gardens. Here the magic of the painter's art has cast a spell over the simple denizens of the soil. The rustic beauties, however, introduced into his earlier landscapes were his wife and pretty daughters, whom he used to pose for the part and in his later life most of the peasant lads were painted from the handsome Jack Hill whom he met in one of his rambles near Richmond.

But youth, however handsome, gained much by being

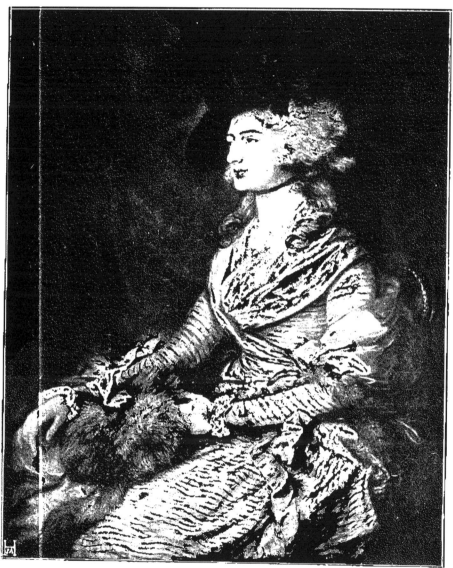

MRS. SIDDONS

painted by Gainsborough, whose instinct for colour was so true, as witness the gorgeous cerulean dress which gave Master Buttall, the son of a London ironmonger, immortality as *The Blue Boy*.

As a colourist Gainsborough can be placed next to Vandyck, and in England he created a new school by his art of making even a lady's petticoat a thing of beauty, a field of colour as beautiful as one of golden cowslips, or as gorgeous as one of scarlet poppies. He could even throw a halo upon a ribbon or a scarf. Look at Mrs. Siddons's dress in the National Gallery, or the Blue Boy's costume at Grosvenor House, or at Mrs. Graham's portrait in the National Gallery at Edinburgh. You will find there is no exaggeration. The dresses are part of a perfect scheme; only Vandyck, Rubens and Gainsborough ever painted such textures in such a manner, and with such a feeling for the beauty of colour as colour.

Gainsborough claims also a supreme rank amongst portrait painters for the characteristic distinction that he bestowed upon many of his sitters. In the portraits, for instance, of the lovely Mrs. Sheridan, first in that lovely sketch of herself and her brother when children, now at Knole, she has that pathetic expression which seems to have grown upon her, for nothing can be sadder or more beautiful than her look in the full-length seated portrait, now at Lord Rothschild's, which the artist painted some years later. In both pictures there is a sad detached expression in the eyes, an expression much intensified in the second, as if she knew that her life was drawing near its close. When one looks at this later portrait, one can believe that such a face could hardly be transfigured by any change, however heavenly that change might be, so

perfect is it in its almost superhuman beauty. It was consistent with such a face as that of Eliza Sheridan that she should pass away almost whilst singing Handel's glorious "Waft her, Angels."

Some of Gainsborough's portraits of ladies have a striking dignity, a particular distinction found in no other artist. This is very marked in the portrait at Edinburgh of Mrs. Graham, and reappears in a portrait of the same lady masquerading as a housemaid. It is also seen in the half-length of Mrs. Siddons, and in many of the heads of handsome youths, especially in that of George Canning, painted shortly after he left Eton, and in those of the Duke of Hamilton and his brothers, now at Waddesdon: it is also very marked in the unfinished portrait of the painter himself, of which there is an illustration in this book. It is the head of a great gentleman without any attempt at pose, with frank eyes looking straight from the picture, eyes full of brilliancy. No one could paint eyes with such success as Gainsborough; they appear to sparkle and to see. Yet when you examine the pictures closely, you find that the effect has been obtained by a few touches of the brush—but those touches could only be given by one man.

Until Gainsborough's appearance, England possessed but one landscape painter in Richard Wilson, and he was little more than a clever imitator of the Italians, and more particularly of Claude Lorraine, with but little individuality. Although some of his landscapes are good, he cannot claim a place amongst artists of originality.

Gainsborough, on the contrary, was not merely an excellent landscape painter, but one of the most original of any time or country. His early work in this branch is somewhat hard and formal, but after he left Ipswich for

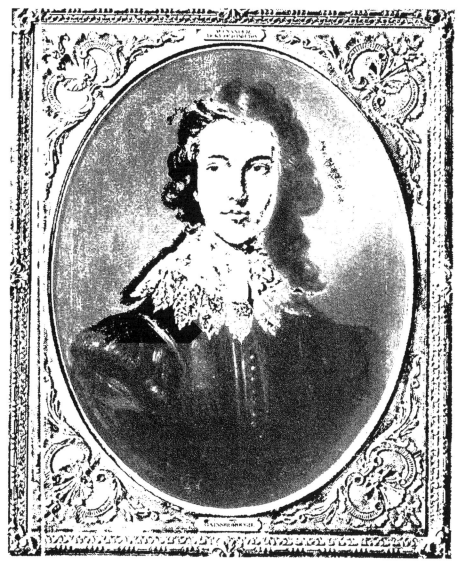

ALEXANDER, DUKE OF HAMILTON

Bath he made immense progress, and worked as hard on landscapes, and with greater zest, than he did on his portraits. The result of this labour we see in such pictures as his forest view at Great Cornard in Suffolk; in his *Watering Place*, in the National Gallery, and in his *Cottage Door*, at Grosvenor House, and in others of his landscapes in many a gallery and private collection, where they hold their place among the finest works of any school, be it Italian, Dutch or Flemish. Admirably has his great brother artist, Constable, written on Gainsborough's landscapes, " The calm of mid-day, the haze of twilight, the dew and pearls of morning are what we find in the pictures of this good, kindly, happy man. . . . As we look at them the tears spring to our eyes, and we know not whence they come. The solitary shepherd with his flock, the peasant returning from the wood with his bundle of faggots, the darksome lane or dell, the sweet little cottage-girl at the spring with her pitcher, were the things which he delighted to paint, and which he painted with exquisite refinement, yet not refinement beyond nature."

If we knew England only through Gainsborough's pictures of its scenery, I think we should love it for its beauty. His views of English scenery, both in oils and chalk, give the same impression as if we were actually looking upon it, before all the hideous works of steam and electricity had come to spoil, blacken, overrun, ruin and scarify what was once the loveliest and most peaceful of islands. And yet, and this but shows the inartistic level of the period, when Gainsborough died, and his widow sold his works, between fifty and sixty of these landscapes were left hanging on the walls of the rooms and passages of his house unsold. As a draughtsman, or

rather sketcher, Gainsborough has no rival. Although there are naturally great inequalities among the many hundred drawings in chalk, in pen, and other mediums, and in water colours—for Gainsborough loved to try every kind of vehicle when at work on his studies—some of the drawings which he dashed off rapidly as he sat by the side of his wife in Schomberg House are pure gems. Some of these are reproduced in this book, and give some idea of the beauty of the originals. They are all full of out-door feeling, although most of them were drawn in a London sitting-room. But Nature was always about Gainsborough, and while sketching and listening to the playing of some of his musical friends, his thoughts would be back again among the Suffolk woods and lanes.

A great number of these studies are in the British Museum, but hundreds are buried in private collections, from which, by the kindness of their owners, I have been permitted to select those here reproduced. Some of them are reminiscent of Rembrandt's landscapes, but where the great Dutch master relied on the distribution of strong lights and deep shadows for his effects, Gainsborough's are all bright, and steeped in full daylight. He saw Nature, bright with sunshine as was his own happy disposition, with no storm clouds or angry skies, serene and clear. Most of these studies are drawn on blue or drab-coloured paper, on sheets of about ten inches long by seven inches high, with black chalk, heightened by white; some have a little red chalk in them. With these three tones Gainsborough would, in a few rapid strokes, draw a coppice or a stream, a wooded hillside or a single tree, a turn in a road dotted here and there with figures and buildings; a cottage or a church, a crumbling ruin, or

DRAWING IN CHALK AND WASH ON YELLOW PAPER

some cattle feeding in a meadow. He loved to reproduce the effects of a fleecy sky, a breezy day or the calm of sunset.

His figure sketches were as rapidly executed as his landscapes. In these the British Museum is especially rich, and among many delightful studies none surpass in grace and charm those for the portrait of one of the Duchesses of Devonshire, in a huge hat and with the most graceful of draperies: she seems to glide over the trim lawn at Chatsworth or at Chiswick.

Gainsborough certainly had shortcomings in his art. What painter, even among the greatest, has not imperfections? These shortcomings, however, in Gainsborough were only the faults of his qualities. He did not always draw correctly, and his figures are sometimes out of proportion, for like Sir Joshua and Romney, he never studied anatomy and very seldom painted from the nude. That his sitters' hands were sometimes too small, and their arms too long, and that in some of his portraits the work is scamped and unfinished all must admit. He certainly lacked tone and precision in the treatment of the hair of some of his sitters, and was often too hurried in his backgrounds. But his defects are atoned for a thousandfold by his excellences, and it is these that give the finality to Ruskin's verdict: "Gainsborough is an immortal painter . . . the greatest colourist since Rubens."

CHAPTER II

SUDBURY

"Gainsborough is an immortal painter . . . a great name his, whether of the English or any other school, the greatest colourist since Rubens."—RUSKIN.

"Reynolds was all will and intelligence, Gainsborough soul and temperament."—R. MUTHER.

"We are all going to Heaven, and Vandyck is of the company."
—GAINSBOROUGH.

THE little that we know of the life of Thomas Gainsborough is due principally to an ill-written pamphlet of some sixty pages, published by Philip Thicknesse—who was also the author—in 1788, the year of the artist's death; and to a short Life written by George Williams Fulcher, and published by his son in the middle of the last century. Allan Cunningham, whose work on British artists is generally so useful, gives Gainsborough one of the most meagre biographies in the series. Although some elaborately illustrated lives of Gainsborough have appeared during the last few years they contain little beyond the facts already given by Fulcher; Thicknesse's brief memoir, "written," he said, "in one day," is little more than a literary curiosity, although it has preserved some record of Gainsborough's life.

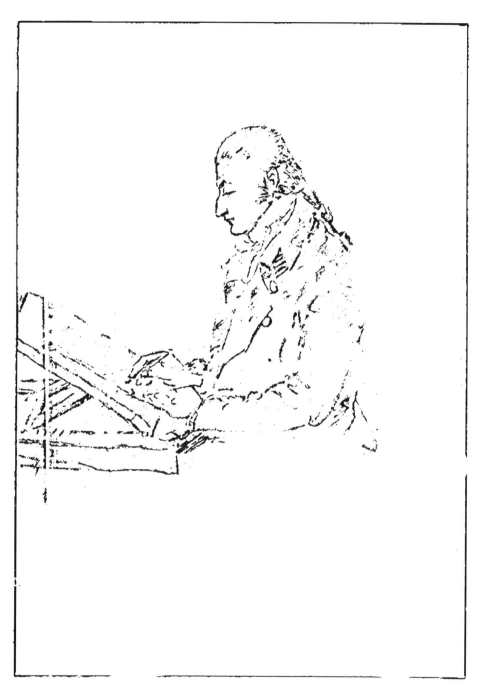

PORTRAIT OF GAINSBOROUGH

Nine years after the artist's death John Thomas Smith, Keeper of the Prints in the British Museum, and the author of an interesting life of Nollekens the sculptor, had the idea of writing a life of Gainsborough. In order to get some information from a Suffolk man he wrote to John Constable, the great landscape painter, who was born near Gainsborough's home, asking for any facts that Constable could give him relating to the portrait-painter's early life. But in a letter written to Smith in 1797, the information given by Constable was so meagre that the Keeper of the Prints seems to have abandoned his idea of writing a Life. According to Fulcher, junior, the son of the author of Gainsborough's Life, up to 1829 "the curious might, indeed, have acquired a few facts from obituary notices in magazines, from collections of anecdotes, from the biographies of eminent men; but previous to the publication of Allan Cunningham's "Lives of Painters," Gainsborough's history was a blank to all the world in general."

The first biographer of our artist, Fulcher, was born in Gainsborough's native town of Sudbury and was educated in the same picturesque old Grammar School. He did not live to complete the life he had begun to write of his gifted fellow-townsman, dying suddenly in the summer of 1855. The Life was completed by his son, who, in the preface acknowledges the assistance and advice he had received from Charles R. Leslie, R.A. This Life of Gainsborough by the Fulcher father and son, although only a booklet which can be read through in a couple of hours, is the most complete account that we possess of one of our greatest painters, and from it all the material of his later biographies has been gleaned.

Sudbury, a quiet market town in East Suffolk was the

birthplace of Thomas Gainsborough. The little town is situated amidst scenery not of striking beauty, in somewhat flat and uninteresting country, but it boasts of rich meadows, gentle, well-wooded hills and tranquil valleys in which glisten the clear waters of the River Stour, flowing by banks bordered with willows. To those who can appreciate the landscapes of Gainsborough and Constable there is great charm in this part of East Anglia, and when visiting Sudbury and East Bergholt they will be constantly reminded of these artists.

"Suffolk," Gainsborough is reported to have said, "made me an artist," and until the close of his busy life he found the material for all his best landscape work in the studies and sketches he made when a youth at Sudbury, and in later life at Ipswich.

Thomas Gainsborough was born early in the month of May, 1727. His father, John Gainsborough, was a Dissenter, an Independent, in his religious views, and a manufacturer of woollen goods, of which the lugubrious department of making shrouds appears to have been his chief business. He apparently migrated to Sudbury from Coventry, taking his shrouds with him. His wife belonged to the Church of England. Her maiden name was Burroughs, and her brother, who was a clergyman, was head of the Grammar School at Sudbury, in which his nephew, Thomas Gainsborough, was educated. All that we know regarding Gainsborough's mother is that she was an admirable housewife and had a talent for flower painting, a talent which may have influenced her son Thomas's early love of drawing. She lived long enough to witness his early success, when he became the best-known portrait painter in Bath, for she only died in 1769, surviving her husband one and twenty years.

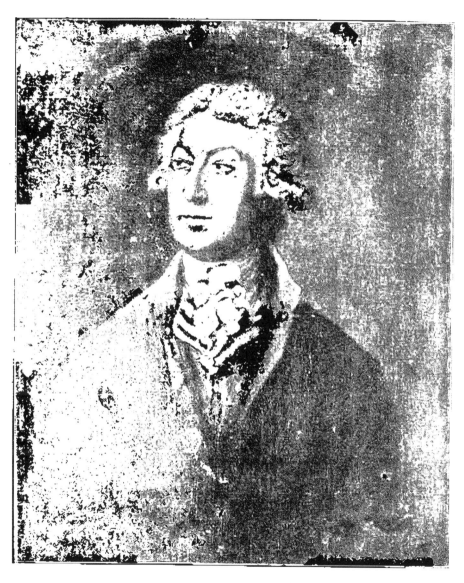

[Collection of the Earl of Leicester

THOMAS GAINSBOROUGH
(THE GIFT OF THE ARTIST TO LORD LEICESTER)

The Gainsborough family was a large one, consisting of five sons and four daughters. The eldest, John, grew up to be what would now be called "a crank." He had an inventive mind and much mechanical skill. One of his inventions, some kind of flying machine, ended its career by landing him in a ditch. Some were more successful, one a cradle which rocked itself, and another a wheel that revolved in a bucket of water. He also attempted to discover an instrument for correcting the longitude, spending all his money over these mechanical toys. Another of the artist's elder brothers, Humphrey, became a dissenting minister at Henley-on-Thames: he too had a mechanical turn of mind. He invented sundials, and was believed by his friends to have anticipated Watt in the invention of the steam-engine. According to Fulcher, Humphrey Gainsborough was a friend of Maria Edgeworth's father, who shared his love of mechanics, and who wrote in his memoirs that he had "never known a man of more inventive mind." Watt's famous invention of condensing the steam in an engine in a separate vessel was supposed by Humphrey Gainsborough's friends to have owed its inception to him. Humphrey used to show the engine that he had made at Henley, and someone who saw it there is supposed to have carried the intelligence of how it was worked to Watt. In his memoir of Gainsborough Thicknesse says, that after Humphrey Gainsborough's death his brother Thomas gave him this model of the steam-engine, which alone, he adds, "would have furnished a fortune to all the Gainsboroughs and their descendants, had not that unsuspicious good-hearted man let a cunning, designing artist see it, who surreptitiously carried it off in his mind's eye." This is a remarkable statement to have been written

so far back as 1788, and gives Thicknesse's words a tone of prophecy of the coming revolution that the discovery of steam and the steam-engine were to work in the world some fifty years after the death of Humphrey Gainsborough in 1776. Fulcher alludes to a sundial made by Humphrey which Thicknesse presented to the British Museum after the death of its maker. This sundial Thicknesse writes, "could point the hours to a second, in any part of the world." Besides sundials and steam-engines Humphrey Gainsborough also invented a tide-mill, for which he received a premium of fifty pounds from the Society of Arts. Besides being an inventor and mechanician of some distinction, Humphrey was also a fervent and zealous minister. Altogether a remarkable individual this; who, had he not been so eclipsed by the fame of his artist brother would probably have found a place in the annals of the distinguished men of his time. Of Gainsborough's two younger brothers, Matthias and Robert, the former died when still a youth; the latter went to Lancashire, was married twice and had some children.

The painter's four sisters all lived to be married; the eldest, Mary, to a dissenting minister named Gibbon who lived at Bath. Susanna became Mrs. Gardiner; Sarah married Mr. Dupont and became the mother of Gainsborough Dupont, the painter's assistant and almost rival; and the fourth, Elizabeth, married a Mr. Bird, of Sudbury. Sarah Dupont's son was the only member of the painter's family who showed any strong artistic feeling, and had he lived he would have carried on the fame of his illustrious uncle; but he was fated to die in 1797, at the age of thirty. Dupont followed his uncle's style and teaching very closely. Many of the portraits alleged to be by Gainsborough are now believed to be the work of his

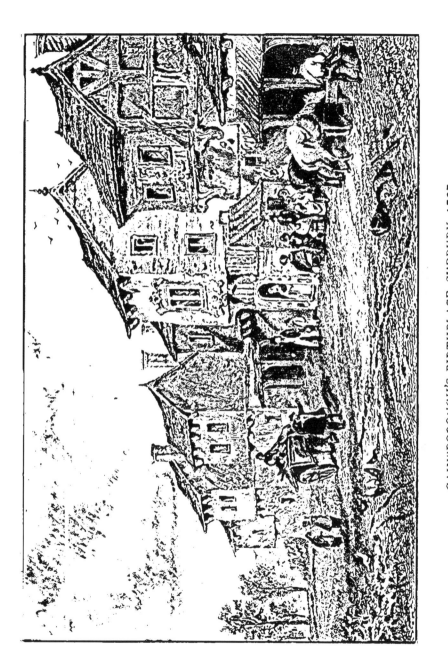

GAINSBOROUGH'S BIRTHPLACE, SUDBURY, 1727

FROM THE VIEW BY G. C. FINDEN

GAINSBOROUGH'S BIRTHPLACE, SUDBURY

FROM A PHOTOGRAPH

nephew, who not only painted in the same style, but had some of his uncle's mannerisms. He also executed some excellent mezzotints after Gainsborough's portraits.

Gainsborough Dupont, to judge by the portrait said to have been painted in an hour by his uncle, and now belonging to Sir Edgar Vincent, was a singularly good-looking youth, with refined features, lit up by a pair of very brilliant eyes. Thicknesse had a profound admiration for young Dupont, and writes of him, " I cannot lay down my pen without mentioning Mr. Dupont, his [Gainsborough's] surviving nephew and scholar, who has been fostered under his wing from a child, to his dying day, because I can venture to pronounce him a man of exquisite genius, little inferior in the line of a painter to his uncle, possessing an excellent heart, and a good understanding; and when his works are known they cannot fail of being equally admired, and I hope and believe, if his own diffidence and modesty does not prevent him, that he will not remove from his late uncle's house, [this was written, it should be remembered, a year after Gainsborough's death] for I am sure he can support its former credit, either as a landscape or portrait painter." Thicknesse then proceeds to describe a portrait painted by Dupont of Gainsborough which, he says, " has all the ease, all the spirit, and all the fire in it, which might be expected in the portrait of the first genius that either this, or any other kingdom ever produced."

To judge by the little view of Gainsborough's birthplace, engraved by Finden in Fulcher's Life of the painter, not only the house in which he was born, but the whole side of the street in which it stands has totally changed in appearance. In the place of a picturesque but very ramshackle house with heavy beams and a

high-pitched roof, we now see a flat, uninteresting, red-brick-fronted building of two storeys, and were it not for the commemorative tablet on the right-hand side of the entrance door, stating that in this house Gainsborough was born, no one who had expected to find the house pictured by Finden could imagine that this was the painter's birthplace. Entering the door and passing through a narrow passage opening into a garden with an orchard beyond, one finds that the back of the building bears more impress of its original form than the part fronting the street, being comparatively little changed since the days when Gainsborough lived there and played in its garden and orchard.

I am indebted to Mr. Kemp, the present owner of Gainsborough's birthplace, for the photographic views which he has allowed to be taken, both of the house and of the orchard, in which is still pointed out the stump of a pear-tree, traditionally said to be that connected with one of the very few incidents known to us of the painter's boyhood. The story goes that this orchard had been repeatedly plundered of its fruit, and that one day young Gainsborough seeing a rustic leaning his elbows on the brick wall, made a sketch of the fellow, who was shortly after arrested for pilfering the fruit, his identity being made known by Tom Gainsborough's sketch. Some time afterwards Gainsborough painted a life-size figure of this yokel, who was dubbed Jack Peartree, in oils on wood, and this is supposed to have been his earliest attempt in that medium. It is still to be seen in all its crudity, but with some of the painter's future excellences, in the fine old building of Christchurch at Ipswich, now, thanks to the generosity of Mr. Felix Cobbold, a possession of that town for all time.

GARDEN FRONT OF GAINSBOROUGH'S BIRTHPLACE, SUDBURY.

JACK PEARTREE

FROM A SKETCH AFTER THE ORIGINAL LIFE-SIZE OIL PAINTING

[Christ Church Museum, Ipswich

This portrait of Jack is cut out in the wood to the shape of his figure after the manner of the old Dutch fire-screens one finds sometimes in country houses, and it was through seeing this painted figure of Jack Peartree that Thicknesse made the acquaintance of the painter.

One day Thicknesse, who was Lieutenant-Governor of Landguard Fort near Ipswich, was taking a walk with a friend when, he says, " I perceived a melancholy-faced countryman, with his arms locked together, leaning over the garden wall." Thicknesse pointed out this strange figure to his companion, who, he adds, " was a very ingenious man, and he with great gravity of face, said the man had been there all day, that he pitied him, believing that he was either mad or miserable. I then," continues Thicknesse, " stepped forward with an intention to speak to the madman, and did not perceive till I was close up, that it was a wooden man painted upon a shaped board."

The Lieutenant-General then introduced himself to the painter of Jack Peartree's life-like portrait, but this introduction and the results to which it led, belong to that portion of Gainsborough's life when he had left Sudbury and had gone to Ipswich.

Fulcher certainly did not appreciate the charm of the quaint old houses of Sudbury, for in his Life of Gainsborough, he calls them, " dilapidated and antique, encumbering and disfiguring the streets of his native town." One can but regret the vandalism of the early part of the last century and even later, when most of these old houses so full of character and irreplaceable charms were either destroyed or refaced by hideous frontages. Amongst these were Gainsborough's home and the old Grammar School in which he was taught by his maternal

uncle. The former has been utterly spoilt; the latter has been torn down. Gainsborough's birthplace had once been an inn, known as "The Black Horse," and if the view of it in Fulcher's Life is faithful, it was a building Prout would have delighted to draw. In 1835 a local bye-law was passed by the Corporation in which was a clause requiring that all houses, from that date, were to "be made to rise perpendicular from the foundation thereof"; and it was after this enactment that Gainsborough's house was transformed into its present ugliness. Fortunately a few of the quaint sixteenth-century timbered houses are still to be seen in Sudbury. Of these some of the most curious are in Stour Street, not far from Gainsborough's home, and one, which is known as Old Salters' Hall, is a perfect specimen of an Elizabethan, or perhaps even earlier building, with its grotesque wooden carvings and barge boards, and its deep bay windows, under one of which there is a curious relief carved in the dark-coloured oak.

The present owner of Gainsborough's birthplace told me that he possesses papers showing that the house is undoubtedly that owned by the artist's father; and oddly enough his occupation is analogous to that of John Gainsborough, for although he does not deal in "says" and "crosses"—the technical terms for yarn differing in quality from that spun from combed wool—he deals in the finer province of silks. On one side of Mr. Kemp's orchard is a large factory in which a number of hands are employed in the making of silk, thus carrying on a branch of trade which was brought to Sudbury in the days of the third Edward, who invited the Flemish weavers over to Suffolk in order that they should teach their industry to the English. Gainsborough's father,

[Destroyed last Century]

THE OLD GRAMMAR SCHOOL, SUDBURY, 1700

according to tradition, was rather an old beau; he wore his hair carefully dressed and powdered, and was remarkable for the excessive whiteness of his teeth. When in full dress he wore a sword, in the use of which he was an adept, being able to fence equally well with either the left hand or the right. His business frequently took him to Holland and to France. He was liberal to his work-people, refusing to take what was called "toll" of their earnings, which toll amounted to nearly one-third of their weekly wages.

Sudbury's old Grammar School must have been a quaint and picturesque house, judging from the sketch of it, which, thanks to the Rev. W. G. Normandale, the head of the present Grammar School, I am able to reproduce in this book. The old school-house was demolished half a century ago, and in its place was erected one of those florid, toy-box buildings; no doubt a far better school than the old one, but utterly without character.

Gainsborough was in his ninth year when he began lessons under his uncle, the Rev. Humphrey Burroughs, in the old schoolroom. According to Allan Cunningham he was already at that early age remarkable for his clever sketches, and when twelve years old was already "a confirmed painter," whatever that term may imply. During these early years Tom filled his own and his fellow-pupils' books with his pencillings, and "whilst," writes Fulcher, "he was engaged in sketching some well-known landscape or laughter-loving face, they busied themselves in preparing his arithmetical exercises, and extracted the cube roots of the vulgar fractions with an accuracy which completely imposed on his worthy relative, leaving young Gainsborough at liberty to pursue his ruling passion."

On one occasion when wanting a holiday he wrote on a slip of paper, "Give Tom a holiday"; the handwriting was so exact an imitation of his father's, that the schoolmaster never doubted who had written the request. Tom therefore had his wish and his holiday, which he spent sketching in the woods. On his return, however, the trick was discovered, and his father exclaimed, "Tom will one day be hanged," which he was, often, but not in the manner his father predicted. When the elder Gainsborough, however, saw the result of this stolen outing, he not only forgave the forger, but, going to the other extreme, prophesied that his son would one day astonish the world.

When fourteen Gainsborough left his uncle's school. His wonderful facility in sketching everything he came across, made his parents feel that such a talent should not be allowed to lie fallow in their small world. Thicknesse in his memoir says that there was "not a picturesque clump of trees, not even a single tree of any beauty, no, nor hedgerow, stem, or post," in and around Sudbury which the boy did not either treasure in his memory or draw. This facility caused his parents and his uncle to decide that he should take up art as a profession. Accordingly he was sent to London and placed under the tuition of an engraver, whose name has not been recorded.

Whilst in London Gainsborough made the acquaintance of the French artist Gravelot, who was an excellent engraver and admirable draughtsman. It was owing to his good offices that the boy obtained admission to the painting academy in St. Martin's Lane, where he became a pupil of Hayman, a roystering dissipated artist, who at that time, when art in England was only kept alive by

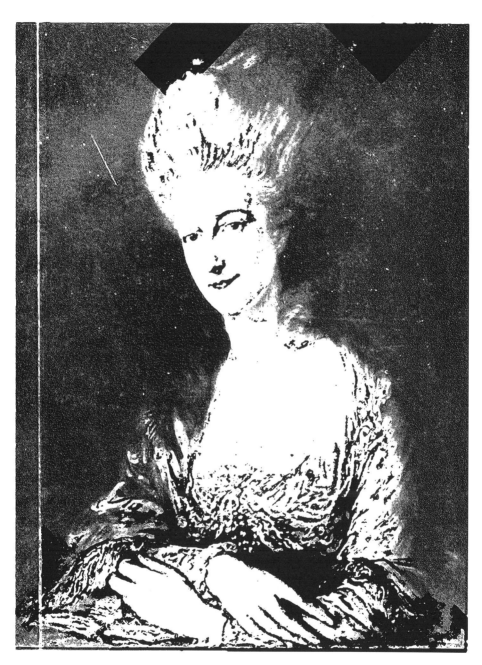

LADY EDEN

Hogarth in figure painting and Wilson in landscape, was considered a fine painter of historical and Shakespeare subjects. Although a miserable dauber, Hayman was one of the first elected members of the Royal Academy, and when he died was its librarian, although he had not the least merit for either post. He loved the bottle, and young Gainsborough appears to have been none the better for his companionship with him, as he himself confessed later in a letter to a friend. He seems to have succumbed also to the temptations that surround a youth in London. And when he was at the St. Martin's Lane Academy of Art, Hayman apparently delighted in taking him upon his own rounds of dissipation. "They frequented the bagnios and taverns about Covent Garden, the prize-rings and gambling saloons about Soho," and Fulcher, touching upon this period of the artist's life says, "Whatever was questionable in his after conduct, must in a great measure be attributed to his early removal from home influence and to Hayman's example."

Fortunately Gainsborough's nature was too good and sound for him to be more than smirched by these early years in London amongst artistic ne'er-do-wells and questionable characters. In a letter written long afterwards to the actor Henderson, a young friend who was beginning his career in the metropolis, Gainsborough gave him this advice: "Don't run about London streets fancying you are catching strokes of nature at the hazard of your constitution. It was my first school, and deeply read in petticoats I am, therefore you may allow me to caution you."

Whilst Gainsborough attended the drawing and painting classes at St. Martin's Academy and dissipated with Hayman at night, English art was falling to such a low

degree that the painter Barry spoke of it as "disgraceful," Fuseli as "contemptible," and John Constable as "degraded," although it was the time when Hogarth was at work on his immortal series of paintings, the *Marriage à la Mode* and *The Rake's Progress*.

After three years' study at St. Martin's Academy, Gainsborough hired a room in Hatton Garden, where he began to paint landscapes and small-sized portraits, for the latter of which he was glad to receive from three to five guineas. He also modelled figures of horses and dogs in clay. But this attempt to start his career in London only lasted a short time, for at the end of the year we find him back at Sudbury.

DRAWING FOR "THE SHRIMP GIRLS"

CHAPTER III

IPSWICH

GAINSBOROUGH was now eighteen: he is described as being uncommonly good-looking, with refined features and singularly brilliant eyes. His pleasant manners charmed everyone he met, and he possessed, what no education can give, natural refinement and courtesy.

On his return to Sudbury he devoted the whole of his time to landscape painting, scouring the countryside in search of picturesque spots, and making scores of out-of-door studies which he afterwards elaborated on canvas. Fulcher says that he used to work at this painting from nature from dawn until nightfall, "taking lessons from the sunset clouds floating in changeful beauty." Fulcher bought one of the landscapes painted at this time. It was a view taken from the young artist's house, and described as "a pleasant performance." According to Allan Cunningham it was during one of Gainsborough's sketching excursions in the woods near Sudbury that he made the acquaintance of his future wife, whilst busily drawing a group of trees under which some sheep were browsing. The girl, who was pretty, was called Margaret Burr, and was the sister of one of the hands employed in the workshop of the artist's father. There was a mystery attach-

ing to her birth, for she received an annuity of £200 a
year, said by some to be given by the Duke of Bedford,
and by others by one of the exiled Stuart princes. Allan
Cunningham says that " Mrs. Gainsborough was said to
be the daughter of one of our exiled princes; nor was
she, when a wife and mother, desirous of having this
circumstance forgotten. On one occasion of household
festivity, when her husband was high in fame, she vindi-
cated some little ostentation in her dress by whispering
to her niece, now Mrs. Lane, ' I have some right to this
for you know, my love, I am a prince's daughter.'"

Margaret Burr's annuity, from whatever source derived,
enabled the young couple to marry, and an extremely
young couple they were, the husband being only nineteen
and the wife a year younger. And the union, so early
entered upon, continued throughout their lives a happy
and a prosperous one.

After their marriage Gainsborough and his wife re-
mained at Sudbury for six months, migrating thence to
Ipswich, where they took a small house in Brook Street,
for which they paid the not exorbitant sum of six pounds a
year. The young artist speedily discovering that however
attractive he himself might find the painting of land-
scapes, they did not provide a source of income, thought
that in the capital of his county he would be likely to
find more occupation as a portrait painter. But at the
outset he received neither encouragement nor sitters.
And a story of this period, related by Fulcher, scarcely
redounds to the sagacity of some of the gentry at Ipswich.
A wealthy squire hearing that one Gainsborough had
come to the town, and that he was a painter, sent for him.
On arriving at the squire's house Gainsborough naturally
expected that he would be asked to paint the portrait of

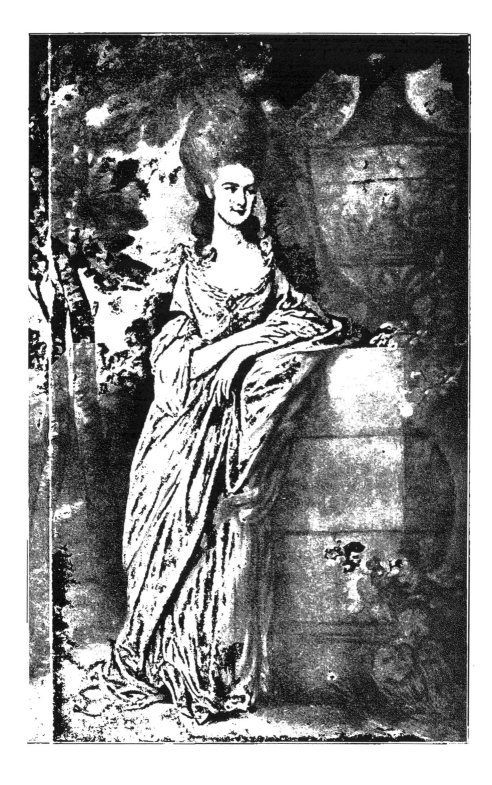

the worthy gentleman or of some member of his family, or perhaps a view of the house, the gardens, or the park. Judge of his disgust, when having been led to the farm-steading the squire told him that he wished him to repaint the palings!

Fifty years ago there were many of Gainsborough's early works to be met with in and around Ipswich, and Fulcher mentions a Mrs. Edgar who had quite a little collection of his water-colour views. On my first visit to Ipswich, in the winter of 1902, I could only discover the portrait of Jack Peartree in the Museum of Christchurch, but on returning to the town later, having heard that some of the artist's paintings done at the beginning of his career were to be seen at Mr. John Cobbold's house of Holy Wells, I was more than rewarded for my journey.

Whilst sketching near Freston Tower, on the banks of the River Orwell, close to Ipswich, Gainsborough made an acquaintance that ripened into a friendship which was one of the happiest circumstances in his fortunate life. This was with Joshua Kirby, a painter of some talent, who was a native of Parham and was thus a fellow-countyman of Gainsborough's. Born in 1716, he had at the age of two and twenty become painter to a coach and house painter at Ipswich, and but for his meeting with Gainsborough might have continued in his very humble following of art. But the younger man's example and instruction fired Kirby to attempt landscape painting, with such success that in 1748 he published a series of etchings of his native county with descriptive letterpress, a work that attracted some attention to him. He then went to London and studied as Gainsborough had done, at the Academy in St. Martin's Lane, and ultimately suc-

ceeded in being appointed drawing master to George III., then Prince of Wales ; and when his royal pupil succeeded to the throne he was made Clerk of the Works at Kew Palace. Kirby made many views of the neighbourhood about Richmond and Kew, and dying at the latter place in 1774 was buried in its churchyard. His daughter Sara was destined to become known to thousands through her writings, few authors of her time being more popular among young folk than the worthy Sara Trimmer. She is one of the small number of authoresses whose portraits figure in the National Portrait Gallery, and she is now better remembered as one of the friends of Dr. Johnson and his circle than as the writer of excellent but some-what *jejune* works on sacred subjects and on education. A close friendship sprang up between the Kirbys and the Gainsboroughs, and when the former went from Ipswich to London in 1753 they left their son William, a clever lad who had inherited his father's artistic tastes, in Gains-borough's charge as his pupil. In a letter written by Sara Kirby to her brother she advises him to study Gainsborough's "gentleness of manner." "Having," she writes, "so good an example to copy after, I imagine you improve very much in politeness."

Later on young Kirby, through George III.'s kindness, was sent to study in Italy, but he died soon after his return. His father shortly followed him to the grave, leaving Gainsborough the poorer by the loss of one of his most devoted and attached friends. When his friend was laid to rest in the peaceful old churchyard at Kew, Gainsborough expressed a wish that when his turn came he might be buried by Kirby's side : his wish was carried out.

The years that Gainsborough passed at Ipswich were

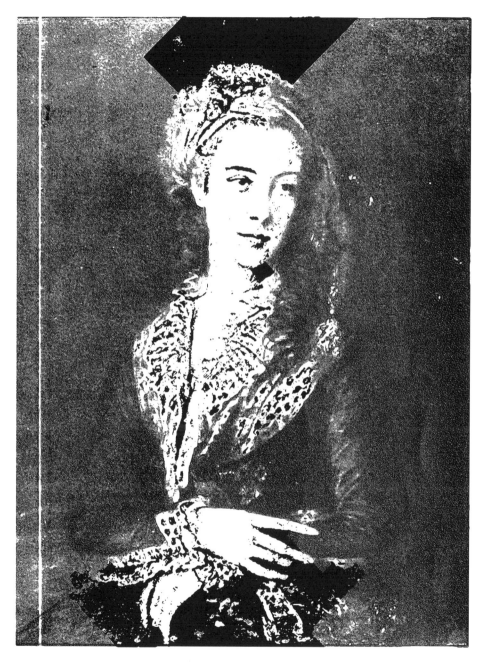

NANCY PARSONS

probably the happiest of his happy life. He had no rival in portrait painting in the town, and no Royal Academy with which to quarrel; he was the life and joy of the pleasantest people in the place, universally popular and adored by his cronies. He was looked-up to by the gentry of the county and neighbourhood, and, above all, his home was a happy one, and his domestic life unclouded. There is a pretty little tale told of his home life which bears repeating. Whenever there had been a little misunderstanding between Gainsborough and his wife, the husband, who had rather a quick temper but who speedily repented of having given way to it, would write a little note of contrition, asking for forgiveness, signing it with the name of his favourite dog "Fox," and addressing it to his wife's pet spaniel "Tristram." Then Margaret Gainsborough would send an answer to her husband's note, addressed to her "own dear Fox," to say that he was always loving and good, and that she was a naughty little woman "to worry you," she wrote once, "as I too often do, so we will kiss and say no more about it. Your own affectionate Tris." Were all domestic squabbles so pleasantly arranged and smoothed over as these between "Fox" and "Tris" what a much happier world this might be.

Among the very few portraits which can be identified as having been painted by Gainsborough whilst living at Ipswich are some ovals, a form he was fond of using all through his life, one of them being of the Hingeston family, between whom and Gainsborough there existed a great friendship, which was maintained until the end of their lives. This picture was in the exhibition of the artist's works at the Grosvenor Gallery in the winter of 1885, and portrays the Rev. James, his wife and his

son, John Hingeston, M.D. Gainsborough painted Mrs. Hingeston twice, in middle life and again in her old age. The latter portrait was also shown at the Grosvenor Gallery, and the actual shawl worn by her when sitting to Gainsborough was exhibited by the side of it.

During the Ipswich period he also painted small portrait groups, and amongst these were two into which he introduced his own portrait and that of his wife, seated on a knoll in a park-like landscape. One finds in this, as well as in others of the somewhat rare portraits of Mrs. Gainsborough, few traces of the beauty with which she was credited by her contemporaries. If, as is possible, some of the rustic women introduced by her husband into some of his landscapes, were taken from her, then her beauty is unmistakable, but in her best portraits, although rather distinguished looking she is by no means beautiful. In another group in which Gainsborough painted himself and his wife, he has also introduced the figure of his little girl, with a dog, painted as only Gainsborough could paint the most lovable of quadrupeds. The dog is drinking in a pool; Gainsborough wears a three-cornered hat. About the year 1750 he painted his own portrait with this three-cornered hat cocked rakishly on one side of his wig, for we know that even at that early age our painter affected that headgear.

Besides these portraits of the Hingestons, of Southwold, Gainsborough also painted many pictures for his friend Mr. Kilderbee, of Ipswich, who at one time was the fortunate owner of one of the painter's most perfect works, that view of the Mall at St. James's, with a group of ladies in the foreground, a picture which ranks in charm and brilliancy with Watteau's famous *Le Départ pour la Cythère*, and which has been compared, not unhappily, to

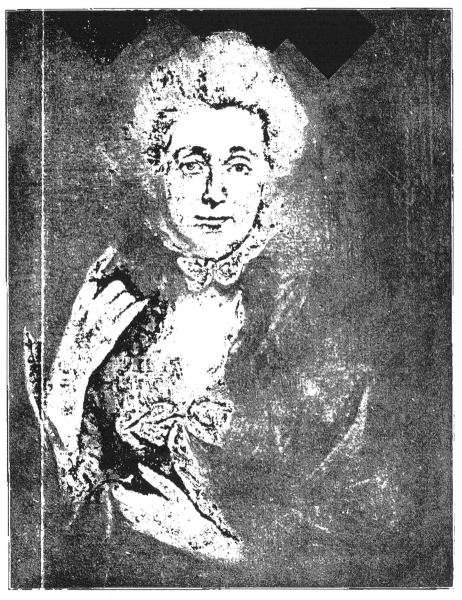

Graves photo] [Owner unknown

MRS. GAINSBOROUGH

the flutter of a lady's fan. Gainsborough also had an ex-
cellent patron in a Mr. Edgar, a Colchester lawyer, who
commissioned him to paint several pictures.

Gainsborough's letters are few, and unfortunately those
that have come down to us are disappointing; for although
racy—somewhat too much so for our sensitive feelings
nowadays—they contain little relating to his work or
his method of painting. But the following, written to this
same Mr. Edgar, and dated Ipswich, March 13th, 1758, is
worth copying.

"Sir, I am favour'd with your obliging letter, and
return you many thanks for your kind intention; I
thought I should have been at Colchester by this time,
as I promised my sister I would at the first opportunity,
but business comes in, and being chiefly in the Face
way, I'm afraid to put people off when they are in the
mind to sit. You please me much by saying that no
other fault is found in your picture than the roughness
of the surface, for that part being of use in giving force
to the effect at a proper distance, and what a judge of
painting knows an original from a copy by; in short, be-
ing the touch of the pencil, which is harder to preserve
than smoothness. I am much better pleased that they
should spy out things of that kind, than to see an eye
half an inch out of its place, or a nose out of drawing
when viewed at a proper distance. I don't think it would
be more ridiculous for a person to put his nose close to
the canvas and say the colour smelt offensive, than to say
how rough the paint lies; for one is just as material as
the other with regard to hurting the effect and drawing
of a picture. Sir Godfrey Kneller used to tell them that
pictures were not made to smell of; and what made his
pictures more valuable with the connoisseurs was his

pencil, or touch. I hope, Sir, you'll pardon this dissertation upon pencil and touch, for if I gain no better point than to make you and Mr. Clubb laugh when you next meet at the sign of the 'Tankard' I shall be very well contented. I'm sure I could not paint his picture for laughing, he gave such a description of eating and drinking at that place. I little thought you were a lawyer when I said one in ten were not worth hanging. I told Clubb of that, and he seemed to think I was lucky that I did not say one in a hundred. It's too late to ask your pardon now, but really, Sir, I never saw one of your profession look so honest in my life, and that's the reason why I concluded you were in the wool trade. Sir Jasper Wood was so kind as to set me right, otherwise perhaps I should have made more blunders."

Although as yet Gainsborough only painted bust and small full-length portraits, and did not attempt full-length size portraits, or any of the large size landscapes with which he was so successful in later life, his style was formed at Ipswich, a style entirely his own, at once vigorous, original and full of character. No painter before him had attempted to portray the surroundings of rural life in England, and Gainsborough from the time that he sketched at the Sudbury Grammar School never ceased to reproduce the scenery of his beloved Suffolk.

Ruskin has given a beautiful description of the happiness of the outdoor life of a landscape painter: they are his own experiences. "Now," he writes, "consider what a landscape painter's life used to be, in ordinary spring weather of old times. You put your lunch in your pocket, and set out, any fine morning, sure that, unless by a mischance which needn't be calculated on, the forenoon, and the evening, would be fair too. You chose two subjects,

Hyatt photo]

[Collection of Henry Pfungst, Esq.

LANDSCAPE WITH SHEEP AND HORSES

Harrison photo]

LANDSCAPE

[Collection of the Duke of Sutherland at Trentham

handily near each other, one for a.m , the other for p.m.;
you sat down on the grass where you liked, worked for
three or four hours serenely, with the blue shining through
the stems of the trees like painted glass, and not a leaf
stirring; the grasshopper singing, flies sometimes a little
troublesome, ants also, it might be. Then you ate your
lunch—lounged a little after it—perhaps fell asleep in the
shade, woke in a dream of whatever you liked best to
dream of,—set to work on the afternoon sketch—did as
much as you could before the glow of the sunset began
to make everything beautiful beyond painting: you medi-
tated awhile over that impossible, put up your paints and
book, and walked home, proud of your day's work and
peaceful of its future, to supper." "That was in the years
between 1830 and 1870," adds the Professor, "before the
deterioration of climate" which he describes in one of his
lectures had set in, and which according to him marred
all outdoor work in England for landscape painters. But
if the weather was so much better half a century or more
ago there is all the more reason for believing that per-
petual summer gilded the sunny fields of Suffolk in the
middle years of the eighteenth century when young
Gainsborough painted their stunted pollards and weep-
ing willows by the side of the rapid Stour, and the tran-
quil Orwell, with their boats and seabound barges; or the
stately parks with their great clumps of immemorial oaks
and noble elms; or the country lanes dotted with the
rustic homes of the frugal peasantry, with children cluster-
ing in the doorways or about the heavy waggon-wheels,
groups of little folk which the artist's genius transfigured
into beings as beautiful as Luini's angels, worthy of
attendance at Heaven's gate.

Gainsborough gave poetry to the humblest of rustic

scenes, and threw the glamour of his art upon such simple themes as a waggon-load of peasants returning from the hayfield on a summer's evening, or a little milkmaid crossing a meadow, or seated, watching the farmer's pigs drinking out of a trough; or a lad asleep by the side of a stile; or a couple of swains pointing out an epitaph in a ruined churchyard—such simple scenes became as beautiful under his touch as those lines of Gray in which he tells of "the simple annals of the poor."

There is a letter from Mr. Hingeston, the son of the clergyman, written to a friend, which gives us more idea of the young artist and his Ipswich surroundings than anything else that has come down to us. "I remember Gainsborough well," he writes, "he was a great friend of my father's; indeed his affable and agreeable manners endeared him to all with whom his profession brought him in contact, either at the cottage or the castle; there was that peculiar bearing which could not fail to leave a pleasing impression. Many houses in Suffolk, as well as in the neighbouring county, were always open to him, and their owners thought it an honour to entertain him, I have seen the aged features of the peasantry lit up with a grateful recollection of his many acts of kindness and benevolence. My father's residence bears testimony alike to his skill as a painter and his kindness as a man; for the panels of several of the rooms are adorned with the productions of his genius; one is a picture of Gainsborough's two daughters, when young; they were engaged in chasing a butterfly; the arrangement of the figures, and the landscape introduced into the background, are of the most charming description; there are several other drawings, all in good preservation, and delineated in his happiest manner."

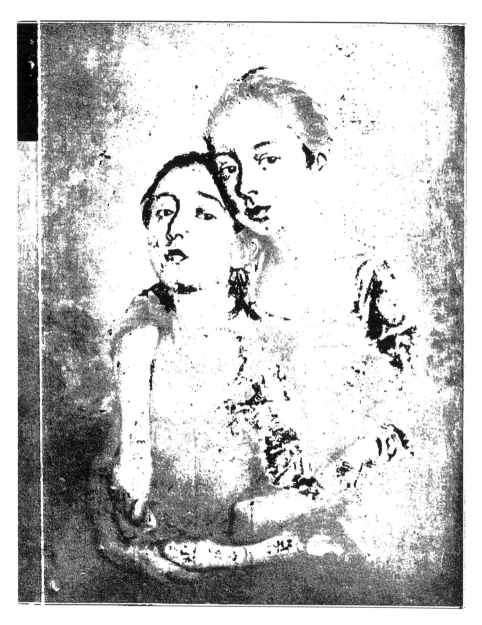

GAINSBOROUGH'S TWO DAUGHTERS
(UNFINISHED)

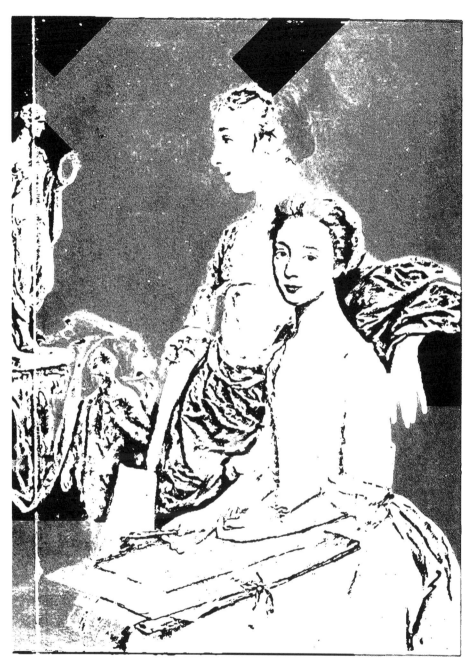

THE TWO DAUGHTERS OF THE ARTIST

The picture here referred to of Gainsborough's daughters is now in the National Gallery, to which it was bequeathed in 1900 by Mr. H. Vaughan. The two little girls, Margaret and Mary, are painted standing hand in hand under some trees. Mary is trying to catch a butterfly. It is very sketchy in treatment, and cannot be said, any more than the portraits of his wife, to give much impression of the possession of good looks: neither does any beauty appear in another slight portrait of his two girls, of which there is a reproduction in this book. The two girls were both born at Ipswich, and in later life both showed symptoms of insanity. The second, Mary, married, but not happily. Even in the time of his death Gainsborough was fortunate, dying before the insanity in his children had become apparent, thus being spared what would have been a terrible and overwhelming sorrow to a man of his strong and affectionate nature.

After painting, Gainsborough's greatest interest was for music. There still exists at Ipswich, by the side of that beautiful Tudor house in the Butter Market, "The Ancient House," formerly in possession of the Sparrow family, and now a bookseller's shop and circulating library —an inn, in the parlour of which Gainsborough is said, by local tradition, to have spent many a jovial evening with some of his boon companions. "Pretty boys they all were in this day," is the judgement passed by a contemporary on the frequenters of the musical club which met at this old inn. John Constable avers that Gainsborough was "the butt of the company. His wig was to them a fund of amusement," as it was often snatched from off his head and thrown about the room; a statement which goes to show that when living at Ipswich Gainsborough did not stand over-much upon his dignity,

but for all that he must have been a most amiable, good-natured individual.

At this period the acquaintance—for it could never be called a friendship—to which reference has been already made, sprang up between Gainsborough and that very singular person, Philip Thicknesse, Lieutenant-Governor of the neighbouring Landguard Fort on the coast opposite Harwich and not far distant from Ipswich. Landguard Fort stands on a small promontory jutting out into the joint estuaries of the Stour and Orwell. The original fort dated from the middle of the sixteenth century, but it was rebuilt in 1718, and has been very much altered since that date—a circular fort of concrete armed with thirty eight-ton guns and other artillery in casemated batteries, which sweep the harbour; it is as strictly forbidden to visitors as the seraglio of the Sultan.

Philip Thicknesse, who was the son of a clergyman and had obtained the governorship of the fort by purchase, appears, to judge by his own writings, to have belonged to that unfortunately common genus, the military snob. Arrogant, selfish, self-assertive, patronizing and irritable, he was a collection in one man of failings, one of which was sufficient to damn a regiment let alone one governor of a military post. Thicknesse loved to parade his connection with anyone who had a title, and was always ready to quarrel or to create a scandal in order that his name should be talked about.

The manner in which the acquaintance between the painter and this Governor of Landguard Fort commenced has already been described and how the general was completely deceived by Gainsborough's presentment of Jack Peartree stuck on a brick wall. The following is Thicknesse's account of his first visit to Gainsborough : " Mr.

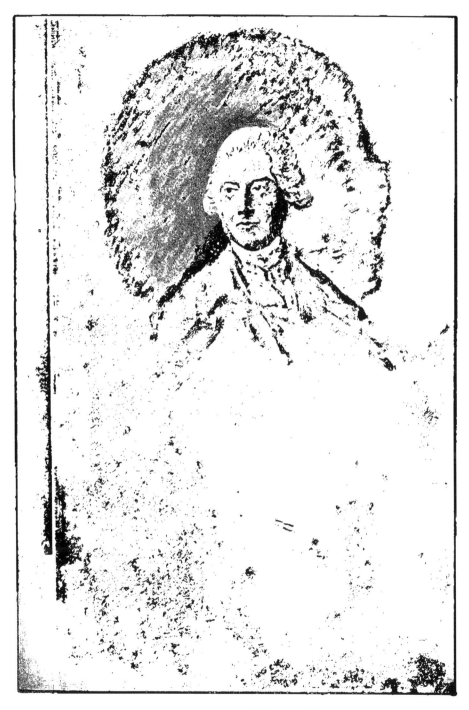

H.R.H. THE DUKE OF CUMBERLAND
FROM THE UNFINISHED PORTRAIT

Gainsborough received me in his painting-room, in which
stood several portraits truly drawn, perfectly like, but
stiffly painted, and worse coloured; among which was
the late Admiral Vernon; for it was not many years after
he had taken Porto Bello with six ships only, but when I
turned my eyes to his little landscapes and drawings, I
was charmed; these were works of fancy and gave him
infinite delight. Madam Nature and not man, was then
his only study, and he seemed intimately acquainted
with that beautiful old lady. Soon after this the late
King passed by the garrisons under my command, and
as I wanted a subject to employ Mr. Gainsborough's
pencil in the landscape way, I desired him to come and
eat a dinner with me, and to take down in his pocket-
book the particulars of the fort, the adjacent hills, and
the distant view of Harwich, in order to form a land-
scape of the yachts passing the garrison under the salute
of the guns, of the size of a panel over my chimney-
piece; he accordingly came, and in a short time after
brought the picture."

For this view of the fort the Governor gave Gains-
borough fifteen guineas, and with them a fiddle, "for I
found," he writes, "that he had as much taste for music
as he had for painting, though he had then never touched
a musical instrument."

Thicknesse caused this view of Landguard Fort to be
engraved in London by Major, and the engraving is still
to be met with, but the painting perished through being
placed against a damp wall. To judge from the print it
must have been a very pleasing work. The foreground
contains some figures, and some stray sheep and a donkey,
all introduced in the artist's delightful manner, and be-
yond, a wind-driven sea breaking on the beach. The

royal flotilla is being saluted by the old wooden war-
ships, and above, great rolling clouds give a dignity to
the whole. This is one of Gainsborough's very rare sea-
scapes. I know but of two others, one of which is at
Grosvenor House; the other was at the Grosvenor Gallery
in 1885, and belonged to Mrs. Clarke Kennedy.

Thicknesse boasts that it was owing to the celebrity
attained for Gainsborough by Major's engraving, and the
praise which he himself deigned to bestow on his *protégé*,
that induced the painter to leave Ipswich and settle at
Bath, where Thicknesse says he told him to "try his
talents at portrait painting in that fluctuating city."
Governor Thicknesse owned a house in that "fluctuat-
ing" place where he passed the Bath season. As he
never troubles to give dates in his "Memoir," it is un-
certain whether the Gainsboroughs left Ipswich for Bath
in 1758 or 1759, but from a letter written by Kirby the
move seems to have been made in the autumn or winter
of the latter year.

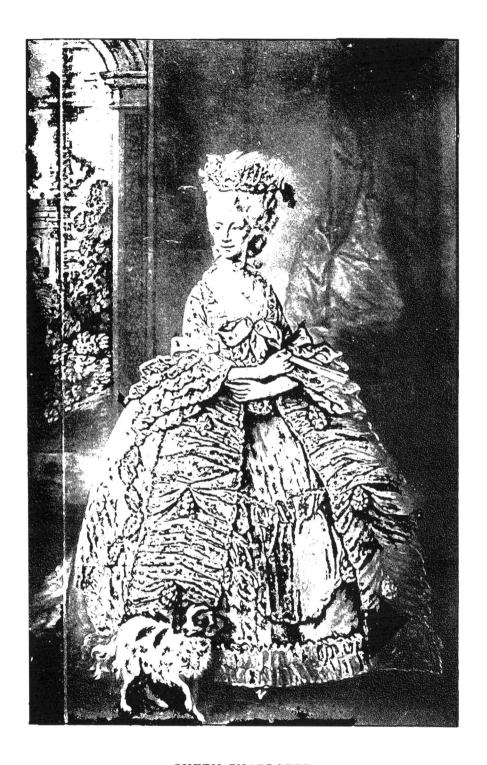

QUEEN CHARLOTTE

FROM THE ENGRAVING BY GAINSBOROUGH DUPONT OF THE PICTURE AT
BUCKINGHAM PALACE

CHAPTER IV

BATH

BATH was at its zenith when the Gainsborough family took up its abode in the city of Bladud. Every winter saw all that was gayest and most fashionable in the London world crowding its streets and walks, its great Pump Room and Assembly Rooms. Bath then held the same place with the wealthy English now occupied by the Riviera and Egypt: it was as frivolous and as luxurious.

Although the halcyon days of Beau Nash were then ended, and his garish chariot and cream-coloured horses no longer drove up and down Milsom Street or on the Parade, the uncrowned King of Bath still lived; and died, at the age of nearly ninety, two years after Gainsborough settled in the town. All the folly, the wit, wealth and fashion of London congregated in the handsome, and then but newly-built Circus, and its adjoining streets and promenades. Sheridan revelled in the humour of the place and in its society, which furnished him with the material for some of his brightest comedies; whilst Miss Burney noted down for use in her next novel the vanities and follies, the gossip and scandal of that frolic crowd.

Goldsmith writes, a year or two after Gainsborough

had settled there, that "upon a stranger's arrival at Bath he is welcomed by a peal from the Abbey bells, and in the next place by the voice and music of the city waits." And in "Humphrey Clinker" we read there was "a peel of the Abbey bells for the honour of Mr. Bullock, the eminent cowkeeper of Tottenham who had just arrived at Bath to drink the waters for indigestion." The season was exclusively in the winter, and in May all the smart folk had departed; to quote Smollett again, "all our gay birds of passage have taken their flight to Bristol-well [Clifton], Tunbridge, Brighthelmstone, Scarborough, Harrogate, etc. Not a soul is seen in this place, but a few broken-winded parsons waddling like so many crows along the North Parade." Quin, the famous actor, and one of Gainsborough's many Bath friends, said the town "was the cradle of age and a fine slope to the grave."

No peal of the Abbey bells, I fear, welcomed the advent of Gainsborough and his family. Mr. Bullock, "the eminent cowkeeper of Tottenham," and his kin were naturally far greater personages in the eyes of the church ringers than the good-looking young artist, who with wife and daughters and probably a large pile of painting materials and properties, had just arrived by the coach from the east and taken lodgings near the Abbey. Yet how the bells would peal, and how warmly would the good city of Bath welcome Thomas Gainsborough, could he again return to that scene of his triumphs. A mural tablet has only comparatively recently been placed upon the house in which he lived and painted, which is a remarkable recognition for England. But if Bath had been in France, and Gainsborough as great a French artist as he was an English one, I imagine

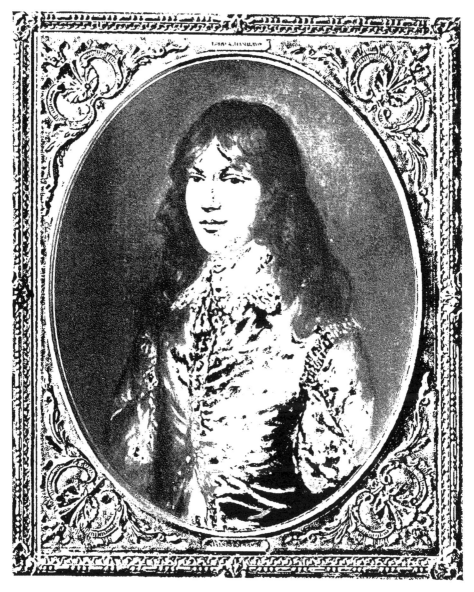

LORD ARCHIBALD HAMILTON

a far more striking memorial of the many years he passed
in the city would have been erected to his memory.

Governor Thicknesse—who appears to have been in
a perpetual state of friction and disagreement with all
mankind, and womankind also, for there is never an
opportunity lost by this ungallant officer of writing dis-
agreeable things and making innuendoes against Mrs.
Gainsborough in his " Memoirs "—thought he now had
the opportunity of causing himself to be considered a
man of taste. With this view, and likewise wishing to
pose before his friends in Bath as a Maecenas, he deter-
mined to intrust Gainsborough with the painting of his
portrait, describing his sitting " as a decoy duck for
customers." But I will give the Governor's own account
of how he introduced Gainsborough to the city. " After
his [Gainsborough's] arrival in Bath, I accompanied him
in search of lodgings, where a good painting-room as to
light, a proper access, etc., could be had, and upon our
return to my house, where his wife was unfortunately
awaiting the event, he told her he had seen lodgings of
fifty pounds a year, which he thought would answer his
purpose. The poor woman, highly alarmed, fearing it all
must come out of her annuity, exclaimed, ' Fifty pounds
a year Mr. Gainsborough! Why you are going to throw
yourself into gaol!' But upon my telling her, if she did
not approve of the lodgings at fifty pounds a year, he
should take a house of a hundred and fifty, and that I
would pay the rent if he could not, Margaret's alarms
were moderated." Thicknesse then describes his sitting
to Gainsborough for his portrait "as a decoy duck for
customers," which was in reality a cheap way of obtaining
his presentment by the artist. It is best to quote the
Governor again. "The first sitting," he writes, "not

above fifteen minutes, is all that has ever been done to it, and in that state it hangs up in my house at this day; business came in so fast at five guineas a head, though he did not much mend in his colouring, or style, yet he was obliged to raise his price from five to eight guineas ... till he fixed it at forty for a half length and an hundred for a full one." This goes to prove that Gainsborough stood in no need of a " decoy duck."

The house to which he went from his lodgings—these were first at 14, Abbey Churchyard, and later at 8, Armistier Belvedere—and where he lived from 1760 to 1774, was one of those large and roomy residences in the handsome Circus, which had then recently been built by one of the greatest architects of that time, the elder Wood. Ten years later Wood's son designed the Royal Crescent, a range of buildings that recalls some of Palladio's designs, and makes Bath the finest city in the kingdom in regard to classical architecture, and which caused Walter Savage Landor, more than half a century after Gainsborough had left it, to declare that both for beauty and purity of architecture, Bath surpassed any of the cities of Italy.

Gainsborough found no lack of " customers " after settling in his new house, No. 24, The Circus. Sitters flocked to his studio, which Fulcher says " was thronged with visitors." " Fortune," said a wit of the day, " seemed to take up her abode with him; and his house became Gains—borough." And, like Opie, Gainsborough is reported to have said that he would be obliged to place cannon before his door to keep the crowd of would-be sitters away from it.

In 1760, with the new King, there came into existence in London a Society of Artists in Spring Gardens, the

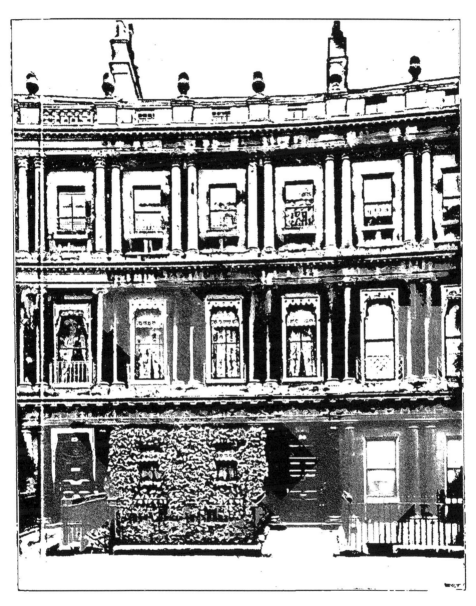

GAINSBOROUGH HOUSE IN BATH

(24, THE CIRCUS)

immediate precursor of the Royal Academy; and to the second exhibition of this society, in 1761, Gainsborough contributed, sending a portrait described in the catalogue, *Whole-length of a gentleman*. It was the first portrait he had ever exhibited, and was of Robert Craggs Nugent. When he sat to Gainsborough, Nugent, who was in his fiftieth year, was Member of Parliament for Bristol, having formerly represented St. Mawes. Seven years later he was created Baron Nugent and Viscount Clare, and in 1776 received a higher rank in the peerage, being made Earl Nugent.[1] He was Irish, a poet and a much-married man. Lord Dover writes of him that he seemed "to have passed his life in seeking lucrative places and in courting rich widows, in both of which pursuits he was eminently successful." But perhaps Lord Nugent's best title to fame is the poem addressed to him by Goldsmith, known as "The Haunch of Venison," beginning:

> "Thanks, my Lord, for your Ven'son; nor finer or fatter
> Ne'er ranged in a forest, or smoked in a platter."

Gainsborough's portrait of him was pronounced by all who saw it in Spring Gardens to be an excellent likeness, and Reynolds, on seeing this work of the unknown painter from the east, must have felt that a rival had at last arisen to compete with him on his own ground. In the following exhibition appeared Gainsborough's portrait of Mr. Poyntz of Midgham, Berks, and in the catalogue (1762) it is described as *A whole-length of a Gentleman with a Gun*. Mr. Poyntz, was the son of Stephen Poyntz, who had been

[1] This portrait of Lord Nugent was at Stowe, the Duke of Buckingham's, and was sold with all the objects of art in that place in 1848, when Field-Marshal Sir George Nugent bought it for £106.

Ambassador to Sweden and France, and whose mother was Anne Mordaunt, a maid of honour to Queen Caroline, and the beauty celebrated in a poem called "The Fair Circassian." He was consequently the brother of Margaret Georgiana, first Countess Spencer, also a beautiful woman, and mother of the still more famous beauty, Georgiana Spencer, afterwards Duchess of Devonshire. William Poyntz was a keen sportsman, and is appropriately painted by Gainsborough with his dog and gun. The portrait had even a greater success than that of Lord Nugent, and practically established the painter's fame. It is indeed seldom that an artist leaps with such rapidity to recognition as did Gainsborough with these two portraits. This particular portrait is now at Althorp, the seat of Earl Spencer, a house rich in Gainsborough portraits; for he also painted William Poyntz's sister, Lady Spencer, and her daughter Georgiana when a child of six, and again as a beautiful young married woman in the heyday of her existence. This portrait of William Poyntz is a delightful one—the easy attitude, as he rests with his back against a tree, whose foliage throws a shimmering light over the figure, is most happily caught. Later, Gainsborough painted an equally fine whole-length of Thomas Coke, first Earl of Leicester, now at Holkham, in which the handsome Norfolk squire is loading his gun. It is as full of life and open air as that of William Poyntz, and I do not know any more excellent or more characteristic portraits of true sportsmen, not of the modern type, but sportsmen to whom *battues* and huge slaughter of almost tame birds and ground game were unknown.

So thoroughly had Gainsborough steeped himself before he left Suffolk in all that gives beauty and charm to the landscapes of that county—its emerald pastures,

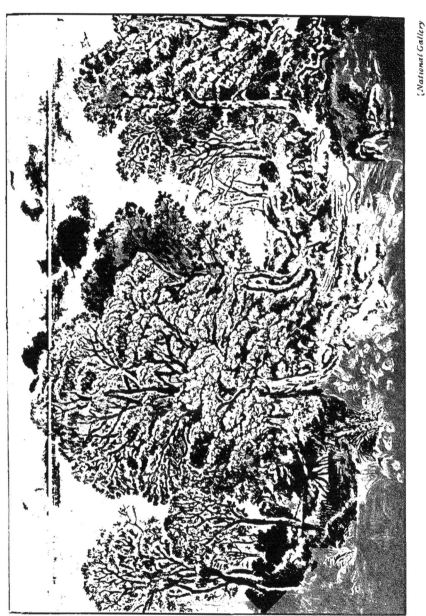

GREAT CORNARO WOOD

FROM THE MEZZOTINT

[National Gallery

its woods, streams, and its ever-changing glory of rolling clouds and misty sunshine—that he could paint the soft scenery of East Anglia in his studio in the Circus at Bath as if he were actually amidst his early surroundings, and when not engaged upon a portrait he would work steadily upon one of those well-remembered landscapes, producing in the midst of the folly and frivolous fashion of Bath such noble pictures as the superb *Great Cornard Wood*, *The Watering-Place*, or a group of cottagers, pictures that are the glory of the English school of painting.

It would be impossible to identify the pictures shown by Gainsborough at the Exhibitions in Spring Gardens, and later at the Royal Academy, if it were not for the catalogues marked by Horace Walpole, in which that assiduous *dilettante* wrote his criticism of the painter's portraits, *A Portrait of a Gentleman*, or *A Portrait of a Lady*, scarcely conveying the historical value that some of them possessed. Gainsborough's contribution to the third Spring Gardens Exhibition was two large landscapes and two portraits, one of Mr. Medlicott, the other of Quin the actor, whose acquaintance he had probably made when a lad in London and when he and Hayman used to disport themselves in the purlieus of Covent Garden. Hayman and Quin were cronies, and Smith in his "Life of Nollekens" tells a characteristic story of these two worthies. "They were so convivial," he writes, "that they seldom parted till daylight. One night, 'after beating the rounds,' and making themselves gloriously drunk, they attempted, arm in arm, to cross a kennel into which they both fell, and when they had remained there a minute or two, Hayman, sprawling out his shambling legs, kicked Quin. 'Hullo! What are you at now?' stuttered

Quin. 'At! Why endeavouring to get up to be sure,' replied the painter, 'for this don't suit my *palate*.' 'Poh!' replied Quin, 'remain where you are, the watchman will come by shortly, and he will *take us both up*.' "

When it is remembered that Quin was considered at that time one of the greatest actors in the country, and Hayman one of its most distinguished artists, we can congratulate ourselves that some progress has been made in matters and manners since the middle of the eighteenth century.

Gainsborough painted Quin twice. In one portrait he has represented the actor seated, holding a volume of plays in his hands. This belonged to the well-known Bath carrier, Wiltshire, with whom both the painter and Quin were intimate. The other portrait is at Buckingham Palace, the head alone. It is a good old face, and reminds one of the portrait by Hogarth of that excellent philanthropist Captain Coram, the founder of the Foundling Hospital, with the difference that Captain Coram wears his own long gray locks, whilst the jolly old player wears a thickly powdered wig. Poor old Quin, who thought Bath "a cradle of age and a fine slope to the grave," went to his own grave (1766) soon after he sat to Gainsborough, at the age of seventy-three. He was of Irish birth, and had played at "old Drury" with both Booth and Cibber, and also with Garrick at Covent Garden. He was excellent both in comic and tragic parts, and reached his highest level as Falstaff, in which he was unapproached. Quin came to Bath about 1746, and remained there until his death, twenty years later. Full of wit and humour, the old actor must have been one of the city's greatest attractions. He gave lessons in elocution to George III. when Prince of Wales, and is reported to have said, when

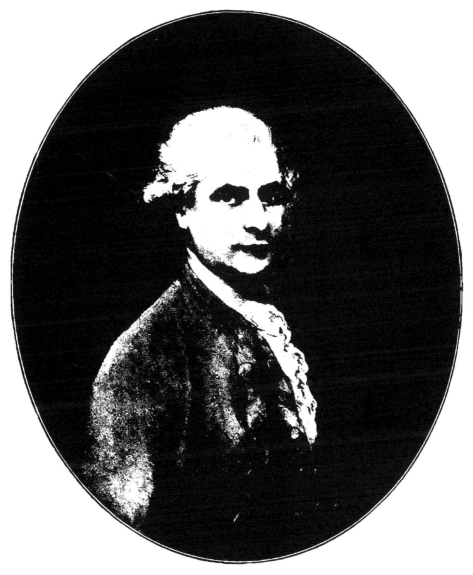

told how well the king delivered his first speech from the throne, " I taught the boy." His monument is on the wall in the Abbey Church, with an inscription written by Garrick.

Until Gainsborough came to live in Bath he had had few opportunities of seeing and studying the works of the great painters of the Low Countries, but there he was within easy reach of many country houses richly stored with the works of these and other artists of the past. Of these houses the principal were Badminton, the Duke of Beaufort's; Longleat, Lord Bath's; Corsham, Lord Methuen's, where there were some excellent paintings by Spanish masters; Bowood, Lord Lansdowne's; and Wilton, Lord Pembroke's, where he could take his fill of some of the finest portraits painted by the great Sir Antony Vandyck during his stay in this country.

Gainsborough never tired of copying Vandyck, whose paintings were to him what Michael Angelo's frescoes were to Sir Joshua Reynolds, altogether sublime. Amongst his copies were the great group of the Herbert family in the " Double Cube " room at Wilton, and some from the works of Velasquez, Teniers, Wynants, Murillo, and Titian.

Gainsborough exhibited many portraits and landscapes during the first seven years of the existence of the newly-established Royal Academy, with unfailing regularity; but, unlike Sir Joshua Reynolds, who had the methodical habit of keeping a register in yearly note-books of all the pictures he painted during the twelve months, Gainsborough unfortunately kept no record of his work, which adds another difficulty in placing his pictures, either as to period or to sequence, and in determining whether they were painted at Bath or in London.

During the last four of the fourteen years that Gains-borough lived in Bath—from 1770 to 1774—we know that he painted seventeen portraits and fifteen landscapes, all of which he exhibited at the Royal Academy from year to year. Among the most notable of these seventeen portraits, besides the one of Quin, to which reference has been already made, was the superb full length he painted in 1765 or 1766 of Quin's brother actor, David Garrick, which is now the artistic glory of Stratford-on-Avon. It was shown at the Academy in the summer of 1766, and was declared by the great actor's wife to be "the best portrait ever painted of my Davy." Garrick is represented standing in a garden, leaning against a pedestal on which is a bust of Shakespeare, and round this he has placed his right arm. He is dressed in a richly embroidered blue and gold-laced coat, and resplendent scarlet waistcoat; the background is richly wooded, and in the distance the famous bridge at Wilton, designed by Inigo Jones, is introduced. The astonishing vivacity and mobility for which the great actor was so renowned are wonderfully rendered in the face, and Garrick's eyes, which could express every emotion, from the tenderest feeling to the wildest fury, are radiant with good humour and kindness. No wonder Mrs. Garrick liked this the best of the many portraits of her husband, who had been painted more often than any man of his day, by Sir Joshua, Zoffany, and every painter of note of the time. Gainsborough loved to paint his actor friend, and there are no less than five portraits of Garrick from his brush, but none are so good as this full-length in the Town Hall of Shakespeare's town, which is traditionally said to have been presented to that place either by Garrick himself, or by his widow shortly after his death. However,

[*Town Hall, Stratford-on-Avon*

DAVID GARRICK

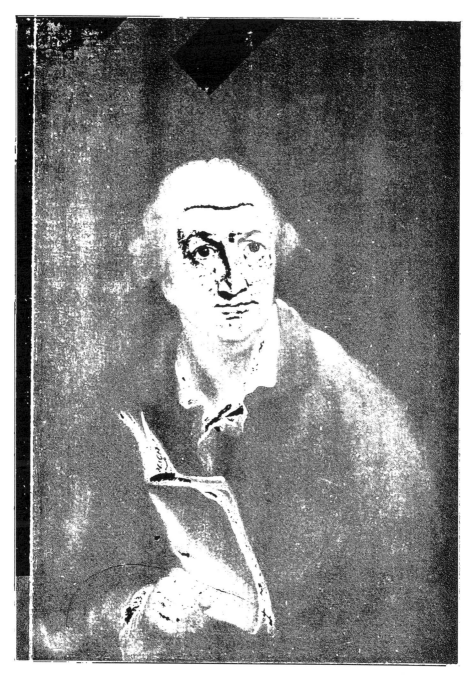

[Common Room, Christ Church, Oxford

DAVID GARRICK

there exists a bill in the Stratford municipal archives kept at the Town Hall, stating that "£63 had been paid to Mr. Gainsborough for Mr. Garrick's picture." It is thought possible that this sum was paid for the magnificently carved gilt frame of the picture, which certainly is sufficiently elaborate to have cost that amount. When this portrait was exhibited at the Grosvenor Gallery in 1885 it stood out above all the other Gainsboroughs in the room, and as few of the crowd which thronged that exhibition had ever been to Stratford-on-Avon, it was the first occasion on which they had seen this masterpiece of the artist.

Two other well-known actors, Henderson and Foote, were also painted by Gainsborough at Bath. But with Foote, as with Garrick, the painter found much difficulty in giving the expression he wanted, they were perpetually changing their expression. "Rot them," Gainsborough is said to have petulantly cried, "for a couple of rogues! They have every one's face but their own."

Henderson was a youth of twenty-five when he sat to Gainsborough. Born in 1747 he was, like Quin, a son of Erin. He appeared for the first time on the stage at a theatre in Bath. Gifted with the talent and the wit that so many of his countrymen possess, he became an immense favourite of Gainsborough, who not only painted his portrait, but made him a present of it, together with much excellent advice, which, as he was twenty years the elder he had every right to give. He painted the young actor twice, the second portrait appearing at the Academy in 1780. In a letter to Henderson, Gainsborough gives the following opinion of Garrick. "Stick to Garrick as close as you can, for your life. You should follow his heels like his shadow in sunshine . . . Garrick is the

greatest creature living in every respect: he is worth study-
ing in every action. Every view and every idea of him is
worthy of being stored up for imitation; and I have ever
found him a generous and sincere friend: look upon him,
Henderson, with your imitative eyes, for when he drops
you'll have nothing but poor old Nature's book to look
in."

This letter is dated from Bath, June 27th, 1773, the
year after Henderson had first appeared on the stage,
and when his acting had attracted Garrick's admiration.
So full of enthusiasm was the great player that he pre-
dicted that young Henderson would reach the topmost
rung of the actor's ladder. The Bath theatre was crowded
nightly to see the new Roscius in Hamlet. Gainsborough
shared Garrick's admiration for the young actor's talent,
which by contemporary accounts must have been of the
highest order, and until the early close of Henderson's
life, they were devoted friends.

All who were distinguished in the many-sided life of
the day passed through Gainsborough's studio in the
Circus between the years of 1763 and 1773. Richardson
and Sterne, Sheridan and Burke represented Literature,
the Drama and Politics; they were followed by lights of
lesser degree. Amongst Gainsborough's military portraits
the most important, although of an unimportant warrior,
is that equestrian one of General Honywood. The florid
old General is riding through a wooded landscape on a
bay horse, which like most of Gainsborough's horses, is
a somewhat wooden steed, for although no one was
happier in painting a pointer or a Pomeranian, and
although the cattle in his landscapes equal those of Albert
Cuyp, he never had success with horses, which invariably
recall the rocking species of our childhood. The most

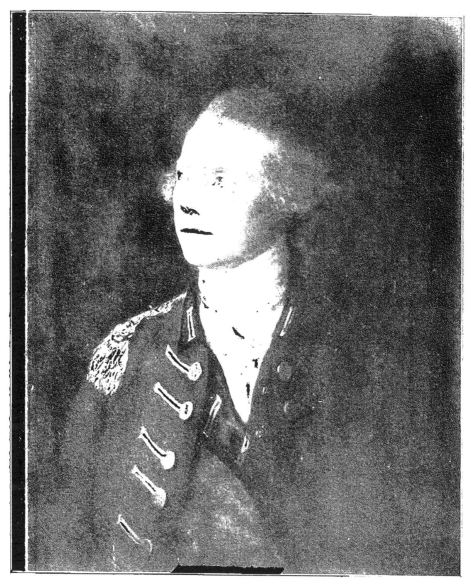

GENERAL WOLFE

illustrious soldier that he painted was General Wolfe, of whom there are two bust portraits in existence, in one of which he wears a hat; in the other he is bareheaded. This latter I am able to reproduce in this little book through the kindness of its owner. It is by far the finest portrait of Wolfe that I know. The young General had an unfortunate profile, a retreating forehead and chin, and an up-tilted nose. Gainsborough hides these shortcomings by painting him almost full face, thus avoiding an expression which possessed nothing imposing, and entirely lacked any suggestion of what is regarded as "military." The expression is bright and intellectual, the eyes full of fire. As Wolfe left England in 1758 to meet his glorious death on the Heights of Abraham, these portraits must have been painted whilst Gainsborough was still at Ipswich. The one with the hat belongs to Mrs. Pym of Braxted, Kent.

Although Gainsborough never attempted to produce works in what was then called "the grand style," or what we should now call Historical and Imaginary subjects, there is evidence in a letter he wrote to Garrick, that at one time he had contemplated painting an imaginary picture of which Shakespeare was to be the subject. It was during the commemoration of the Shakespeare Jubilee at Stratford-on-Avon that he wrote to Garrick of this projected picture which was "to take the form from the Bard's pictures and statues, just enough to preserve his likeness past the doubt of all blockheads at first sight." In another letter to Garrick, dated Bath, August 23rd, 1768, he says: "I doubt I stand accused (if not accurst) all this time for my neglect in not going to Stratford, and giving you a line from there as I promised; but, what can one do such weather as this—continual rainy? My genius is so

damped by it, that I can do nothing to please me. I have been several days rubbing in and rubbing out my design of Shakespeare, and hang me if I think I shall let it go, or let you see it at last. I am willing, like an ass as I am, to expose myself a little out of the simple portrait way, and had an idea of showing where that inimitable poet had his ideas from, by an immediate ray darting down upon his eye turned up for the purpose; but confound it, i can make nothing of my ideas, there has been such a fall of rain from the same quarter. You shall not see it, for I will cut it before you can come. Tell me, dear Sir, when you propose coming to Bath that I may be quick enough in my motions. Shakespeare's bust is a silly, smiling thing, and I have not sense enough to make him more sensible in the picture, and so I tell ye, you shall not see it. I must make a plain picture of him standing erect, and give it an old look, as if it had been painted at the time he lived; and there we shall fling 'em. I am, dear Sir, your most obedient, humble servant, THOMAS GAINSBOROUGH."

It is as well that Gainsborough's imaginary portrait of Shakespeare was never completed, for to judge by the bust of the poet, round which Garrick has placed his arm in the portrait at Stratford-on-Avon, the artist's conception of the Bard would doubtless have been what he himself calls it, "a silly, smiling thing," and as unlike the original one as was Roubiliac's affected statue, which at that period was the accepted likeness of Shakespeare.

The years at Bath were busy ones for our painter, especially after 1767. Among his numerous sitters was Lady Grosvenor, of whom he painted a full length, but of this only the upper part remains, the picture having been cut in two by the lady's irate husband—the divorce case

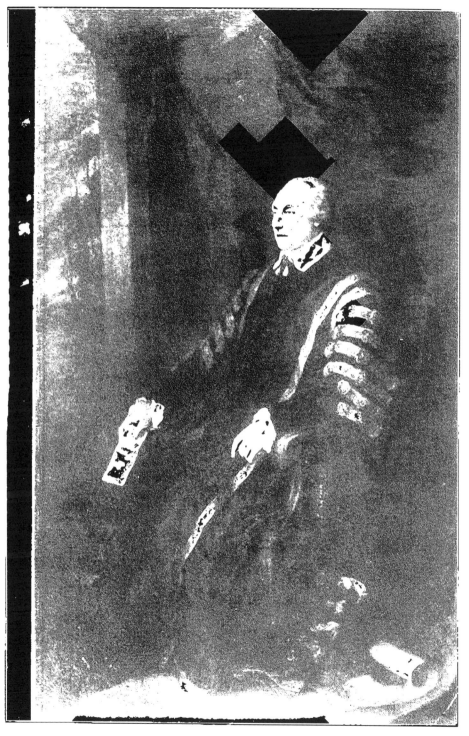

LORD FREDERICK CAMPBELL

in which she figured with H.R.H. the Duke of Cumberland was one of the great *causes célèbres* of the early days of George the Third's reign. We must be grateful, however, for small mercies, as this picture of the peccant countess might have been utterly destroyed, as was the fate of Lady Derby's portrait by Sir Joshua Reynolds, instead of being cut. It is difficult to understand what possible consolation it could have been to Lords Grosvenor and Derby to mutilate and destroy the portraits of their inconstant wives.

At Inverary Castle are three noble full-length portraits which also belong to the years at Bath. One of these is of Field-Marshal Seymour Conway in general's uniform: there is a replica of this portrait in the Town Hall of St. Heliers, Jersey, of which island the Field-Marshal was Governor. The two others are family portraits, one of John Campbell, fourth Duke of Argyll, and the other of his son, Lord Frederick Campbell, who is seated, and wears the robes of Lord Clerk Register. The portrait of the Duke, in which Gainsborough has painted him in his peer's robes and wearing the Order of the Thistle, is as fine in its way as a Titian or a Tintoretto. With one hand he grasps the *bâton* of his Lord High Stewardship of Scotland; the other is lightly placed upon his coronet. There is about this picture an atmosphere and a sentiment which suggest his country's motto, " Nemo me impune lacesset " which must have pleased both the painter and his subject.

At Ickworth, Lord Bristol's house near Bury St. Edmunds, is a fine full-length of Captain Augustus Hervey, painted by Gainsborough at this period. The gallant Captain, who later became Earl of Bristol, and a Lord of the Admiralty, wears a naval uniform, and holds a long

telescope in his hand—field-glasses were not then invented.
He leans against an anchor, and in the background a
man-of-war rides on a somewhat tempestuous sea. Horace
Walpole, who was not often very favourable in his criti-
cisms of pictures, writes of this one of Captain Hervey
that it was "very good and one of the best modern pictures
I have seen."

During the years that Gainsborough lived at Bath he
employed Wiltshire, who seems to have been above the
average in useful intelligence, a man of real taste, and
a deservedly popular functionary, as the carrier of his
pictures. Wiltshire loved pictures, and admired Gains-
borough's work so deeply that he would never accept any
payment for carrying them to London. " No, no," he
would say, " I admire painting too much." Gainsborough,
who was liberal and generous to a fault, would not be out-
done, and gave the carrier a considerable number of his
paintings. Amongst others was that noble portrait of old
Orpin, now in the national collection. Another of Gains-
borough's gifts to the fortunate carrier was that most ex-
quisite landscape called *The Harvest Waggon*, a waggon
passing through a lane in the gloaming; the driver has
stopped his team to allow a peasant girl to climb up
into the waggon: she and another girl in the picture are
Gainsborough's daughters. The leader of the team, which
is held by a youth who looks like a Greek upon an antique
frieze, is also a portrait of a horse given to the painter by
Wiltshire, and which he often introduced into his land-
scapes. This painting now belongs to Lord Tweedmouth
—and Gainsborough knew its value, for he told Wiltshire
that he liked it better than any other of his paintings of
such subjects.

Gainsborough contributed four pictures to the Exhibi-

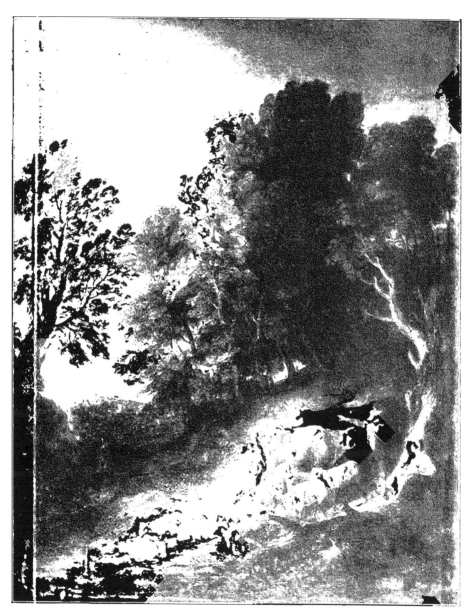

LANDSCAPE

tion in 1769. His name appears with the letters R.A. after it in the first catalogue of the institution among the thirty-six original members, and was not included in the two lists of artists' names submitted by Reynolds for the approval of the King. "It is evident," writes Mr. Tom Taylor, in a note in Leslie's "Life of Reynolds," "that there was a determination to secure him for the new Academy; and that he let himself be secured, but he seems never to have taken any part whatever in the work of the Academy, and his membership is hardly traceable in the Academy records except by a quarrel occasionally about the hanging of his pictures."

On his election Gainsborough presented a picture to the Academy which he called *A Romantic Landscape with Sheep at a Fountain*. A companion landscape to *The Harvest Waggon*, and almost a replica of it, called *Landscape with Figures* was exhibited by Gainsborough at the Academy in 1771. It is as fine as the first work, and again the painter introduced portraits of his family. It is now in the possession of Mr. Lionel Phillips. There can be but few artistic possessions which are more to be envied—if the failing is permissible—than one of these beautiful landscape paintings by Gainsborough. Such pictures are a ceaseless joy to those who value the highest expression that English art has attained.

Among the portraits sent to the Academy in 1769 by Gainsborough, were those of Isabella, Lady Molyneux, of Lord Rivers, and two others, together with the head of a boy. In the following year he exhibited six pictures, but only one of the portraits has been identified: it is one of the five he painted of Garrick. The Academy of 1771 showed five full-lengths by Gainsborough, two of which were of ladies—Lady Sussex with her daughters, Lady

Barbara Yelverton, and Lady Ligonier; the two others were of Lord Ligonier and Mr. Nuthall.

The next year Wiltshire carted from Bath to London no less than fourteen paintings by Gainsborough. Of these, ten were landscapes, and the remainder portraits. But unfortunately none of these have been identified, Fulcher vaguely describing some of the landscapes of that year as "drawings in imitation of oil painting." If Raffaelli's invention of painting with oil sticks had been made in the middle of the eighteenth century instead of the beginning of the twentieth, one would be inclined to believe that Gainsborough had tried this new process from Fulcher's account, but it is probable that these landscapes were drawn with coloured chalks, of which some beautiful examples are occasionally met with: or perhaps they were in water colour combined with body colour, painted on canvas and then varnished in order to give them the brilliancy and surface of oil painting—a process known on the continent as "gouache" and generally reserved for scene-painting.

After 1772 there was an interval in Gainsborough's exhibits at the Academy, and it was not until four years later that any of his pictures were seen in London.

It has already been said that Gainsborough was passionately fond of anything relating to music, and William Jackson, organist, author and composer, who was one of his greatest musical cronies, has left an interesting account of the painter's love of music, or it would be more correct to say, of musical instruments. "There were times," writes Jackson, "when music seemed to be Gainsborough's employment and painting his diversion. When I first knew Gainsborough he lived at Bath, where Giardini had been exhibiting his then unrivalled powers on the violin.

LANDSCAPE

His excellent performance made the painter enamoured of that instrument, and he was not satisfied until he possessed it. He next heard Abel on the viol-di-gamba. The violin was hung on the willow, Abel's viol-di-gamba was purchased, and the house resounded with melodious thirds and fifths. My friend's passion had now a fresh object—Fischer's hautboy; but I do not recollect that he deprived Fischer of his instrument; and though he procured a hautboy, I never heard him make the least attempt on it. Probably his ear was too delicate to bear the disagreeable sounds which necessarily attend the first beginnings on a wind instrument. The next time I saw Gainsborough was in the character of King David. He had hired a harper at Bath—the performer was soon harpless—and now Fischer, Abel, Giardini were all forgotten; there was nothing like chords and arpeggios! He really stuck to the harp long enough to play several airs with variations, and in a little time would nearly have exhausted all the pieces usually performed on an instrument incapable of modulation (this was not a pedal harp), when another visit from Abel brought him back to the viol-di-gamba. This, and an occasional flirtation with the fiddle, continued some years, when, as ill-luck would have it, he heard Crosdill—but by some irregularity of conduct, for which I cannot account, he neither took up nor bought the violoncello. All his passion for the bass was vented in description of Crosdill's tone and bowing, which was rapturous and enthusiastic to the last degree. Happening on a time to see a theorbo in a picture of Vandyke's, Gainsborough concluded, because, perhaps, it was finely painted, that the theorbo must be a fine instrument. He recollected to have heard of a German professor, and ascending to his garret found him dining on roasted

apples and smoking his pipe, with his theorbo beside him.
'I am come to buy your lute—name your price, and
here's your money.' 'I cannot sell my lute.' 'No, not
for a guinea or two? but you must sell it, I tell you!'
'My lute is worth much money—it is worth ten guineas!'
'Aye, that it is—see, here's the money.' So saying he
took up the instrument, laid down the price, went half
way down the stairs and returned. 'I have done but
half my errand. What is your lute worth if I have not
your book?' 'What book, Master Gainsborough?' 'Why,
the book of airs you have composed for the lute!'
'Ah, sir, I can never part with my book!' 'Poh! you
can make another at any time; this is the book I mean
—there's ten guineas for it—so once more good day."
He went down a few steps and returned again. 'What
use is your book to me if I don't understand it? And
your lute, you may take it again if you won't teach me to
play on it. Come home with me and give me the
first lesson.' 'I will come to-morrow! 'You must come
now!' 'I must dress myself.' 'For what? You are the
best figure I have seen to-day!' 'I must shave, sir?'
'I honour your beard!' 'I must, however, put on a
wig!' 'D——n your wig! Your cap and beard become
you! Do you think if Vandyke was to paint you he'd
let you be shaved?' In this manner he frittered away
his musical talents, and though possessed of ear, taste
and genius, he never had application enough to learn his
notes. He scorned to take the first steps, the second was
out of his reach, and the summit unattainable."

One wishes there were more such descriptions extant
of Gainsborough's oddities and delightful enthusiasms,
for one gleans a far acuter impression of the painter from
this scene with the owner of the lute than from the whole

LANDSCAPE

of Thicknesse's narrative, much of which is wholly un-
trustworthy. Oddly enough, it was owing to a quarrel
with Thicknesse regarding a musical instrument that
Gainsborough left Bath for his final home in London,
and the following is the Governor's version of the matter.
" I cannot help relating," he says in his sketch of the life
of Gainsborough, "a very singular and extraordinary
circumstance which arose between him [Gainsborough],
Mrs. Thicknesse, and myself; for though it is very pain-
ful for me to reflect on and much more so to relate, it
turned out fortunately for him and thereby lessened my
concern, as he certainly had never gone from Bath to
London had not this untoward circumstance arisen be-
tween us; and it is no less singular, that I who had
taken so much pains to remove him from Ipswich to
Bath, should be the cause, after twenty years [fourteen
it should be] afterwards, of driving him from thence."
Thicknesse then goes on to explain that the cause
of the "untoward circumstance," as he calls it, which
led to his quarrel with Gainsborough was, that in the
first instance the artist had painted a portrait of Mrs.
Thicknesse before she became the Governor's wife, and
that Thicknesse had wished to have his own portrait
painted as a pendant to that of the lady.[1] Knowing the

[1] Mrs. Thicknesse was the Lieutenant-Governor's third wife. She
was the daughter of Thomas Ford, brother of Dr. Ford, Queen
Charlotte's physician. Before she was married she gave Sunday
concerts at which Dr. Arne, Tenducci and others assisted the ama-
teurs of fashion, Anne's singing to the guitar and playing on the
viol-di-gamba being the principal attraction. Her dancing was so
good that she was praised by no less a personage than Lord Chester-
field. Her father, however, disapproved of her singing in public,
and having secured a magistrate's warrant had his daughter taken
prisoner at the house of a friend where she had taken refuge. Ulti-

painter's passionate fondness for musical instruments, he arranged that Mrs. Thicknesse should make him a present of a valuable viol-di-gamba. Accordingly the Thicknesses asked the Gainsboroughs to supper, and after the meal Mrs. Thicknesse remarked how much she would enjoy hearing Gainsborough play on her precious viol, which he accordingly did, and "charmingly too," says Thicknesse, " one of his dear friend Abel's lessons, and Mrs. Thicknesse told him that he deserved the instrument for his reward and desired his acceptance of it, but said, "At your leisure, give me my husband's picture to hang at the side of my own." Gainsborough was highly delighted by the gift of the viol-di-gamba, and next morning " he sketched a canvas," continues Thicknesse, " called upon me to attend, and he soon finished the head, rubbed in the dead colouring of the full-length, painted my Newfoundland dog at my feet, and then it was put by, and no more said of it or done to it."

Some time then elapsed, and one day when the Thicknesses called at the house in the Circus to see how the Governor's portrait had progressed, Gainsborough invited

mately, however, she was able to give a subscription concert at the little theatre in the Haymarket in the spring of 1760, which her friends had secured for her, and raised £1,500 in subscriptions. But Anne's father was relentless. He had the street and the theatre watched by Bow Street runners, and she would have been arrested again if Lord Tankerville, Lieut.-Colonel of the Foot Guards, had not threatened to send for a detachment of his regiment. She made Thicknesse a good wife, and was a kind mother to his children, one of whom became Lord Audley. After Thicknesse's death she lived in France, and was arrested during the Commune, only escaping the guillotine by the death of Robespierre. The last fifteen years of her life were spent with a friend in the Edgware Road, in whose house she died, in 1824, at the age of eighty-six.

THE HARVEST WAGGON

Mrs. Thicknesse to go into his studio. She fully expected
to see her husband's portrait well advanced, if not finished,
but to her disgust the painter led her up to the canvas on
which was the portrait of the musician Fischer, that
splendid full-length which until recently was at Hampton
Court, " completely finished," writes the aggrieved Thick-
nesse, "and mine standing in its tatter-a-rag condition
by the side of it." Mrs. Thicknesse burst into tears at
the sight and "flounced" out of the studio, and imme-
diately upon returning home wrote to Gainsborough that
she would thank him to put her husband's portrait in the
garret. On the receipt of this message Gainsborough at
once returned the viol-di-gamba. Then followed a pretty
quarrel, which culminated in Gainsborough sending the
still unfinished portrait to the Governor. This his irate
wife returned with a note in which her husband says,
"she bid him take his brush and first rub out the counten-
ance of the truest and warmest friend he ever had, and
so done, then blot him for ever from his memory." We
know there are always two sides to a quarrel as to a
shilling. The above is the Governor's version, but more
probably the true history of this musical squabble be-
tween the Gainsboroughs and Thicknesses is that given
by Allan Cunningham, who had it from one of Gains-
borough's relatives. " The painter," writes Cunningham,
" put a hundred guineas privately into the hands of Mrs.
Thicknesse for the viol-di-gamba; her husband, who may
not have been aware of what passed, renewed his wish for
his portrait, and obtained what he conceived was a promise
that it should be painted. This double benefaction was,
however, more than Gainsborough had contemplated; he
commenced the portrait, but there it stopped, and after
a time, resenting some injurious expressions from the lips

of the Governor, the artist sent him the picture, rough and unfinished as it was, and returned also the viol-di-gamba."

I imagine that Thicknesse and his wife must have been thorns in poor Gainsborough's flesh, and possibly one of his reasons for leaving Bath was that they haunted it every winter ; otherwise there was no special inducement for him to give up his residence in a place where he had made his home for so many years, and where he had as much work as he could possibly find time to accomplish. But people of the type of Governor Thicknesse can become an intolerable nuisance. He himself shows the bent of their minds when he describes his wife's action and his own over the viol-di-gamba, a sprat to catch a mackerel, and it is not surprising if Gainsborough were willing to face any change of life to get away from them.

During the fourteen years Gainsborough had passed at Bath he had become known throughout England as one of the greatest artists of the day; when he had arrived there his name had not been heard outside his native county. His portraits were now as eagerly awaited on the walls of the Academy as those of the President, and together with his beautiful landscapes always called forth the keenest interest and admiration, so that he was sure of a warm welcome in London, and a position in the world of art only second to that of Sir Joshua.

But before we take leave of our painter at Bath there are some of the portraits he painted there which must not be overlooked. Among the many beautiful women he painted there was not one more refined and more purely featured than Elizabeth Linley, the eldest daughter of the musician, Thomas Linley, born in 1754 at Bath. Gains-

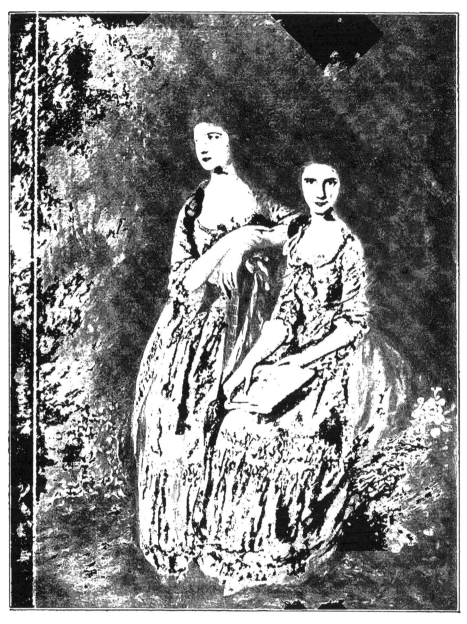

THE TWO MISS LINLEYS (MRS. SHERIDAN AND MRS. TICKELL)

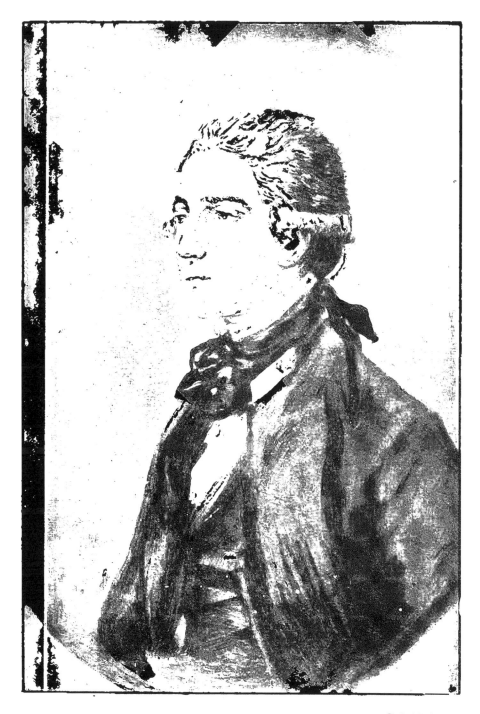

Dulwich Gallery

SAMUEL LINLEY, R.N.

borough must have often seen her as a child of nine stand-
ing with her little brother at the entrance to the Pump
Room selling tickets for her father's benefit concerts; and
later also, when she had become the acknowledged beauty
of the town—" The Fair Maid of Bath," as she was called,
and from whom Foote took the title of one of his plays,
" The Maid of Bath"—surrounded by admirers and
courted by the rich and titled. The old miser, Walter
Long, offered to lay his thousands at her feet, regardless
of the expense of a prospective wedding ; when she sang
at Oxford the whole University went wild over her, and
later when she sang in one of Handel's oratorios at Covent
Garden in the Lent of 1773, even that most virtuous of
sovereigns, George the Third, is said to have publicly
expressed his admiration, and, if Horace Walpole is to
be believed, " ogl'd her as much as he dares do in so holy
a place as an oratorio." Her fate was to marry, when
eighteen, the most brilliant, if not the most reputable, man
of the day, Richard Brinsley Sheridan, who had proved
his devotion to Miss Linley by fighting two duels of which
she, like Helen of Troy, was the cause of battle. Their
married life, although it commenced with a runaway
wedding and was short, was a happy one.

Gainsborough painted several portraits of this beautiful
woman, the most beautiful of them all being the one at
Knole, where she appears as a child of thirteen or fourteen
with her little brother Tom peering over her shoulder.
This portrait is but a sketch, and was probably painted
at one or two sittings, but nothing more beautiful can be
imagined than these two heads of the girl and boy. She
has that pathetic expression so strongly marked in all her
portraits, and a look of subdued awe is on the boy's face
which reminds one of the head of the Infant Saviour in

Raffaelle's great picture of the Madonna at Dresden. There is a life-size group of Elizabeth Linley with her sister, who afterwards became Mrs. Tickell, in the Dulwich Gallery, but it is a less beautiful likeness than her head at Knole, or the full-length portrait of her seated on a bank, belonging to Lord Rothschild, which was painted by Gainsborough in 1783, and was formerly at Delapré Abbey.

Even ladies admired Mrs. Sheridan, which is an uncommon thing for ladies to do; and they said so, which is more uncommon still. Madame d'Arblay writes in 1779 that "the elegance of Mrs. Sheridan's beauty is unequalled by any I ever saw, except Mrs. Crewe." Macaulay has called her "the beautiful mother of a beautiful race"; her grandchildren were famous for their beauty, and three of her granddaughters were the famous trio of sisters—all gifted with brains as well as good looks—the Duchess of Somerset, Mrs. Norton, and Lady Dufferin, the mother of the well-known statesman and diplomat, Lord Dufferin, who wrote thus of his great-grandmother, " For Miss Linley I have not words to express my admiration. It is evident, from the universal testimony of all who knew her, that there has seldom lived a sweeter, gentler, more tender or lovable human being." Wilkes said of her: " She is superior to all I have heard of her, and is the most modest, pleasing and delicate flower I have seen for a long time." Dr. Parr said she was "quite celestial." A friend of Rogers, the poet, wrote " Miss Linley had a voice as of the cherub choir. She took my daughter on her lap and sang a number of childish songs, with such a playfulness of manner and such a sweetness of look and voice as was quite enchanting." Garrick always alluded to her as " the saint"; one bishop called her "the connecting

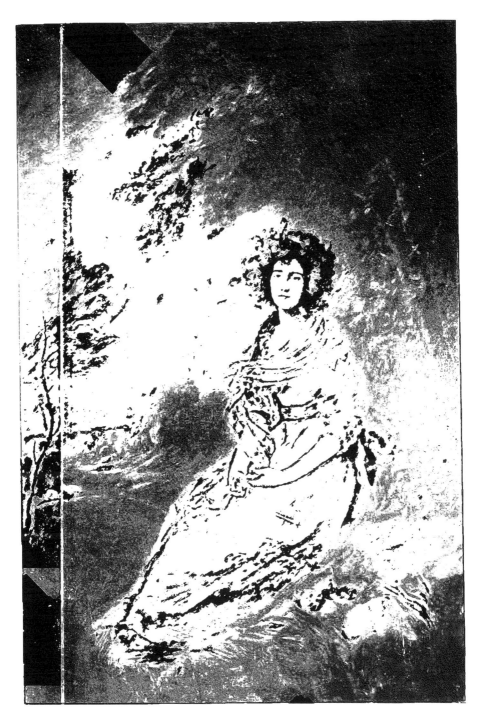

MRS. SHERIDAN

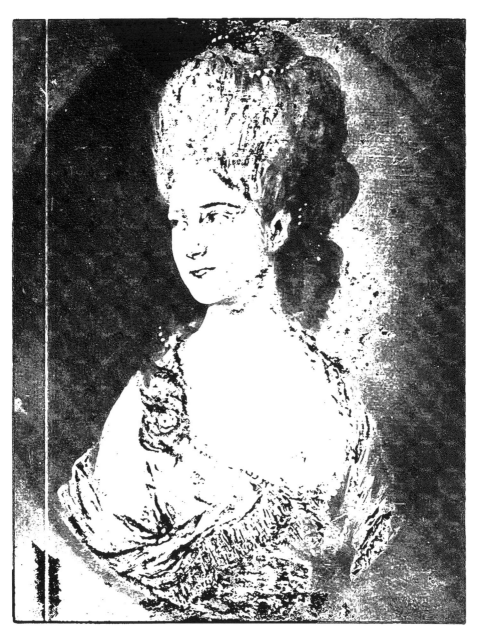

MRS. SHERIDAN

link between a woman and an angel;" and another said, "to look at her when singing was like looking into the face of a seraph." Evidently kings and bishops were great admirers of the peerless Eliza of Bath.

Sheridan must have had some good in him to have been so loved by this saint-like woman. In a letter to a friend she writes, " Poor Dick and I have always been struggling against the stream, and shall probably continue to do so until the end of our lives; yet we would not change sentiments and sensations with —— for all his estates."

Gainsborough not only painted Miss Linley, but he also modelled a bust of her beautiful head and shoulders. He had been to one of the concerts at which she sang— he never missed one where her beautiful voice was to be heard—and on his return to the Circus he got some clay out of a beer-barrel and in a few minutes had made a little bust, which, when dry, he coloured. Thicknesse declared that it was better than any portrait he had ever painted of her ; but the next day the bust disappeared; no doubt it had been "dusted" by the maid, and had come to pieces in the process, as so many fragile objects do in similar circumstances. Leslie is said to have had a cast taken from another bust Gainsborough made of Miss Linley, but that also perished, probably in the same way as the first one.

According to Fulcher, Gainsborough occasionally modelled busts of his friends in the evening, taking his material from the wax candles burning before him : these were said to be admirable likenesses. Probably these little portraits in wax were the profiles of his friends, like those little elaborately coloured wax medallions which one sees in museums, made by Italian artists

in the sixteenth and following centuries, of which the most remarkable, of a late period, are those of the clever medallist, Tassie, who although of Italian descent was born in Glasgow, where he had a great vogue in the middle of the eighteenth century.

Jackson, the portrait painter, refers to Gainsborough's love of modelling in the following memoranda. "He made . . . little clay men for human figures; he modelled his horses and his cows, and knobs of coal sat for rocks . . . the limbs of trees which he collected would have made no inconsiderable wood-rick, and many an ass has been led into his painting-room." Reynolds, too, refers to this habit of Gainsborough's of bringing still-life subjects into his studio. "Stumps of trees, weeds and animals of various kinds; and designed not from memory but immediately from the objects." Reynolds adds that he even found "a kind of model of landscapes on his table composed of broken stones, dried herbs and pieces of broken looking-glass, which he magnified and improved into rocks, trees, and water. . . . It shows the solicitude about everything that related to his art, that he wished to have his objects embodied as it were, and distinctly before him; that he neglected nothing that could help his faculties in exercise, and derived hints from any sort of combination." This little "model of landscape," as Sir Joshua calls the miniature copy of natural objects which Gainsborough used for his landscapes and the backgrounds to his portraits, was sold at Christie's a few years ago.

Mrs. Sheridan died when eight-and-thirty; her brother Tom, the beautiful bright-eyed lad who appears on the same canvas with her at Knole, was drowned whilst still a youth when on a visit with his sisters to the Duke of

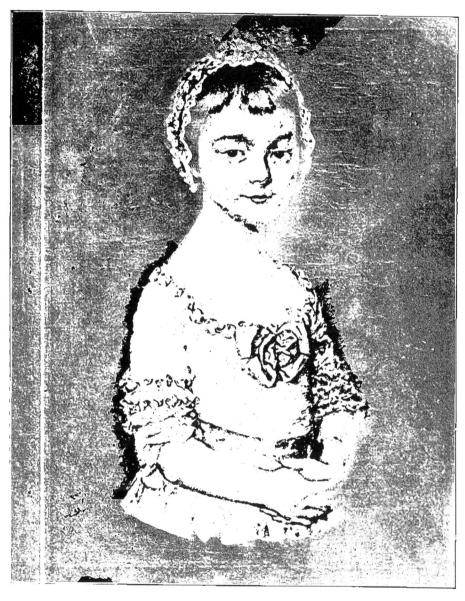

THE HONOURABLE GEORGIANA SPENCER, AFTERWARDS
DUCHESS OF DEVONSHIRE

Ancaster at Grimsthorpe. Another of her three brothers, who was in the Navy, was lost at sea: all were remarkably handsome, as one can see by the portraits by Gainsborough at Dulwich. A small replica of the portrait of Mrs. Sheridan which belongs to Lord Rothschild used formerly to be at Dover House, Lord Clifden's, where it formed a pendant to one of the Duchess of Devonshire, but whether it was of Georgiana Spencer or Lady Betty Foster is uncertain. Both these portraits were painted in oil in a monochrome of Vandyke brown. Some experts believe that they were the work of Gainsborough's nephew, young Dupont, which had been copied and reduced to the scale of 23 inches by 15 inches, in order that the engraver might work from them. That of the Duchess of Devonshire was engraved by Messrs. Graves and has been reproduced and photographed in countless numbers.

It was Gainsborough's habit, when he received a commission to execute a full-length portrait, to first make a small sketch of the figure generally in oils, before beginning to work on the full-size canvas, upon which he would lay in the head, the figure, the drapery and other accessories when the small sketch was completed. These he would completely finish, painting in the head at the final sittings of his model.

At Althorp there is a delightful half-length portrait of Georgiana Spencer, when a child of six. She wears a tightly fitting little lace cap over her thick auburn hair which is cut in a fringe across her forehead. Her frock is adorned with cherry-coloured bows, and her little hands are demurely folded across her chest. There is little promise of future beauty in the face, with its pert little upturned nose and merry blue eyes; but this girl was

destined to grow up into one of the most famously beautiful women of her time, and the most resplendent of duchesses, the lady to whom Southey wrote the verse with the refrain

"Oh lady, nursed in pomp and pleasure,
Whence learnt thou that heroic measure?"

The Duchess· had written some verses after visiting William Tell's chapel on the Lake of Lucerne, in which her expressions of hatred towards tyrants, and her admiration of that very patriotic but mythical Swiss hero, roused the future Laureate's praise and sympathy.

Born in 1758, Georgiana Spencer married William, fifth Duke of Devonshire, when only sixteen, and died in her forty-eighth year after a brilliant, but not very happy life. Whether the Duchess owed more to Sir Joshua and Gainsborough for their portraits of her, or they owed more to her for sitting so often to them both, it is not easy to determine. In any case it must have been surpassingly difficult to have done her justice, for her charm consisted more in fascination of manner and expression, than in great beauty of features, like the beautiful Mrs. Crewe, Mrs. Sheridan, and the Duchess of Rutland. Duchess Georgiana not only possessed that indefinable quality which for want of a better name we call charm, but also as a contemporary expressed it, "feminine softness and dignity of person."

Gainsborough painted a full-length of her at the time of her marriage. She is dressed in white with her hair, which was abundant and beautiful, brushed off her forehead and falling in thick curls on her neck. This portrait is at Althorp, her old home: it was exhibited at the

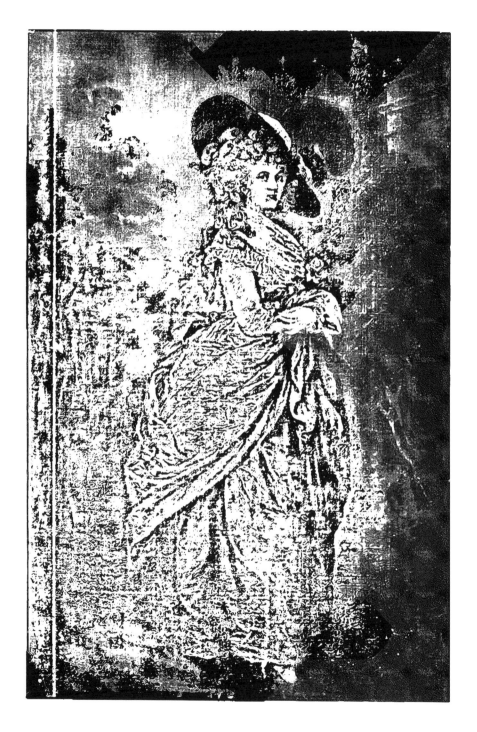

THE DUCHESS OF DEVONSHIRE

GEORGIANA, DUCHESS OF DEVONSHIRE

GEORGIANA, DUCHESS OF DEVONSHIRE

Academy of 1778, and a mezzotint of it was published in 1808 by Barney.

Gainsborough is said to have found the Duchess's mouth the most difficult that he ever had to paint, and on one occasion, after painting and repainting it in vain, he dashed his brush across the canvas in despair, crying "Your Grace is too hard for me."

Over the life-size portrait of the Duchess, the one known as the "Lost Duchess," there will always hang a mystery. As I have already said it was Gainsborough's custom to make a preliminary sketch, sometimes in oil, sometimes in "grisaille," sometimes in colour, before commencing the life-size painting. I have seen one of these sketches, that for the portrait of Queen Charlotte at Buckingham Palace. It was found in a shop at Homburg, and had undoubtedly been in the Palace of that place, brought there by Queen Charlotte's daughter, the Princess Elizabeth who married the Landgrave of Hesse-Homburg.

For my own part I believe, after much uncertainty in the matter, that the so-called "Lost Duchess," which disappeared so mysteriously from Messrs. Agnews' and was found again after many years, is the portrait of Duchess Elizabeth of Devonshire, and not of Duchess Georgiana. But it will always remain one of those unexplained mysteries like the Man in the Iron Mask and Casper Hauser. This "Lost Duchess" painting of Gainsborough is singular in another respect: no work of the artist, and no picture of modern times has been so frequently reproduced in every possible style and size.

Conspicuous amongst a large number of Gainsborough's sketches and studies in the British Museum are two in black and white chalk on blue paper, studies for this

portrait. They are amongst the most fascinating of any of our artist's studies, studies upon which he generally spent only a few moments, but which show the perfection of his art in their skill and unstudied grace of movement.

STUDY FOR A PORTRAIT GROUP

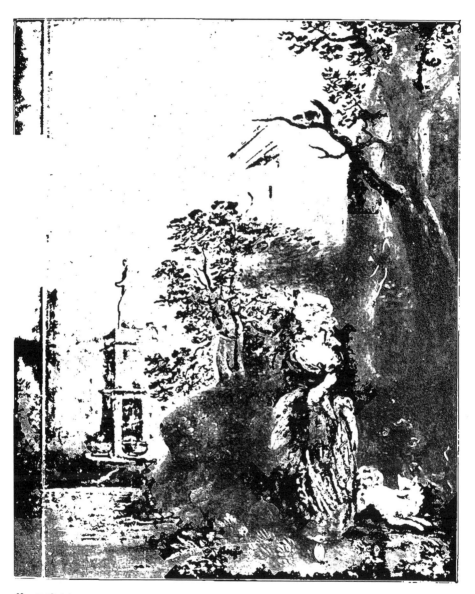

SKETCH

CHAPTER V

LONDON

IT was in the summer of 1774 that Gainsborough, with his wife and daughters, left Bath and went to London. Thirty years had come and gone since Gainsborough had been in the capital, a raw country lad, under the bad influence of Hayman ; he now returned to pass the remainder of his life there, and although some of his best work had been done during the fourteen years he had lived at Bath, the next fourteen were as productive of noble efforts and assured success.

He first took rooms in Oxford Street, or, as it was then called, the Oxford Road, but he soon migrated to Pall Mall, then as now the centre of the fashionable world, with the Palace of St. James's at one end of it and the new Palace of Carlton House, soon to be occupied by the heir to the throne, at the other. The house in Pall Mall, of which Gainsborough took one wing, was, and still is, known as Schomberg House, standing cheek by jowl with the great block built by Wren, in which the indomitable Sarah Jennings Duchess of Marlborough, had lived, and where she died thirty years before Gainsborough's occupation of the neighbouring house.

Schomberg House takes its Dutch name from Frederic Armand Schomberg, a French duke and Field-Marshal,

who had fought both under the tricolour of Holland and the lilies of France. He was one of the favourites of William the Third, and it was while fighting with his royal master at the Battle of the Boyne that he was killed by a cannon-ball whilst leading his regiment across the river; in Benjamin West's well-known picture of that battle Schomberg is seen in the foreground in the throes of death. When first built, Schomberg House stood fronting a double row of elm trees, and at the back were spacious gardens. These had been laid out by the famous garden-architect Kent, for the Lord Burlington who built Burlington House and the Palladian Villa at Chiswick; they were profusely ornamented with bowers and grottoes, statues, busts and terraces; there was even a cascade in them and a bathing-place. These Armidean Gardens continued from those of old Carlton House to those of the Duke of Marlborough, and beyond to the parterre of St. James's Palace; they are now covered by the houses of Carlton House Terrace and Gardens. Whilst Prince Regent, George the Fourth had the excellent idea of connecting Carlton House, Marlborough House and St. James's Palace by a gallery in which portraits of the English sovereigns and historical British personages should be placed. Unfortunately the architect Nash, of Regent Street and stucco fame, bought Carlton House and its gardens, and covered the ground they had occupied with buildings, and the structure which might eventually have developed into a National Gallery worthy of the capital of Great Britain, which the present National Gallery can scarcely be said to be, was absorbed with the rest.

Fourteen years before Gainsborough took up his residence in Schomberg House the Duke of Cumberland,

SCHOMBERG HOUSE
GAINSBOROUGH'S RESIDENCE IN PALL MALL

known as "the Butcher" to the Jacobites and "the Hero of Culloden" to the Hanoverians, had died there, after which it was bought by John Astley, known as "Beau Astley." He had been a fellow-pupil of Sir Joshua's in Rome, and was then so poor that he had made use of some of his canvases as articles of clothing. But since the Roman days "the Beau" had come into at least one fortune. He had married a rich widow, who died soon after becoming Mrs. Astley, leaving her husband all her money. Astley had divided Schomberg House into three portions, occupying the central part himself. This, after his death, was taken by the greatest of miniature painters of the time, Richard Cosway, and here he and his clever and attractive wife, Maria Hadfield, who was also a good artist, entertained the Prince of Wales and the less disreputable of his friends. Here they gave that form of entertainment which someone has truly described as "those splendid nuisances called evening parties;" and here "the charming Mrs. Cosway," as she was always designated, received all the lions and the lionesses of the season. Among her women friends were the sculptress Mrs. Damer, Lady Ailesbury and Lady Townshend; and among her men friends, Paoli and Lord Erskine. The Prince of Wales, to whom Cosway was miniature painter, was a frequent visitor.

On the roof of the house Astley had built a large painting-room, which he called his country house, because of the view it gave over St. James's Park to the wooded slopes of Sydenham on the horizon. He had built a secret staircase up to this chamber, which also communicated with some other rooms. Gainsborough occupied the west wing of Schomberg House, which is little changed externally from what it was in the days of his occupation.

The basso-relievo of a seated female figure, emblematical of painting, which still adorns the entablature above the central doorway, was placed there by Astley as were probably also the caryatidal figures supporting the portico over what was formerly the principal entrance. Schomberg House now forms a portion of the War Office, and nothing remains in the interior of the building as when Gainsborough lived within its old red-brick walls. The east wing has been pulled down, but the central portion and the west wing remain exactly as they were; it is one of the oldest and most interesting houses in Pall Mall, and if Gainsborough were to revisit that thoroughfare he could not fail to recognize his old London home, although new clubs and houses have risen all round it. For his portion of Schomberg House Gainsborough paid a rental of three hundred pounds a year, a very large sum even for a house in Pall Mall in those days, and it goes to show how successful he was in his profession, indeed, next to Sir Joshua, Gainsborough held the foremost place in London as a painter. Great ladies, churchmen, statesmen, famous soldiers and sailors, lawyers, actors and actresses—if they were successful—all these were amongst his sitters, and his studio was as thronged by those who made the history in the middle decades of the eighteenth century as had been the case at Bath.

There was a tradition that he painted some landscapes on the walls of his London home, and in 1857, when part of Schomberg House was connected with one of the Government buildings these paintings were discovered, black and begrimed with London dirt, soot and smoke. The canvases were removed from the plaster in which they had been placed, and were then found to be painted in oil: they were imaginary landscapes. Originally there

THE WOODCUTTERS

UNFINISHED SKETCH, SHOWING GAINSBOROUGH'S METHOD OF PAINTING IN OIL
OVER BLACK CHALK SHADING

had been four of these paintings but one of them had been destroyed in the days of the window tax when an alteration had been made in the windows of the house. Of the three that were preserved two were re-lined and restored. One represented a mountainous country with water in the foreground, a waterfall falling over some cliffs into a pool below: the other was of a more pastoral character pervaded throughout with a mellow golden tone flecked with clouds. These pictures were evidently intended by Gainsborough as purely decorative work, and it is much to be regretted that there is no clue to their history after being restored, or to their present whereabouts.

Another inmate of Schomberg House, and that during Gainsborough's tenancy of the west wing, was a Dr. Graham, a notorious quack who took rooms there in 1781. With him came a very beautiful young woman who was sometimes called Miss Hart, and sometimes Miss Lyon—this beautiful young person whose Christian name was Emma, ultimately became the celebrated Lady Hamilton, the model and inspirer of Romney's finest paintings, and the devoted friend of Nelson. Graham was the son of a saddler, and was born in Edinburgh where he studied medicine and took that city's medical degree. He went to America where he posed as a philanthropic curer of all the fleshly ills of his fellow-mortals. He returned to England with the reputation of an almost miraculous healer, and in 1779 opened his " Temple of Health " in the Adelphi. He was handsome, insinuating, and a perfect charlatan, and all the ladies were attracted by the good-looking young doctor who could effect such wonderful cures. His " Temple of Health " was removed to Schomberg House in 1781

and with it came the incomparable Emma Hart, or, as she was called in Graham's advertisements, the "lovely Hebe Vestina, the rosy Goddess of Health." There were other things to be seen besides Emma, by paying for them. Graham fitted up his rooms to look like something in the Alhambra; or a scene out of Aladdin's palace. "The enchanting glory of these scenes," as he described it, commenced at seven in the evening and "died away" about ten o'clock, during which time "oriental odours and ethereal essences and dulcet strains perfumed and made musical the air."

In 1784 Graham with his "Temple of Health" and its accessories suddenly disappeared. Emma Hart's engagement with this rare quack had ceased long before. No quack ever had such a splendid advertisement as the beautiful Emma, and being so near a neighbour one would have thought that perhaps Gainsborough would have come under the spell of her beauty, and that its influence would be noticeable in some of his pictures. But no portrait of her by him is known to exist unless she sat to him as the beautiful nymph Musidora, bathing "her fervent limbs in the refreshing stream," now in the National Gallery. It might well be the form of the lady whom Romney called "the divine." Just as there are only two sea views painted by Gainsborough in existence, his paintings from the nude are equally rare, the only ones known to me being the Musidora, and a beautiful but unfinished sketch in oils of Diana and her nymphs surprised by Actaeon whilst bathing, which is at Windsor.

A very plausible reason would account for there being no portrait of Lady Hamilton by Gainsborough, and that is the probability of Mrs. Gainsborough not allowing him to paint the fair Emma. That some famous painter's

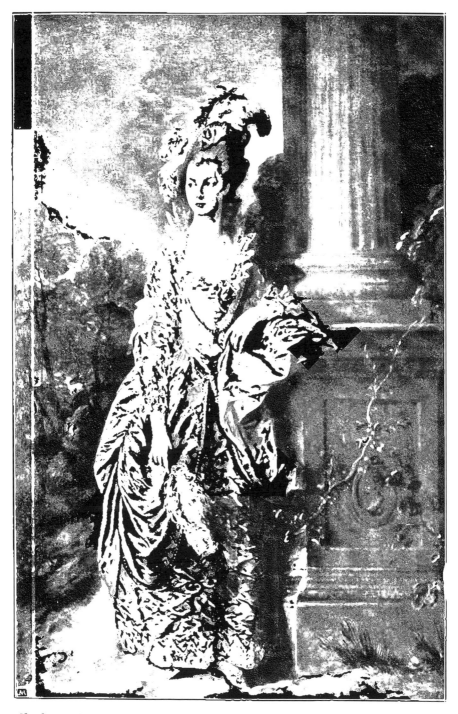

THE HON. MRS. GRAHAM

THE HOUSEMAID

FROM THE ORIGINAL DRAWING

THE HOUSEMAID
FROM THE LITHOGRAPH BY RICHARD LANE, AFTER THE ORIGINAL DRAWING
IN THE POSSESSION OF THE EARL OF NORTHBROOK

wives have been jealous of their husbands is, I believe, not
an unknown fact, and if Mrs. Gainsborough had any
jealousy in her character—and what woman who loves
her husband has not—one can quite understand that she
would object to such a siren as Emma Hart coming to
be painted, either in the classical costume she wore in
Graham's "Temple of Health," or without it. Be the
reason what it may he certainly did not paint Lady
Hamilton's portrait, which is singular, seeing that not
only did Romney paint her constantly, but Sir Joshua,
Lawrence and many other artists followed his example,
to their "great content" as Samuel Pepys would say.

Although we have no portrait of Emma, Lady Hamilton
from Gainsborough's brush, we have more than one by
him of a woman equally beautiful, but of a totally differ-
ent type of beauty. This was Mary Cathcart, daughter
of Lord Cathcart, who married Thomas Graham of
Balgowan, afterwards Lord Lynedoch, a distinguished
officer, who was one of Wellington's most able captains
in the Peninsular War. In her Gainsborough seems to
have found the type of womanly beauty that he most
admired, for not only did he paint that superb life-size
and full-length portrait which is the gem of the National
Gallery of Edinburgh, but he repeated her face in several
other portraits, and in one of his most delightful unfinished
works, the portrait of the so-called *Housemaid*, at Castle
Howard, in which we find Mrs. Graham's lovely features
under the pretty cotton cap of a maid, standing at a
cottage door, broom in hand.

There is a pathetic story attached to the portrait of
Mrs. Graham in the Scottish National Gallery at Edin-
burgh. When she sat to Gainsborough she was nineteen
years old and had just returned from her honeymoon,

which had been passed upon the Continent. She died when only thirty-five, after a marriage of such unclouded happiness that her heartbroken husband could not bear to look upon Gainsborough's life-like portrait of her as a bride. He consequently had it bricked up at one end of the drawing-room in which it hung, and there it remained, forgotten until half a century later, when some alterations being made in the room it was disclosed as fresh, perfect, and as brilliant as on the last day when the great painter passed his magic brush over it.

This portrait was bequeathed to the Scottish National Gallery by Mr. Graham of Redgorton; and the public had their first view of its incomparable loveliness at the Manchester Exhibition in 1857. Since this beautiful work became national property few of Gainsborough's paintings have had such a popular vogue: it has been engraved, etched, copied and photographed times beyond number. Nor is its popularity a matter of surprise. If one were asked to give one's opinion as to which was the typical work of Gainsborough's genius, I for one, would give mine in favour of this portrait of Mary Graham, for it combines in the intensely high-bred look of this beautiful young creature in her shimmering silks, her exquisite features, and even in the plume of ostrich feathers in her hair, all the artist's finest qualities of distinction in portraiture and beauty of colouring.

The unfinished life-size portrait of Mrs. Graham at Castle Howard is said to have been seen in its uncompleted state by the fifth Earl of Carlisle, who was so delighted with it that he would not hear of the artist putting another stroke upon it, and purchased it upon the spot. It is a most interesting painting, for it shows the manner in which Gainsborough "laid in" his figures, and the

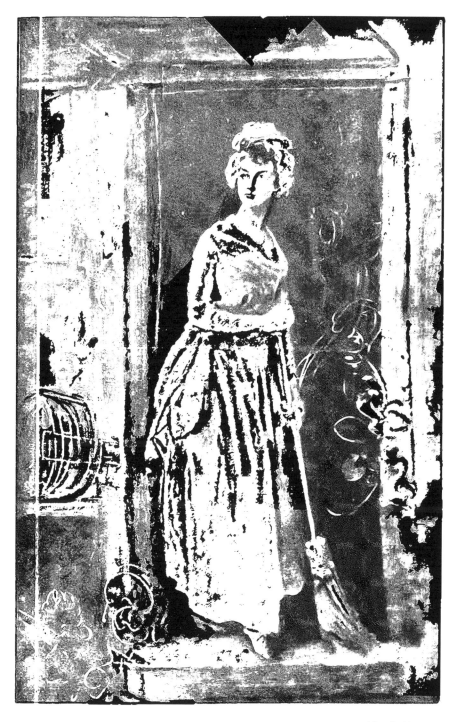

THE HOUSEMAID

Princess Marie Duchess of Gloucester

vigorous brushwork. Some of the accessories are painted in Vandyke brown, the only colour besides being a few touches of carmine in the cheeks and on the lips, but the small amount of actual performance compared with the immense effect of beauty is amazing, and, to the artist, makes this unfinished picture one of Gainsborough's most interesting works. It is seven feet ten inches long, by four feet eleven inches wide. In the portrait of Mrs. Graham at Edinburgh the dress has been more elaborately painted than is usually the case in most of Gainsborough's portraits of women. The upper portion is creamy white, contrasting very happily with the pale mulberry skirt, and this again stands out in contrast with a group of massive foliage against a somewhat lurid sky. Gainsborough, after painting Mrs. Graham, seems to have been ever haunted by her beautiful, sad, young face, for in addition to her many portraits he introduced her in the guise of a peasant into several of his landscapes.

Another strikingly fine portrait is the one known as *The Blue Boy*, at Grosvenor House, which has all the glamour and charm of a portrait of a fairy prince. But the original was young Jonathan Buttall, the son of a reputed immensely rich ironmonger in Greek Street, Soho. After his father's death young Buttall continued the business; but in 1796 his pictures, of which he seems to have had a great number, were sold, and no more was ever heard of him. However, he has been immortalized by this painting, which in some respects is the finest portrait ever painted by an Englishman. It dates probably to the year 1779, and traditionally is said to have been painted by Gainsborough to confute the dictum given by Sir Joshua Reynolds in his eighth "Discourse," in which the President said: "Although it is not my business to

enter into the detail of our art, yet I must take this opportunity of mentioning one of the means of producing that great effect which we observe in the works of the Venetian painters, as I think it is not generally known or observed. It ought, in my opinion, to be indispensably observed, that the masses of light in a picture be always of a warm, mellow colour, yellow, red, or a yellowish white, and that the blue, the grey, or the green colours be kept almost entirely out of these masses, and be used only to support or set off these warm colours; and for this purpose, a small proportion of cold colour will be sufficient. Let this conduct be reversed; let the light be cold, and the surrounding colour warm, as we often see in the works of the Roman and Florentine painters, and it will be out of the power of art, even in the hands of Rubens and Titian, to make a picture splendid and harmonious."

In the portrait of young Buttall, and also in that of Mrs. Siddons in the National Gallery, it will be seen that Gainsborough has absolutely traversed this opinion, and has created two consummate works of art in which blue is the predominant colour, in which the light was cold and "the surrounding colour warm." In the case of. *The Blue Boy* the artist introduced into the background of the picture a mass of deep rich brown which harmonizes admirably with the blue of the costume. But in both pictures the blue has many tones, varying from the deepest hue of lapis lazuli to the palest turquoise.

Although there can be little doubt that *The Blue Boy* at Grosvenor House is the original, replicas of it exist. It is supposed at one time to have been in the possession of Hoppner in trust on behalf of the Prince of Wales, to whom it may have belonged, for there is a letter extant, written by Hoppner's son, in which he says he remem-

[Collection of the Duke of Westminster at Grosvenor House

MASTER BUTTALL

(THE BLUE BOY)

bered seeing the picture at their house in Charles Street, St. James's, and that it then belonged to the Prince. The picture was bought early in the last century by the then Earl Grosvenor.

Gainsborough also painted a *Pink Boy*, the portrait of a younger-looking boy than Jonathan Buttall, called Nicholls, who was a grandson of the famous Dr. Mead. Formerly it was at Waddesdon, but is now the property of the Baroness de Rothschild, and is in Paris.

The Blue Boy hangs almost opposite to Sir Joshua Reynolds's portrait of Mrs. Siddons as *The Tragic Muse*, at Grosvenor House. There are no finer examples of the genius of our two greatest portrait painters which were so essentially different; and the supreme qualities of each are the more easily discernible because of this juxtaposition.

Sir Joshua Reynolds is supposed to have called upon Gainsborough soon after he settled at Schomberg House, but the President's visit was not returned, and these two great artists remained comparative strangers until near the end of Gainsborough's life. There was some talk of Gainsborough's painting the President's portrait, but although Reynolds sat once, the sitting was not repeated, owing to Sir Joshua being seized with a slight paralytic attack which sent him to Bath for the cure. On his return to London he sent word to Gainsborough announcing his convalescence, with a view to resuming the sittings; the latter merely returned an answer saying he was glad to hear that the President's health was restored, but he made no allusion to the portrait. And it was not until the fatal month of July, 1788, that the two artists met again —and for the last time.

Four years passed after Gainsborough had settled at

Schomberg House before he again sent pictures to the exhibition of the Royal Academy. In the meantime he had been on several occasions to Buckingham House, as Buckingham Palace was then called, to paint King George and Queen Charlotte and their children. His first portraits of any members of the royal family were those of the Duke and Duchess of Cumberland. The latter was the beautiful Anne Luttrell, and the widow of Mr. Horton, and her marriage with his brother Henry displeased George III. so deeply that it led to the Royal Marriage Act, which made marriage illegal between princes of the blood royal and subjects without the sovereign's consent. Gainsborough painted the Duchess several times, as well as her first and second husbands. All the portraits are beautiful, but the most beautiful is the one at Buckingham Palace, in which the Duke and Duchess are walking arm in arm in Kensington Gardens, with the Duchess's sister, Elizabeth, seated in the background. There is also a superb full-length of the Duchess at Buckingham Palace in full Court dress, and a third, an unfinished life-size half-length, at Windsor. Her sister, who looks so demure in Gainsborough's picture, very much belied her appearance. She was a notorious gambler, and, like so many women gamblers, cheated at cards; she ended in utter ruin and disgrace, and being unable to remain in England went to Germany, where she was convicted of picking pockets and thrown into prison. At Augsburg she was compelled to clean the streets chained like a dog to a barrow—so says Fitzpatrick, a chronicler of the scandals of the day; but as he was often inaccurate, one may hope that the ugly story was not true.

Gainsborough painted the royal children at Buckingham House, that set of oval-shaped, kit-cat portraits now

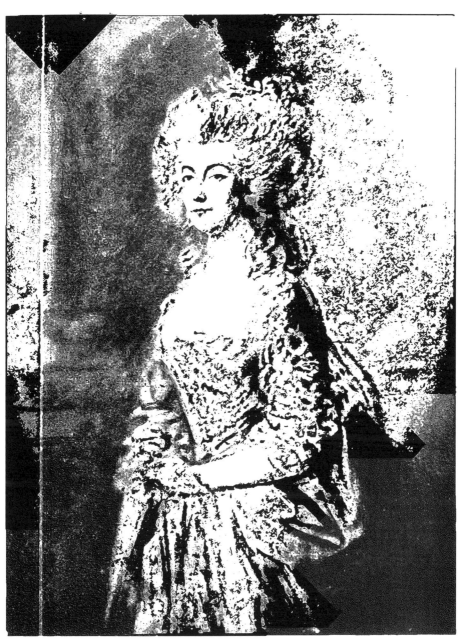

THE DUCHESS OF CUMBERLAND

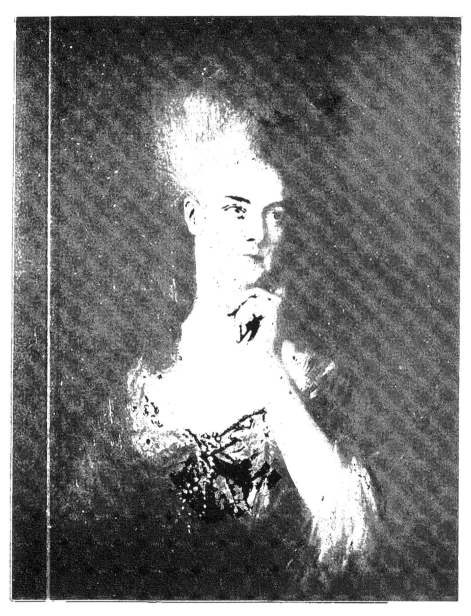

(Collection of H.R.H. the Duke of Cambridge, K.G.

ANNE LUTTERELL, DUCHESS OF CUMBERLAND

at Windsor, and seems to have had a real enthusiasm for the beauty of the princes and princesses. " Talk of the Greeks," he said, " pale-faced, long-nosed ghosts! "—it is well to remember for the sake of our painter's reputation that probably he had never seen a fine Greek statue in his life—" Look at the living delectable countenances in the royal progeny. Talk of old Dame Cornelia, the mother of the Gracchi, sir, here you behold half a score of youthful divinities!" A man who could call George the Third " the morning star of England," and transfigure the more than plain Queen Charlotte into, if not a beautiful, at any rate a very pleasing-looking middle-aged lady, was capable of a great deal; but one cannot go so far, by the light of other history and other statements, to believe what Gainsborough declared to be a fact, that King George was not only a first-rate connoisseur in matters of art, but that he uttered more and better *jeux de mots* than any other person (of rank) that the painter had ever met. Perhaps the " of rank " saves the statement from being entirely fulsome flattery.

The artist related that upon one occasion he told the King that painters should be employed to design the fashions for women's dress, to which his Majesty replied: " You are right, Mr. Gainsborough. Why do not you and Sir Joshua set about it, hey? But," added the King, "the ladies are beautiful enough as it is—what! Hey, Gainsborough, hey, hey?" " Like a saucy fellow as I am," continues Gainsborough, " I said, ' Yes, and please your Majesty, it were as well to leave the dowdy angels alone.'"

Gainsborough's success with his portraits of the House of Guelph was immense, and he succeeded in making all the members of it who sat to him interesting, if not beautiful; even the Duke of Cumberland, who was con-

sidered by all who knew him to be the very reverse of all that is considered to be a gentleman. But his *tours de force* were his portraits of Queen Charlotte, whom he painted several times. In 1781 he exhibited a whole length life-size of George the Third in his blue morning uniform, and one of the Queen in white satin and gold ; these are amongst the finest portraits in Buckingham Palace. Unlike Reynolds, he was *persona grata* at Court, and painted every one of the royal children, with the exception of the Duke of York. Princess Augusta is reported to have said that Gainsborough was "a great favourite with all the royal family," and told the following anecdote. The artist was at Windsor at the time of the death of one of the little princes, and was engaged to paint the dead child. The next day the King, passing the room in which Gainsborough was at work sketching the features of the dead prince, only saw his back, and passing on sent a page to request Gainsborough not to paint on that day. The page gave the message, and returning to the King told him the nature of the painter's occupation. George the Third said no more, and Gainsborough finished the portrait.

Whilst painting all these royal and other sitters, Gainsborough found time to pay occasional visits to his brother Humphrey, the minister, at Henley. Humphrey died in 1776, his model of the steam engine, which he had given to Thicknesse, eventually finding its way to the British Museum, where it may be still.

Compared with that of Reynolds, we know but little of Gainsborough's home life. He never wrote a letter if he could possibly avoid doing so, and kept no record of the passing of his days, not even a list of his sitters. He lived entirely in the society of his family and in that of a

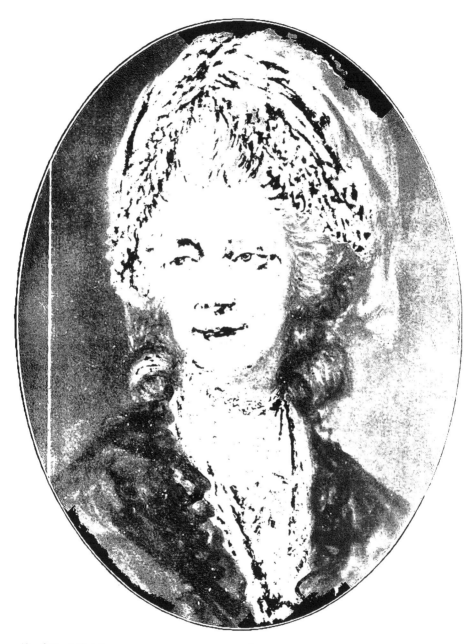

Hanfs'ängl photo] [*Collection of H. M. the King, Windsor Castle*

QUEEN CHARLOTTE

GEORGE III.

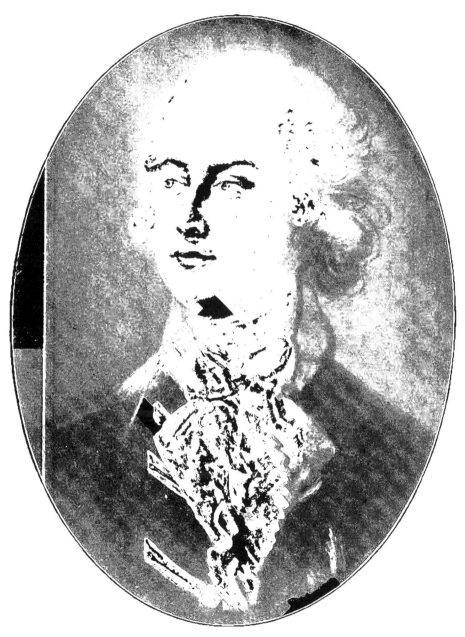

GEORGE, PRINCE OF WALES

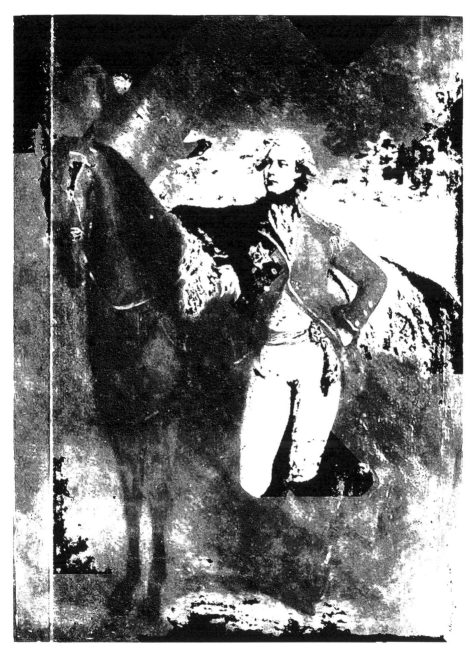

Thomson photo. [*Collection of Miss Alice Rothschild*

GEORGE, PRINCE OF WALES

few friends, for the most part professional or amateur musicians, and seems to have seen very little of any of his fellow-artists, or of anyone connected with his profession.

In the autumn of 1777 Mrs. Gainsborough and her children paid a visit to Suffolk. Writing at the time to a friend, Gainsborough says : " My family had a great desire to make a journey to Ipswich to Mr. and Mrs. Kilderbee's for a fortnight, and last Sunday morning I packed them off in their own coach with David on horseback; and Molly wrote to let me know that they arrived very safe—but somehow or other they seemed desirous of returning sooner than the proposed time, as they desire me to go for them next Tuesday ; the bargain was that I should fetch them home. I don't know what's the matter ; either people don't pay them honour enough for ladies that keep a coach, or else madam is afraid to trust me alone in this great town."

Soon after this was written we hear that Gainsborough got rid of the " family coach." According to Fulcher the artist was too proud to be seen using a public conveyance, and the " chaise was not allowed to drive up to the door" of Schomberg House. Thicknesse, who invariably infers something disagreeable when writing about Mrs. Gainsborough, attributes her husband's concealing his use of a hackney carriage to her parsimony. Gainsborough, he writes, " was obliged to be set down in St. James's Square, or out of sight of his own windows, for fear of another set down, not so convenient either to his head or his heels, as riding out twelve pennyworth of coach hire after having earned fifty guineas previous thereto."

In that same year Gainsborough's finest full-length

portrait was that of the musician, Karl Frederick Abel, who was one of the painter's principal cronies. Abel came from Germany to London in 1759, and speedily became famous for his musical talent and execution upon many instruments, but especially for his playing upon the one Gainsborough loved so well, the viol-di-gamba. Abel was appointed " Chamber Musician " to the Queen, and composed many popular airs; he died in 1787. This portrait was in the Academy of 1777, when Horace Walpole described it as being " very like and well." He was painted at least twice by his artist-friend, who also painted the musician's dogs, a beautiful white Pomeranian with its puppy; the same dog is seen stretched out half asleep under the table on which his master is writing in the portrait, which is one of Gainsborough's happiest successes. By the expression upon the German's shrewd, clever face, he seems to be pausing for a happy turn to some fresh bars of music for the viol-di-gamba that he seems to have just set down and is resting across his thigh. The details of the picture—the big viol-di-gamba with its glowing wood, the paper, and even the snuff-box on which the musician's left hand is lightly laid—all are painted with minute finish, yet without being over-elaborated. One feels that in his portraits of his musical friends, in this of Abel and in that of Fischer, formerly at Hampton Court, Gainsborough painted, as the Italians call it, "with love," and in both he has given the very mind of his sitters; and as with that of Garrick at Stratford-on Avon, the soul of each is caught and shines forth from the eyes on the canvas. The viol-di-gamba is as true to actuality as the musical instrument in Holbein's great picture of *The Ambassadors* in the National Gallery—it was this viol-di-gamba which

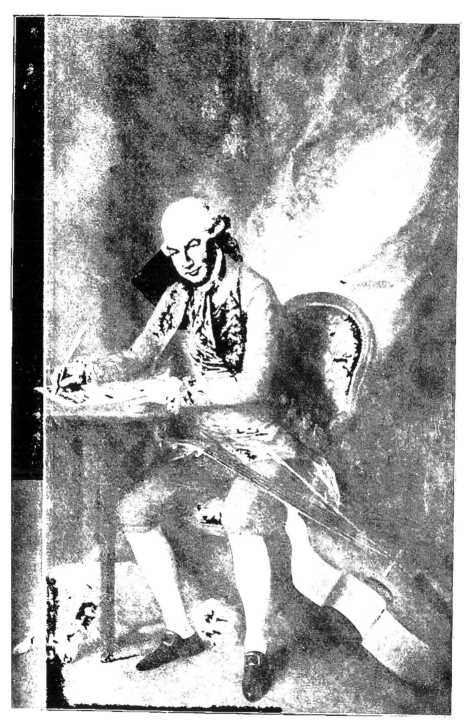

CHARLES FREDERICK ABEL

the painter Jackson said that Gainsborough would contemplate in rapt attention for minutes together. The artist showered sketches upon Abel in recompense for the latter's musical performances. Henry Angelo, the great master of fence, frequently refers in his "Reminiscences" to Abel and Gainsborough being constantly together, and how Abel's walls were literally covered with Gainsborough's drawings. These were sold after the musician's death at Longford's auction rooms.

To the same exhibition as that in which the full-length portrait of Abel was shown, Gainsborough also sent one of his large landscapes, but unfortunately the subject is not known. Walpole writes of it that "it is in the style of Rubens, and by far the finest landscape ever painted in England, and equal to the great masters." Praise like this from the critical master of Strawberry Hill is praise indeed; of another landscape he says: " What frankness of nature in Gainsborough's landscapes, which entitle them to rank in the noblest collection." Gainsborough, however, had one severe critic in a fellow-Academician—that eccentric and somewhat malevolent painter, Henry Fuseli, a Swiss, who in his lifetime enjoyed the reputation of being one of the first painters of the so-called "grand style," but whose somewhat ghastly and macabre works are now relegated to attics and cellars. For some unknown reason Fuseli hated Gainsborough, and when editing a new edition of Pilkington's "Dictionary of Painters" professed not to know Gainsborough's Christian name. He also wrote: " Posterity will judge whether the name of Gainsborough deserves to be ranked with those of Vandyke, Rubens, and Claude." Posterity has judged, and Gainsborough's name ranks with that triumvirate, both as a portrait and

a landscape painter, and it is therefore additionally to be regretted that "the penury of contemporary biography," as Allan Cunningham has truly expressed it, tells us so little of his life, beyond the meagre details which have been noted.

One would give much for some account of the painter's daily life, "the common round," in Pall Mall, or to possess even some notes of his sitters at Schomberg House, either regarding his manner of painting and the arrangement of accessories, or the impression made by his personality on the sitters. Cunningham says that, like Sir Joshua Reynolds, Gainsborough painted his portraits standing in front of his easel. But this is the usual manner of portrait painters, and in this respect Gainsborough may be said to resemble every painter. He had, however, one peculiarity entirely his own; he used brushes which were stuck in "shafts sometimes two yards long," and stood as far away from his sitters as from the canvas on which he was painting, in order to obtain, as nearly as possible, the same effect on the canvas as he himself did of his model. He rose early, beginning to work between nine and ten o'clock, and remained in front of his easel until two or three o'clock in the afternoon: his work for the day finished, he generally played on one of his beloved violins or listened to his friends making music; occasionally he went out to pay visits. After dinner, which was probably about six o'clock, Gainsborough loved to sit by his wife's side; and whilst music was being played, or some one read aloud, he would work away at those delightful sketches of landscapes or figures in different coloured chalks—red, white, blue or black. When a sketch was finished he would toss it under the table and commence another, only keeping, at the end of the

COTTAGE CHILDREN

LANDSCAPE

FROM AN ETCHING ON PEWTER

evening, those he considered the best: these studies he used for his larger landscapes, painted in oils. During the summer he took lodgings at Hampstead or Richmond, where the open country and fine views, and in the latter place the reaches of the Thames, would inspire him with fresh subjects for his brush. Thus passed away a busy, harmless, happy existence. His was the most enviable of natures—the easily pleased and seldom bored. The simplest object, if he thought it in any way beautiful or artistic, gave him infinite pleasure—a well-written letter, the polish upon a musical instrument, or a piece of glistening silk. Smith in his Life of the sculptor Nollekens tells us how he found Gainsborough one day listening to a Colonel Hamilton, who was playing superbly on the violin. "Go on!" cried Gainsborough, "and I will give you the picture of the Boy at the Stile, which you have so often wished to purchase." The tears, writes Smith, stood in the painter's eyes as he listened to the music, and when it ceased a coach was called, in which the lucky Colonel placed the painting he had so long coveted and so easily acquired, and drove away with it. This story paints Gainsborough to the life, and is like one of his own admirable portraits—the enthusiastic devotee of all that is great and refined in art, with an inborn generosity equal to his own genius; a most lovable character, a man born to be envied and admired.

I have not succeeded in tracing this "picture of the Boy at the Stile" which Colonel Hamilton carried away. It belonged to that class of the artist's works—his paintings of English peasant children—which are more beautiful than Murillo's Spanish children, if not as true. Of Gainsborough's pictures of boys, that of Jonathan Buttall takes the first place; but personally, had I the

choice between this and that of the cottager's child carrying a jug of milk and a puppy, which was exhibited at the Guildhall in 1902, I think I would choose the latter. Of this Leslie writes in his admirable " Handbook for Young Painters," a book which all young painters should get and study, " that it is unequalled by anything of the kind in the world "; and he goes on to say that this little girl is the same one as the one who appears in the picture of the *Girl with Pigs*, which was bought by Sir Joshua Reynolds and afterwards by the fifth Earl of Carlisle, and which was one of the greatest treasures of the collection at Castle Howard. The fortunate owner of the *Cottage Girl* is Mr. A. F. Basset of Ichedy, Cornwall. Gainsborough painted several pictures of a little girl watching a litter of tiny pigs drinking out of an earthenware platter; in one all the pigs are ranged round the basin, and lap their milk discreetly, but in another one of the little animals has a hoof as well as his snout in the milk. This very natural trait is said to have been suggested to Gainsborough by overhearing a farmer criticizing the picture, the one for which Sir Joshua Reynolds gave him one hundred guineas, although only sixty were put upon it when it hung at the Academy exhibition. " They be deadly like pigs, but nobody ever saw pigs feeding together but one on 'em had a foot in the trough." On hearing the opinion of one so versed in pig nature and habits, Gainsborough painted the replica in which the pig has his " foot in the trough." Fischer's mezzotint gives the second version of the painting.

Another picture of this class represented a woodman caught in a thunderstorm He gazes upward with a frightened expression at the tumult in the sky. This painting excited George the Third's admiration, but it

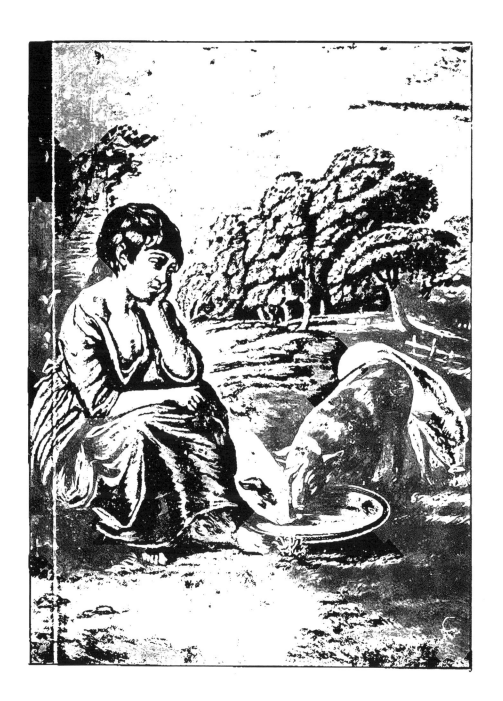

GIRL AND PIGS

FROM THE MEZZOTINT BY W. DICKENSON

was not sold until after the artist's death, when it was
bought by Lord Gainsborough: unfortunately it was
burnt in a fire at Eaton Park. To judge by the litho-
graph taken of the picture by Gainsborough's nephew
Lane, it must have been a very remarkable work; the
terror of the woodman with his dog crouching at his
feet, and looking up at his master for protection, is full
of dramatic power. An even finer work with a similar
subject was one called *The Shepherd's Boy in the Storm*.
In Northcott's opinion it was even finer than *The Wood-
man*, and Hazlitt wrote of it: "What a truth and beauty
in these; he (the shepherd boy) stands with his arms
clasped, looking up with a mixture of timidity and resig-
nation, eyeing a magpie chattering over his head; while
the wind is rustling in the branches. It is like a vision
breathed upon the canvas." There are a large number of
such works as these in which children are introduced.
In one called *Interior of a Cottage*, two children are
standing before a fire with outstretched hands to the
blaze, whilst another is seated eating out of a porringer,
a cat looking greedily on from the chimney corner—a
painting, alas! that has disappeared and is only known
by the mezzotint of it by Charles Turner. There is also
another, similar again to the last, called *The Little
Cottagers*, in which a child stands by a paling, which is
now only known by the engraving.

Gainsborough was fond of introducing cottage children
to give life and animation to his landscapes and rustic
views of Suffolk, as in that most beautiful painting at
Grosvenor House known by the name of *The Cottage
Door*. There are others full of stress and of movement,
as for instance that in which some dogs are fighting whilst
their master is trying to separate them. The dogs are

painted with all the vigour of one of Snyder's wolf-hounds, and one is not surprised to learn that Gainsborough was a great admirer of that artist, of whose paintings he had several at Schomberg House. The original of this picture is at Lord Tollemache's, but a fine mezzotint of it was done by Henry Birche. Gainsborough painted a replica of the work.

In some respects one prefers Gainsborough's children of the people to those of Sir Joshua Reynolds, beautiful as Reynolds's children are, for in actual truth to nature Gainsborough bears away the palm. I know of none of Reynolds's pictures of children that I would choose in preference to the little peasant maid carrying her puppy and milk-jug, which has already been noticed, not even the President's *Strawberry Girl* at Hertford House, or *Master Bunbury* at Barton.

A favourite model of Gainsborough's was a very handsome lad called Jack Hill, whom he had met at Richmond, and he figures in many of the artist's later works. So taken was Gainsborough by the boy's striking beauty and his possibilities as a model, that he took him back to Schomberg House and added him to his establishment. Jack Hill belonged to a tribe of gipsies. " Molly," Gainsborough's daughter, was as much taken by Master Jack's good looks as was her father, and the whole family seemed to have combined to make a pet of him, with the result that he became thoroughly spoilt and gave much trouble. After running away several times, he fell ill and was sent by Mrs. Gainsborough to Christ's Hospital, and there we lose sight of him. But the lad's handsome, swarthy face endures in many of Gainsborough's most delightful pictures of peasant life.

The only event of importance in the tranquil lives led

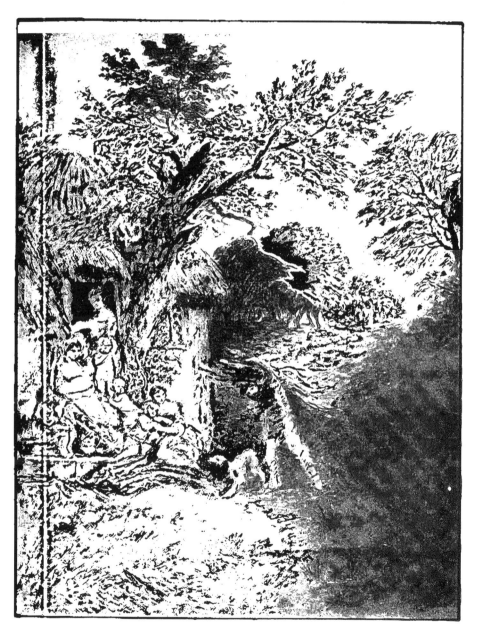

THE WOODCUTTER'S HOME

by the Gainsboroughs in Pall Mall was the marriage of
their younger daughter with the artist's old friend of Bath
days, the musician Fischer. The marriage was made al-
most secretly, and entirely in opposition to the wishes of
the parents. Johann Christian Fischer, who was famous for
his playing upon the hautbois, had met and seen much
of the Gainsboroughs when they were living at Bath, and
probably followed them to London after they had settled
there. In 1780 he and Molly Gainsborough were married,
little to the father's liking, as the following letter, written
to his sister early that year, will show: "Dear sister," he
writes, "I imagine you are no stranger to the alteration
which has taken place in my family. The notice I had of it
was very sudden, as I had not the least suspicion of the
attachment being so long and deeply seated; and as it
was too late for me to alter anything, without being the
cause of total unhappiness on both sides, my consent,
which it was a mere compliment to affect to ask, I needs
must give: whether such a match was agreeable to me
or not, I would not have the cause of unhappiness lie
upon my conscience, and accordingly they were married
last Monday, and are settled for the present in a ready-
furnished little house in Curzon Street, May Fair. I can't
say I have any reason to doubt the man's honesty or
goodness of heart, as I never heard anyone speak amiss
of him; and as to his oddities and temper, she must learn
to like them as she likes his person, for nothing can be
altered now. I pray God she may be happy with him,
and have her health. Peggy has been very unhappy about
it; and I endeavour to comfort her, in hope that she will
have more pride and goodness than to do anything with-
out first asking my advice and approbation. We shall see
how they go on, and I shall write to you further upon the

subject. I hope you are well, and with best wishes, I remain Your affectionate bro: Thos: Gainsborough."

Fischer died in 1800, twenty-six years before his wife, who went out of her mind. One of her hallucinations was that the Prince of Wales was deeply in love with her, and at her death she bequeathed Gainsborough's portrait of her husband, painted at Bath, to the Prince, then become George the Fourth. This was one of the best of the modern English portraits at Hampton Court, but now it is no longer kept there. Gainsborough represented his future son-in-law standing by the side of a spinet, apparently in act of composing music, for he gazes upward as if seeking inspiration. In front of him is an open music-book and an oboe, one of those instruments which Gainsborough loved; a violin is placed on a chair, and Fischer wears a coat of crimson velvet. This fine portrait was painted about 1767 or 1768, when Fischer was a constant visitor at the Gainsboroughs' house in the Circus.

We have a glimpse of the life at Schomberg House after the marriage in a book called " Wine and Walnuts," said to have been written by an artist named Pyne, which shows that despite their dislike to the union the Gainsboroughs kept up kindly and friendly relations with their daughter and son-in-law. " The two enthusiasts" (Gainsborough and Fischer), says the book, "sometimes left their spouses, mamma and daughter, each to sleep away half the night alone. For one would get at his flageolet, which he played delightfully, and the other at his viol-di-gamba, and have such an inveterate set-to that, as Mrs. Gainsborough said, a gang of robbers might have stripped the house, and set it on fire to boot, and the gentlemen been none the wiser." " In truth," said Caleb Whitefoord, " I

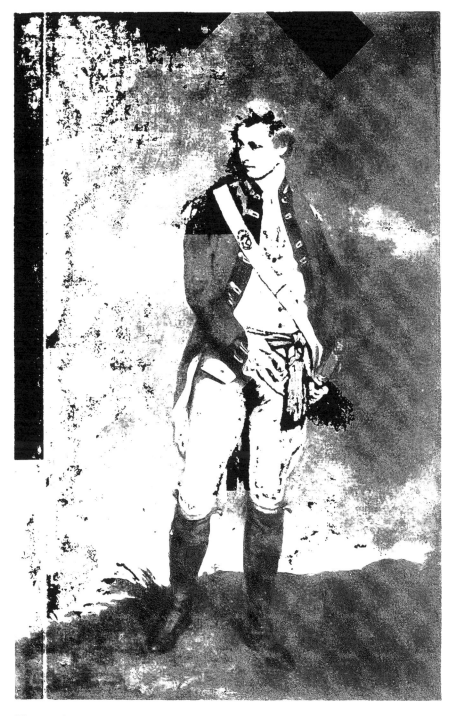

COLONEL ST. LEGER

never met with fellows like these, who lost all reckon-
ing of time when tuning it to their cat-gut and tootle-
too !''

There was also at Hampton Court another full-length
portrait by Gainsborough of Colonel St. Leger, a par-
ticular friend of George the Fourth when Prince of Wales.
This was painted as a pendant to one of the Prince, who,
like St. Leger, appeared in regimentals with a horse by
his side. The two friends exchanged portraits. "Jack"
St. Leger was one of the riotous young rakes about
London when George the Fourth was Prince of Wales.
He was perhaps more wildly extravagant than the other
"bloods" of the Regent's set, and was known as "Hand-
some Jack St. Leger." Born in 1756, he belonged to the
Doneraile family and became Colonel of the Foot Guards
in 1782, soon being promoted to the rank of General
through the influence of his friend the Prince, ultimately
being appointed Commander of the Forces in Ceylon,
where he died in 1799. He is said to have been the
founder of the "Hell-Fire Club," and gave his name to
the St. Leger Stakes at Doncaster. His spirit is still
supposed to haunt his estates in Ireland, where he is
declared to appear in a phantom coach driven by a head-
less coachman and drawn by headless horses, with a
headless footman seated behind him. He was certainly
one of the handsomest rakes of his day, as this portrait
proves ; there is a replica of it at Miss Alice de Roth-
schild's house at Waddesdon. "Jack" St. Leger's portrait
was hung in the Academy in 1782, together with its
companion picture of the Prince of Wales. But the fault
in both portraits is the horse, which is ungainly and
wooden, like all Gainsborough's horses. There is a fine
mezzotint of the St. Leger portrait by Gainsborough's

nephew Dupont, made in 1783, as well as a recent one published by Messrs. Graves.

In the Academy of 1783 Gainsborough exhibited eight portraits, the most important of which, but not the most successful, being the large group of the Baillie family, now in the National Gallery. Of this group of extremely plain-looking persons, Ruskin made the astounding remark in one of his lectures, " It is the best Gainsborough in England known to me." Surely Ruskin must have seen Gainborough's *Blue Boy*, *Mrs. Siddons*, and many others of his portraits which had distinction, individuality and the charm that are so pointedly lacking in this group of Mr. Baillie with his wife and children, a group that not even Gainsborough could succeed in making attractive or interesting. Near the Baillie family hangs a full-length portrait, by the same hand, of a benign-looking old gentleman in a thickly-powdered wig, leaning on his cane. This is Dr. Ralph Schomberg, of the same family as the Duke of Schomberg. A stately old medico looks Sir Ralph, in his court suit and cocked hat in hand, and his gold-mounted, clouded cane—a brilliant contrast to the Baillie picture.

In the course of that year (1783) Gainsborough paid a visit to the English lakes with his old Ipswich friend Kilderbee, who described him as being a delightful travelling companion, as one can easily imagine. Writing to a Dr. Pearce at Bath from Kew Green, where he had a little house in the summer, Gainsborough says, " I don't know if I told you that I am going along with a Suffolk friend to visit the Lakes of Cumberland and Westmoreland, and purpose when I am back to shew your Grays and Dr. Brown (Dr. Brown is said to have been the first who wrote of the beauties of the Lake country) were

DRAWING FOR ONE OF GAINSBOROUGH'S TRANSPARENCIES IN BLACK CHALK ON

tawdry fan-painters. I purpose to mount all the lakes at the next exhibition, in the great style, and you know if the people don't like them, 'tis only jumping into one of the deepest of them from a wooded island, and my reputation will be fixed for ever. I took the liberty of sending you a little perry out of Worcestershire, and when the weather settles in hot again, shall be much obliged if you and Mrs. P—— would drink a little of it and fancy it champagne for my sake." Perhaps the decorative picture found on the walls of Schomberg House long after his death were Gainsborough's recollections of this expedition to the lakes.

In the same year Gainsborough was much interested by an exhibition organized by a French artist, Philippe de Loutherbourg, who had settled some dozen years before in London, and where he remained until his death in 1812. Loutherbourg had earned a considerable sum of money and made a deserved reputation by painting, since he was an admirable artist, and was engaged to paint the scenery for Drury Lane Theatre. He was made an R.A. in 1781. His military pictures were also good, and are still to be seen in some of our royal palaces and at Greenwich Hospital. The most powerful of his works is one representing the Great Fire of London as seen from old London Bridge; this is at Lord Northbrook's country house. Loutherbourg had painted some transparencies on glass which were views of English scenery and country life which were lighted from the back of the paintings. Gainsborough was so delighted with these transparencies when he saw them in the French artist's exhibition that he imitated them. A set of these transparencies by Gainsborough was for sale a short time ago in a London art gallery. They were mounted in one

frame upon a stand and occupied a certain amount of space, and were interesting rather as being the work of the painter, than because they were artistic.

Later in the year Gainsborough paid a visit to his native town in order to give his vote as a Tory, he having been made a free burgess of Sudbury. He is said to have made a considerable stir in his old home by his evidently worldly prosperity. His fellow-townsmen had every reason to be proud of this son of their soil, but one doubts whether they had any real conception of the greatness of the artist to which Sudbury had given birth.

This year of 1784 was one of the most varied and important in Gainsborough's placid career; in addition to his journeys and visits, it was marked by his rupture with the Royal Academy, a portrait group of the three eldest daughters of George the Third being the immediate cause. This picture was originally designed for the Prince of Wales, to be placed in a panel at Carlton House; it is now at Buckingham Palace. The three princesses—the Princess Royal, Princess Augusta, and Princess Elizabeth—are shown half-length, one being seated whilst the two others are standing. There is a mezzotint of this group by Gainsborough Dupont, published in 1793, which makes the figure full length, but from other evidence I believe that the original state of the group is as we now see it—the figures half-length, and Gainsborough's letter to the Hanging Committee of the Academy confirms this view. The frame had already been designed when the group was painted, and Gainsborough wished it to be hung on the Academy walls on exactly the same level as that on which it was to be placed at Carlton House. But his wish was not complied with—hence the famous quarrel.

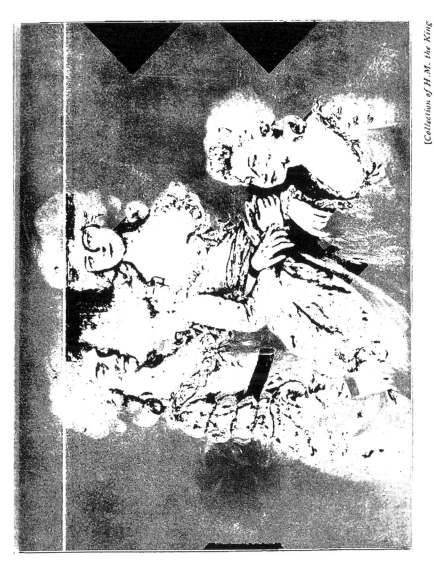

THE ROYAL PRINCESSES
(DAUGHTERS OF GEORGE III.)

On the 23rd of April, 1784, the following account was published in one of the daily papers: "An event has taken place which must concern the Fine Arts in this kingdom. The celebrated Mr. Gainsborough, whose labours have so much contributed to enrich the Royal Academy for several seasons past, has been under the necessity of withdrawing his performances from this year's exhibition! The occasion of this step, it is said, was a refusal on the part of the Academical Council to hang one particular picture in a situation capable of showing its effect."

Gainsborough apparently had some knowledge of the intention of the Hanging Committee with regard to the picture, otherwise he would not have sent them this ultimatum: " Mr. Gainsborough presents his compliments to the gentlemen appointed to hang the pictures at the Royal Academy, and begs leave to *hint* to them, that if the Royal Family he has sent for the exhibition (being smaller than three-quarters) are hung above the line along with full-lengths, he never more whilst he breathes will send another picture to the Exhibition. This he swears by God. Saturday Morning."

The answer of the Academy was to return the group of the princesses and other pictures that he had sent for that year's exhibition to Schomberg House, where Gainsborough had an exhibition on his own account. This was not however very successful

Gainsborough kept his threat, and never again sent any of his works to the Academy: the breach between him and that institution was final. The painting which caused the quarrel is not one of the great artist's happiest works, and compared with the group of the Waldegrave sisters by Sir Joshua Reynolds, seems somewhat artificial

and affected. Reynolds certainly had far more beautiful models in the Waldegraves than had Gainsborough with the royal princesses, whose features somewhat recall those of their excellent mother, Queen Charlotte. Instead of painting them grouped at some occupation as the three sisters in Reynolds's lovely composition, the three princesses have all the air of " sitting," which robs their portraits of all ease and spontaneity; the shape of the canvas also is unfortunate, and is a further drawback to the beauty of the work. But one of Gainsborough's most successful portraits, that of Mrs. Siddons, belongs to this same year. I have already called my reader's attention to that masterly work. The lovely portrait of "*Perdita*" *Robinson*, with the marvellously life-like Pomeranian at her feet, belongs to this period of Gainsborough's career, a period when it may be said to have reached its zenith. It is amongst the finest paintings in that treasure house of art, Hertford House. Perdita holds a miniature in her hand, probably that of her royal and fickle lover Prince Florizel, who for a time adored her, and then, when he tired of the poor creature, cast her off like an old shoe. In this portrait she has a sad expression, as if prophetic of her later life when abandoned by her butterfly admirer.

Somewhere between 1774 and 1784 Dr. Johnson is supposed to have given Gainsborough a sitting for his portrait, and the artist is said to have painted him stick in hand. If this portrait had come down to us it would rank amongst the most interesting from Gainsborough's brush, but there is no trace of such a picture, nor is any mention made by Boswell of the lexicographer ever having given a sitting at Schomberg House.

Some time back a small portrait of Dr. Johnson, pur-

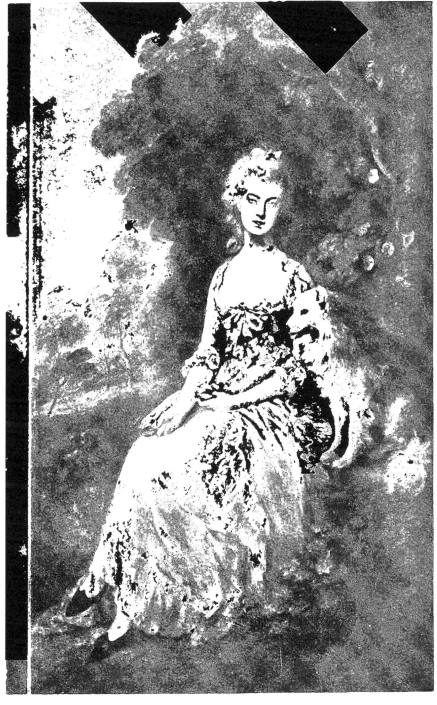

MRS. ROBINSON AS PERDITA

porting to be by Gainsborough, since it had his initials on the frame, was sold at Christies' Sale Rooms. It found its way to Tunbridge Wells in 1902, when I bought it, and discovered it to be an admirably painted reduction of Opie's life-size portrait of Dr. Johnson, belonging to Lady Wantage. This small replica is now in the National Portrait Gallery.

Amongst Gainsborough's portraits of statesmen, one of his latest is a beautiful oval of George Canning, painted in 1787, immediately after the future Prime Minister had left Eton. He wears a Vandyke dress with a deep lace collar, a costume in which Gainsborough loved to paint his handsome young men sitters, and George Canning was one of the handsomest that ever sat to him, with his finely-cut features, and his long dark-brown hair falling low on his neck. Accustomed as one is to Canning's portrait as a bald-headed, prematurely aged man, as he appears thirty years later when painted by Lawrence, it is hard to realize that Gainsborough's handsome youth is one and the same person, and that this long-haired young cavalier should so soon become a worn-out looking states-man, with a hairless crown and sunken features—the cares of office and the weight of governing an empire account, perhaps, for this rapid transformation.

Among military heroes Gainsborough painted a por-trait of the first Lord Amherst, now in the National Portrait Gallery. Amherst was one of England's greatest soldiers and commanders at a time when there were giants in the land. He had smelt powder both at Det-tingen and Fontenoy, and when fifty, carried all before him in North America. In 1758 he captured Cape Breton, and Montreal two years later. He was afterwards placed in command of our army in British North America, and

on his return to England was made Commander-in-Chief.
Yet with all this record no life has ever been written of
the great soldier to whom England owes the Dominion
of Canada. If Lord Amherst had been a Frenchman, and
had he done but half for France of that which he did for
England, he would have found a place by the side of
Lafayette.

There are three hundred portraits conclusively known
to be the work of Gainsborough's hand. Many so-called
Gainsboroughs are by his nephew, Gainsborough Dupont,
and a still greater number by imitators and copyists; the
number of these the astutest of picture dealers cannot
gauge, not even Mr. Algernon Graves himself.

The following notes on the imitators of Gainsborough
were written for me by a friend who is a connoisseur, and
has a wide knowledge of the tricks so often played in the
buying and selling of pictures. They are of interest, and
may perhaps save some would-be purchaser from becom-
ing the possessor of a spurious Gainsborough. With the
increase in value of Gainsborough's work these forgeries
are liable to a corresponding increase, since they purport
to be genuine ; therefore a warning by one so competent
to judge is of great value.

"A great many pictures with Gainsborough's name
attached to them are often by one or other of the following
artists. Some are frankly copied from well-known works;
others are simply in the manner of the master and
painted under his influence. By far the best of the
imitators is *Thomas Barker* of Bath (1769-1847). His
landscapes are of the highest artistic merit, and resemble
Gainsborough in their touch to an extent that experts
are frequently deceived. A very favourite trick of
dealers, anxious to depreciate a genuine landscape by

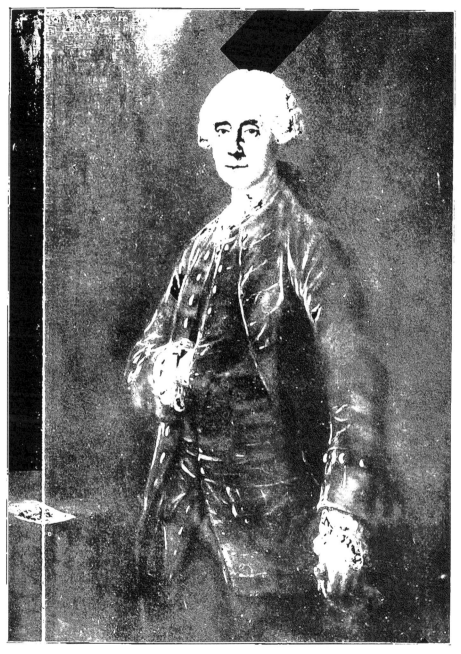

THE HON. WELBORE ELLIS

Gainsborough in order to obtain it at a low price, is to attribute it to Barker of Bath. There is, however, a certain lightness in the drawing of Barker's finest pictures never visible in Gainsborough, except in very early works, and these Barker never tried to copy.

"*Hoppner's* landscape drawings are often wrongly ascribed to Gainsborough by collectors unfamiliar with this side of Hoppner's art. They are easily distinguished by the *round* strokes in the trees in distinction to Gainsborough's flattening strokes. The composition and motive are very similar to Gainsborough's and where there are no figures may lead to mistakes.

" *William Edward Frost* (1810-1877), made clever copies whilst a student at Sass's Academy, of many pencil drawings by Gainsborough. At Frost's death these came into the market and were offered for sale as Gainsboroughs. They are not difficult to detect, for what is loose and free in Gainsborough's handling becomes mere weakness with Frost.

"*William Jackson of Exeter* (1730-1803), besides writing Gainsborough's life painted landscapes in the same style. These, however, have a good deal of Wilson in them and are more highly glazed than Gainsborough's work.

" In portraiture, besides *Gainsborough Dupont, Mary Green* (1776-1845), better known as a naturalist, copied and imitated Gainsborough. Her copies are usually signed, but when the signature is faint they are offered in sale rooms as genuine Gainsboroughs. Some pictures, doubtless executed as replicas of the original for relatives of owners of the originals, are often shown in all good faith in country houses as being genuine Gainsboroughs.

"*Joshua Kirby* (1716-1774), and his son both painted some of the pictures upon which Gainsborough, no doubt,

worked himself. In sale rooms and private collections excellent landscapes ascribed to Gainsborough, are often by the father or son. The faults are too glaring to accept the whole picture as a Gainsborough, and where a weak canvas contains some very brilliant passage which no imitator seemed capable of executing, it may be taken as Gainsborough's own touch, and the picture may be ascribed to one of the Kirbys.

"Genuine landscape and figure studies by Gainsborough are frequently offered for sale, but so retouched as to be worth nothing. A favourite modern trick is to heighten the lights with Chinese white in order to make a sketch seem more elaborate. Where Gainsborough has left a face only suggested, a modern forger will elaborate it with colour, and many of his finest sketches have been ruined in this way, especially since the rage for his drawings set in. Where the coloured chalk has been rubbed or defaced the forger supplies the deficiency, and it is no uncommon thing to see a sketch fall at an auction to some dishonest dealer, and to find the same sketch, elaborated and "faked" offered for sale, and commanding a far higher price, some months later."

Gainsborough's sketches and studies amount to over a thousand. Small as is Gainsborough's output when compared with Reynolds and Romney's number of portraits, they are almost as various in treatment as those of the former painter, and infinitely more varied than those of the latter. And were all Gainsborough's oil paintings to vanish he would still hold rank as a consummate artist and as one of the greatest of English painters by his studies and sketches.

Gainsborough's last years passed very tranquilly. He had an income of a thousand pounds a year, which he

PORTRAIT STUDY OF A YOUNG GIRL, PROBABLY DAUGHTER
OF THE ARTIST

found sufficient for the comfort of his family and for the provision of his own few wants and hobbies. He was extremely generous, but had no personal extravagances. He was as liberal with his fortune as with his pictures, giving freely of both, without ostentation and seemingly for the mere love of conferring pleasure on others. In some respects he carried his generosity too far, as on one occasion when he gave a lady a score of his matchless sketches, which the foolish woman at once fastened with paste to the walls of her sitting-room.

Sir George Beaumont, a great friend of all good artists, and an artist himself, used to relate that one evening, when he, Sheridan and Gainsborough were dining together, Gainsborough was full of his wonted good-humour and in his usual high spirits. So much did they enjoy themselves that at parting it was arranged that the three should soon dine together again, and an evening was fixed. But when the dinner took place a great change had come over Gainsborough. He sat silent, and irresponsive to Sheridan's most brilliant sallies, with an expression of unwonted and fixed melancholy on his handsome face. When they were alone Gainsborough took Sheridan by the hand, and gazing earnestly into his eyes said, "Now don't laugh, but listen. I shall die soon—I know it—I feel it—I have less time to live than my looks infer, but for this I care not. What oppresses my mind is this—I have many acquaintances but few friends; and as I wish to have one worthy man to accompany me to the grave, I am desirous of bespeaking you — will you come — aye or no?"

Sheridan naturally promised to fulfil Gainsborough's wish, although he treated the matter as a joke. The

painter's face then lost its miserable expression, and he
became as gay and merry as was his wont, the evening
ending without a further cloud. This dinner took place
probably early in the winter of 1788, and in the month of
February that year the trial of Warren Hastings com-
menced, a trial which roused intense public interest and
which Gainsborough, like everyone else who could pro-
cure a seat, attended. One day during the trial he was
seated by an open window in Westminster Hall when he
felt a sudden shoot of pain accompanied by intense cold
at the back of his neck. On returning home and showing
his neck to his wife and one of his nieces, they found a
hardness under the skin and a swelling of the size of a
shilling which continued to give him great pain, and also
the sensation of cold. A doctor was sent for; two arrived,
Dr. Hebenden and the great surgeon John Hunter. They
declared that the swelling and the cold were produced
by a chill on the glands of the neck which had produced
inflammation, and that in the coming spring the trouble
would cease. Gainsborough then went for a change of air
to his cottage at Richmond, but he steadily grew worse,
and, losing strength, returned to Pall Mall. Shortly after-
wards a gathering appeared in the neck, with accompany-
ing suppuration; Hunter became gravely alarmed, and
the terrible word "cancer" was pronounced. "If this be
cancer," said Gainsborough to his sister, Mrs. Gibbon,
who had come from Bath to be near her suffering brother,
"I am a dead man."

Alas! it was too true, and, knowing that the end was
at hand, Gainsborough made his will, and his peace with
God and man. As the summer advanced so did the
terrible malady, and in July it was only too apparent
that the close was near.

There can have been but few people to whom Gains-
borough felt he must make reparation, or with whom he
had quarrels to settle, but there was one to whom he felt
he had not acted generously or fairly, and to him he
wrote that touching letter which is now kept as a precious
possession in the archives of Burlington House, where it
is placed near the portrait of the writer and not far from
that of its recipient, Sir Joshua Reynolds. It was my
good fortune to be the first to reproduce the text of
Gainsborough's last letter in my little life of Sir Joshua
Reynolds, by the kind permission of the Council of the
Royal Academy, and in this life of Gainsborough I have
been permitted the further privilege of being allowed to
give it in facsimile.

The letter bears no date; it was probably written in
the month of July, when the great artist felt the shadows
of death gathering around him. "Dear Sir Joshua,"
Gainsborough writes, " I am just to write what I fear you
will not read, after lying in a dying state for 6 months.
The extreme affection which I am informed of by a friend
which Sir Joshua has expressed induces me to beg a last
favour which is to come under my Roof, and look at
my things. My Woodman you never saw. What I ask
now is not disagreeable to your feeling, that I may have
the honour to speak to you. I can from a sincere Heart
say that I always admired and sincerely loved Sir Joshua
Reynolds. Tho: Gainsborough."

In referring to his farewell visit to the dying Gains-
borough, Reynolds said: "If any little jealousies had sub-
sisted between us, they were forgotten in those moments
of sincerity; and he turned towards me as one who was
engrossed by the same pursuits, and who deserved his
good opinion by being sensible of his excellencies." The

two great artists—the leaders of their profession—were alone in that "back room on the second floor" of Schomberg House. What passed between them can only be imagined, but one thing said by the dying painter as he lay back in his bed with his hands clasped in those of Sir Joshua, his former rival and now his still greater friend, has come down to us, and will always remain in our memory, "We are all going to Heaven, and Vandyke is of the company."

On 2nd of August, 1788, Gainsborough passed away, in his sixty-second year. By his particular desire he was laid to rest in the churchyard at Kew, by the side of his old friend of Ipswich days, Joshua Kirby.

The funeral took place on the 9th of August, the painter's nephew and favourite pupil, Gainsborough Dupont, being chief mourner. The funeral pall was carried by Sir Joshua Reynolds, Sir William Chambers, Benjamin West, Francis Cotes, Bartolozzi, and Paul Sandby, all Academicians; whilst amongst those who followed the coffin were Sheridan, Linley the musical composer, Meyers the miniature painter, and Kirby's son. In later years the remains of the painter's widow and of Gainsborough Dupont were laid beside him.

According to his wish, Gainsborough's gravestone was unornamented, merely his name cut on the flat blue slab which covered all that was mortal of one of England's greatest painters. But the grave was allowed to fall into decay until late in the last century, when that distinguished painter and Royal Academician, the late E. M. Ward, had his resting-place restored and a memorial tablet put up in the neighbouring church.

Perhaps it is as well in a country where sculpture has never been understood, and rarely appreciated, that no

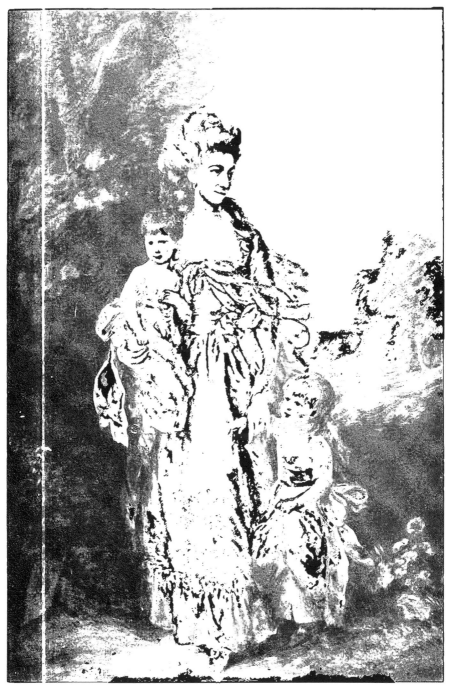

MRS. MOODEY AND HER CHILDREN

statue of the great painter has been erected—his fame will endure as long as any of his creations exist, without aid from memorial stone or marble.

Gainsborough is one of England's glories; not only as Ruskin has described him as "an immortal painter," but as one of the noblest of her children; a man full of heart, of generosity, of goodness, and genius; happy in his life, in his art and in his affection, and happy too, surely, in the time of his death, for had he lived the mental affliction which fell upon both his children would have embittered and saddened his later years, and made the close of his life full of sorrow.

Rarely has a painter been so successful both in landscape and in portrait painting, two of the most difficult forms of the art, and one has to recall such giants as Titian, Rembrandt and Rubens to find a parallel to this double gift. In his dying interview with Reynolds the great painter said, "that his regret at losing life was principally the regret of leaving his art, and more especially as he now began to see what his deficiencies were, which he said he flattered himself in his last works were in some measure supplied."

Gainsborough gave us not only some of the finest portraits of the most beautiful women and most famous men of his day—Georgiana of Devonshire and Mrs. Sheridan, William Pitt and James Wolfe among a score of others—but matchless landscapes of what is most beautiful and characteristic of our scenery, with its noble old trees, its wonderful verdure, its radiant freshness, with groups of English peasants as graceful and picturesque as any painted by the greatest Italian or French artists. He has, in fact, placed Nature before us, Nature at her best.

CHAPTER VI

THE ILLUSTRATIONS

IN looking over the illustrations to this little life of Thomas Gainsborough I think it will be found that as complete a collection of the painter's life-work has been brought together as was compatible with the form and scope of the book. Views of the places most connected with Gainsborough's life—from the modest little house at Sudbury where he was born, to the almost palatial wing of Schomberg House, in which he died, have been photographed from the actual houses themselves, and in connection with the latest home of the painter it has been my good fortune, through the kind permission of the President and Council of the Royal Academy, to be able to place before the readers of this little book a facsimile of the letter which the dying Gainsborough wrote at the close of his career to his old rival, the first President of the Royal Academy, Sir Joshua Reynolds. A more interesting letter than this does not exist in all artistic literature. Through the courtesy of the owners of some of Gainsborough's finest works I have also been able to have reproductions made of many paintings and sketches, hitherto unpublished, whilst retaining the old favourites, such as the portraits of *The Blue Boy*, and Mrs. Graham, of which one can never weary, however often they are reproduced.

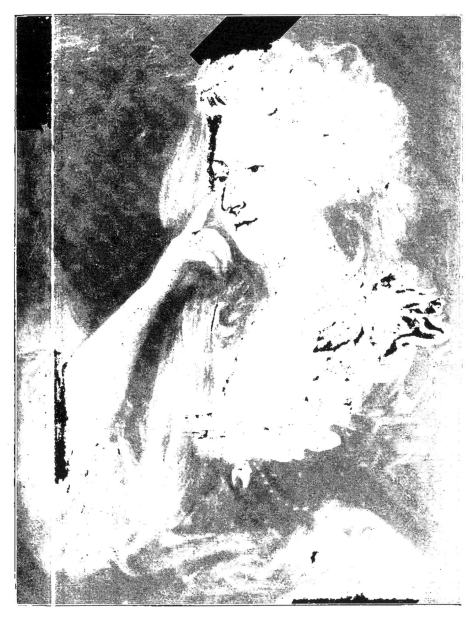

MRS. FITZHERBERT

As the object of this series is to popularize the works of the greater artists, it has been attempted, and I hope with some success, to give as varied a collection of Gainsborough's work as space permits, from the slightest of his pencil or charcoal sketches, struck off as we have seen as he sat by his wife's side and enjoyed his friends' music and flung carelessly on the floor when finished, to the life-size and masterly full-length portrait of some great lady such as the Duchess of Devonshire, or of a handsome young Squire with his dog and his fowling-piece.

To one with no previous knowledge of Gainsborough's work, I believe that a careful study of the paintings and sketches reproduced in this volume will give a very just idea of the nature of his excellences and talents, and although they are mere shadows of the originals, since they lack their marvellous colouring, some of the charm and exquisite grace of the great artist is evident.

It is to be hoped that with the advance of colour printing the day is not distant when even the very touch of a master's hand, and all the hues of his palette will be reproduced, in short that illustrations to art books will be facsimiles of the originals.

Mrs. Siddons (p. 4). Mrs. Siddons was in her twenty-ninth year when this splendid portrait of her was painted by Gainsborough, the year after she had sat to Reynolds as *The Tragic Muse*. It is said that one day when she was sitting to him, Gainsborough, seized with a fit of impatience, exclaimed, " D—— it, Madam, there is no end to your nose!" " Two years before the death of Mrs. Siddons," writes Mrs. Jameson, " I remember seeing her when seated near this picture, and looking from one to the other; it was like her still at the age of seventy."

Alexander, tenth Duke of Hamilton (p. 6), was born in

1767, and married in 1810 Susan Euphemia, youngest daughter of William Beckford of Fonthill, by Lady Margaret, daughter of Charles, fourth Earl of Aboyne. He died in 1852.

Portrait of Gainsborough (p. 10). A clever sketch in pencil of Gainsborough drawing; but I have never been able to discover the name of the sketcher of the portrait.

Portrait of the Artist (p. 12). As this portrait was given by the artist to Thomas Coke he evidently himself considered it a satisfactory likeness; but the unfinished oil sketch, the frontispiece of this volume, is far more pleasing and characteristic.

Gainsborough's Birthplace at Sudbury (p. 14). This view is after the engraving by Finden in G. W. Fulcher's "Life of Thomas Gainsborough," published by Longman in 1856. In comparing this little view with that taken of the birthplace as it appears to-day, it will be seen how completely the appearance of the front of the house has been changed.

Garden Front of Gainsborough's Birthplace (p. 16) This view of Gainsborough's birthplace at Sudbury shows the back, or garden side of the house, and is apparently much in the same state as when Gainsborough lived in it.

Jack Peartree (p. 16), after the original oil painting on wood now in the Museum at Christ Church, Ipswich There was no photograph from which I could have a plate made of this early work of Gainsborough's, which played so important a part in his early career, and I consequently had to make a sketch from the original for which I beg the kind reader's indulgence: it is in tended only to convey an impression of the work.

The Old Grammar School, Sudbury (p. 18). The view

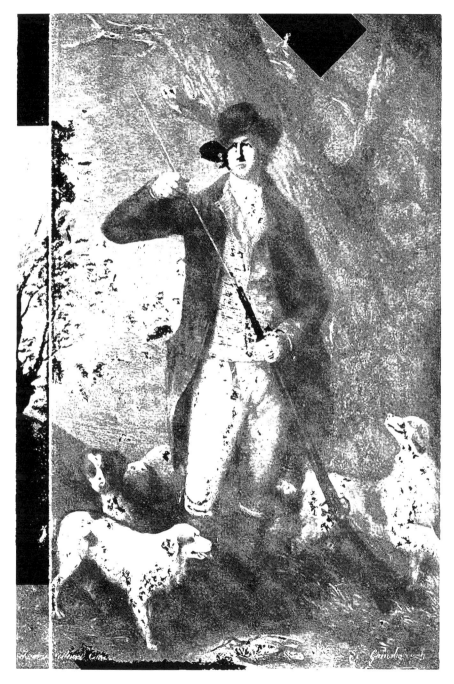

LORD LEICESTER

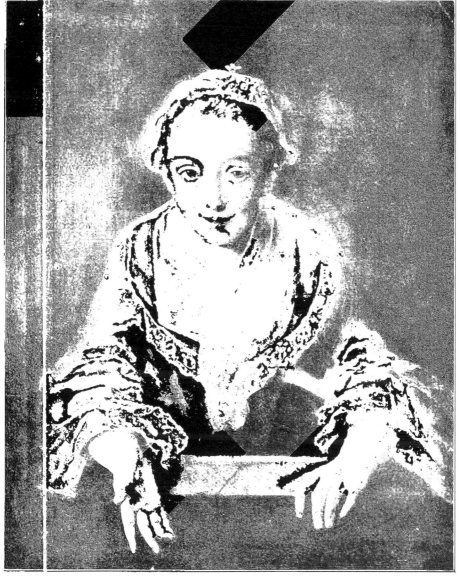

GIRL AT A WINDOW

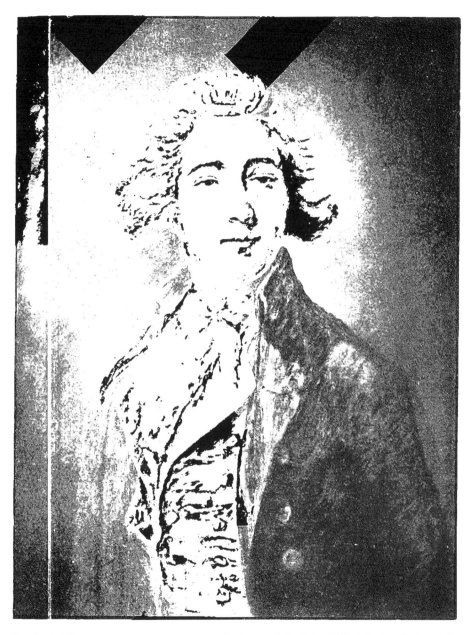

ROBERT, VISCOUNT BELGRAVE

of Gainsborough's Grammar School, from which this illus-
tration is taken, was lent to me by the Rev. W. G. Nor-
mandale, the present master of Sudbury Grammar School;
it appeared in a local magazine. This building was de-
stroyed towards the middle of the last century, a preten-
tious red-brick edifice now occupying its site.

Mrs. Gainsborough (p. 28). I have been unable to trace
any history of this portrait of the artist's wife.

Landscape with Sheep and Horses (p. 30). One of the
beautiful sketches, vivid in colouring and truth to nature,
belonging to Mr. Henry Piungst.

Henry Frederick, Duke of Cumberland (p. 34). The
brother of George the Third, who married Anne Horton.
He was a man of loose life and narrow intellect. Con-
temporary history gives him few good qualities. Gains-
borough showed a courtier-like tact in making so present-
able a portrait. This study in oils forms a pendant to
that of the Duke's wife.

Queen Charlotte (p. 36). This illustration is taken
from one of the few fine mezzotints by Gainsborough
Dupont of his uncle's portraits. It was published in 1790.
The original is at Buckingham Palace, and is a *tour de
force*; it gives a delightful character to the homely features
of Queen Charlotte. A sketch in oils of this portrait
was discovered at Homburg by the Duchess of Ser-
moneta.

Lord Archibald Hamilton (p. 38), was brother of the
tenth Duke of Hamilton, and was born in 1769. He was
member of Parliament for Lanarkshire, and died un-
married in 1827.

Gainsborough's House in Bath (p. 40), in which he spent
fifteen happy years. It forms one of the houses of the
famous Circus, and has recently been inscribed with a

memorial plaque recording that it was the dwelling-place of the artist.

Great Cornard Wood (p. 42). This is taken from a very rare engraving in mezzotint of the famous landscape by Gainsborough in the National Gallery known as " Gainsborough's Forest." It represents the wood near the village of Cornard in Suffolk, and was one of the artist's favourite landscapes.

David Garrick (p. 46), in the Town Hall at Stratford-on-Avon. This is undoubtedly the finest portrait of the many Gainsborough painted of his great friend. The frame has been purposely reproduced as it is of great artistic merit and rare beauty, and in every way worthy of the splendid portrait it contains.

David Garrick (p. 46). This one of Gainsborough's many portraits of Garrick cannot be compared with the full-length at Stratford. The artist seems to have wished to portray the great tragedian in one of his sterner moods—probably in one of his parts ; but in a painting one prefers Garrick's wonderfully mobile face with a less stern and assumed expression.

General Wolfe (p. 48). The conqueror of Quebec was painted at least twice by Gainsborough. In one the painter placed a three-cornered hat on the hero's head. This illustration gives us a more favourable impression of Wolfe's countenance than any other of his portraits. It was probably painted whilst Gainsborough was still at Ipswich. Wolfe was very little in England after receiving his commission, but he was on garrison duty from 1749 to 1758, and this interesting portrait was probably painted between these dates.

Lord Frederick Campbell (p. 50). This is one of the finest portraits by Gainsborough at Inverary Castle, where

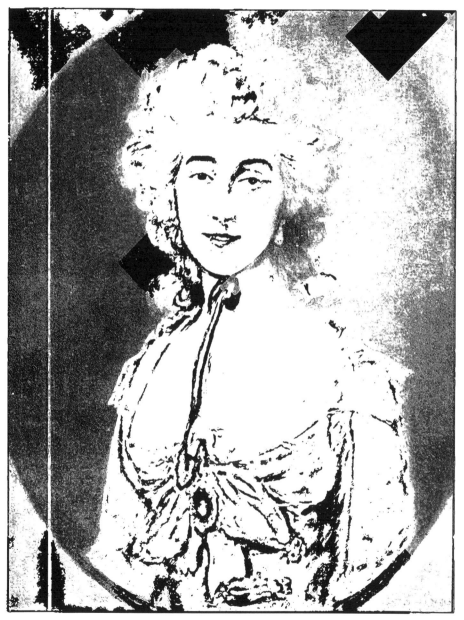

GRACE DALRYMPLE, MRS. ELLIOTT

Hanfstängl photo)

MUSIDORA BATHING HER FEET

STUDY OF A DOG

IN COLOURED CHALK

are also the full-length by him of the Duke of Argyll, and of Field-Marshal Conway.

Landscape (p. 52). It is such a subject as this that justifies the appellation of Gainsborough as " the father of English landscape painting." His admirable land-scapes inspired Constable, who, in turn, inspired the French painters of the middle of last century; yet Gains-borough has never been equalled in works of this type.

Landscape (p. 54). Whilst still the owner of this de-lightful little landscape, I remember on showing it to Mr. Gladstone, when he honoured my little house at Windsor with a visit, how it roused his enthusiastic ad-miration. I do not know to whom it now belongs.

Landscape (p. 56). This landscape is one of the least happy from Gainsborough's brush, and is almost as savage as one of Salvator Rosa's gloomy scenes, and with a group of bandits among the rocks the illusion would be complete.

The Harvest Waggon (p. 58). A very noble landscape of the painter's, closely resembling the one belonging to Mr. Lionel Phillips.

The Linley Sisters (p. 60). Eliza and Maria Linley, daughters of Thomas Linley of Bath. Eliza married Richard Brinsley Sheridan. Maria, who married a Mr. Tickell, is the seated figure; she holds a music-book in her hand and gazes somewhat vacantly before her. The far more beautiful Eliza is also apparently lost in thought, but her expression is one of rapt enjoyment. The Gains-borough portraits of the Linley family came to the Dulwich Gallery in 1831, on the death of the Rev. Ozias T. Linley, who was a Fellow of the College.

Samuel Linley, R.N. (p. 60). The likeness of this handsome youth to his beautiful sister (Mrs. Sheridan),

is very striking. Samuel Linley's end was mysterious; he started on a voyage and never returned. There is a tradition that this portrait was painted in forty-eight minutes: it is at Dulwich College.

Mrs. Sheridan (p. 62). This is the most beautiful of all Gainsborough's portraits of this lovely woman.

Georgiana Spencer, afterwards Duchess of Devonshire (p. 64). This is the earliest portrait painted by Gainsborough of the famous Duchess. She was the eldest daughter of John, first Earl Spencer. Born in 1757 she married in 1774 William, fifth Duke of Devonshire, and died in 1806. When this portrait was painted she was six years old; she wears a lace cap, and is dressed in a white frock trimmed with cherry-coloured ribbons. This delightful portrait belongs to Lord Spencer and is at Althorp.

The Duchess of Devonshire (p. 66). This is the little oil sketch of the celebrated portrait of the Duchess of Devonshire, which disappeared so mysteriously from Messrs. Agnews' sale rooms some quarter of a century ago. Whether Gainsborough has here portrayed Georgiana or Elizabeth Devonshire will probably never be ascertained. For my own part I believe it to represent the latter lady, for various reasons, and one that the face more closely resembles other portraits of her than of Georgiana.

Georgiana, Duchess of Devonshire (p. 66). One of Gainsborough's full-length portraits of this beautiful lady. This portrait was in the Exhibition of the Royal Academy in 1778, and was considered by Horace Walpole to be "bad and washy." It was whilst painting this picture that Gainsborough is said by Allan Cunningham to have drawn his wet brush across the mouth, exclaiming, "Your Grace is too hard for me!" I have never liked this por-

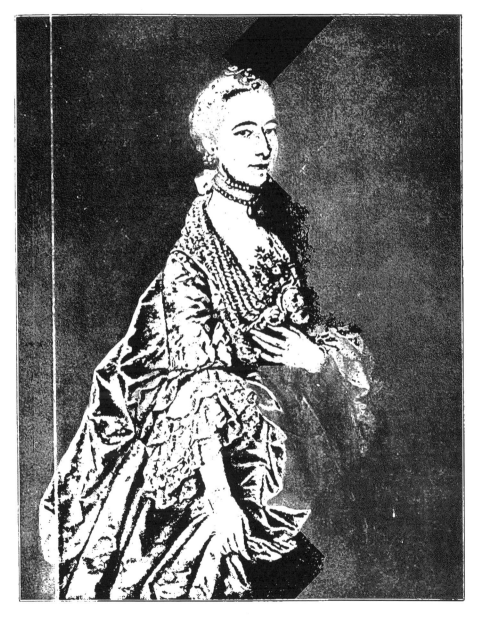

MRS. LEYBORNE

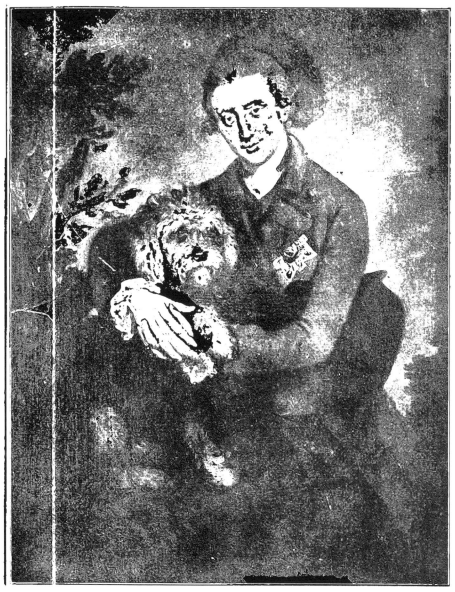

HENRY, THIRD DUKE OF BUCCLEUCH

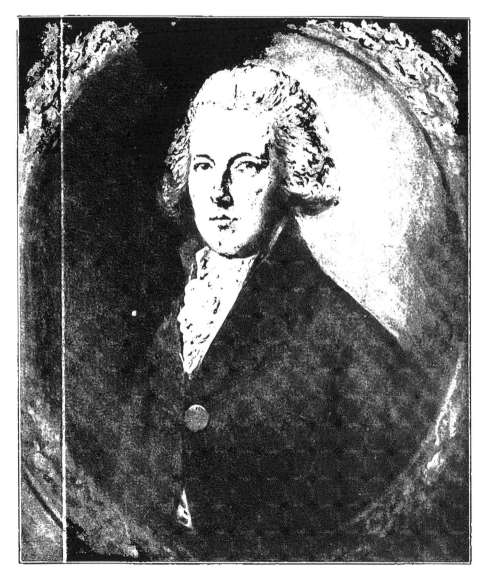

WILLIAM PITT

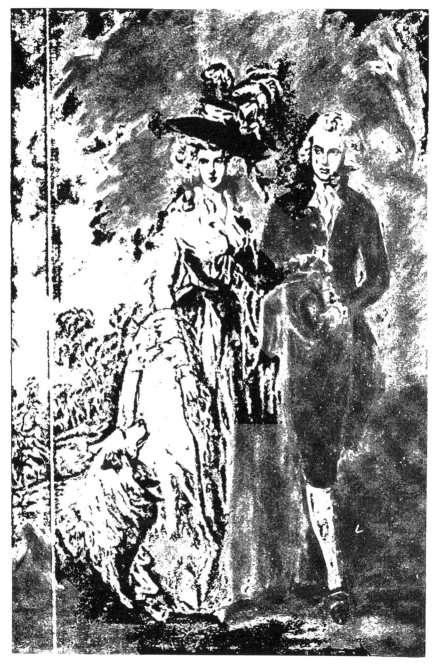

Hyatt *photo*] [*Original picture in collection of Lord Rothschild*
 Sketch in collection of H. Pfungst, Esq

SKETCH OF THE PICTURE OF THE MORNING WALK
SQUIRE HALLETT AND HIS WIFE

trait of Duchess Georgiana, and it certainly gives little impression of her beauty, charm, and fascination.

A Study (p. 68). A graceful study in black chalk, belonging to Mr. Henry Pfungst.

Sketch (p. 68). This pretty study of a garden scene seems to have formed a portion of Gainsborough's *St. James's Park*, as a similar figure is introduced into that delightful work.

Study for a Portrait Group (p. 68). A delightful study of three ladies who were supposed to represent the three Princesses in the celebrated group at Buckingham Palace.

Gainsborough's House in London (p. 70). The wing on the right of Schomberg House was that occupied by Gainsborough and his family, and through the door at which, in the photograph, a policeman is standing, Sir Joshua Reynolds passed when he called to visit the dying artist in the month of July, 1783.

The Woodcutters (p. 72). A clever unfinished sketch in oil over a ground of black chalk. This is one of the artist's many experiments to obtain novel effects by the use of different mediums.

The Hon. Mrs. Graham (p. 74). This lady was the second daughter of Charles, ninth Lord Cathcart. She was born in 1757, and married in 1774 Thomas Graham of Balgowan, afterwards Lord Lynedoch, a distinguished Peninsular general, who, born in 1748, lived until 1843. Mrs. Graham died in 1792. This picture, as has already been said, was bricked up by her husband after her death, and was forgotten for a half century. When it was discovered it was as fresh as on the day on which it was painted. It was bequeathed to the National Portrait

Gallery of Scotland by Mr. Robert Graham in 1859, and it is one of the artist's noblest works.

The Housemaid (pp. 74, 76). A very interesting life-size oil study of a beautiful young woman—the Hon. Mrs. Graham—masquerading as a housemaid. The fifth Earl of Carlisle, who was a great collector, is said to have seen this painting in its unfinished state in Gainsborough's studio, and begged him not to add another touch to it, which proves Lord Carlisle to have possessed good taste, as no further finish could add greater charm to this delightful work.

Maria Walpole, Duchess of Gloucester (p. 76). Maria Walpole was the daughter of Sir Edward Walpole, and married first in 1759, James second Earl of Waldegrave, and secondly in 1766, William Henry Duke of Gloucester, brother of George the Third. By her second marriage she had three children, the eldest of whom became the second Duke of Gloucester; as her marriage took place before the passing of the Royal Marriages Act it was acknowledged by the King. The Duchess was a niece of Horace Walpole, who refers frequently in his letters to her beauty, and mentions an occasion when she and Lady Coventry were mobbed one Sunday in the Park. She sat frequently to Reynolds, and there is a superb half-length of her by him at Newnham. She was the mother by her first marriage of the three beautiful Ladies Waldegrave, whom Reynolds has immortalized in his famous group, formerly at Strawberry Hill. The Duchess died in 1803, aged seventy.

Master Jonathan Buttall, "The Blue Boy" (p. 78). One of Gainsborough's best and most popular portraits. Young Buttall was a handsome lad, the son of a rich London ironmonger, in whose steps he followed. This portrait

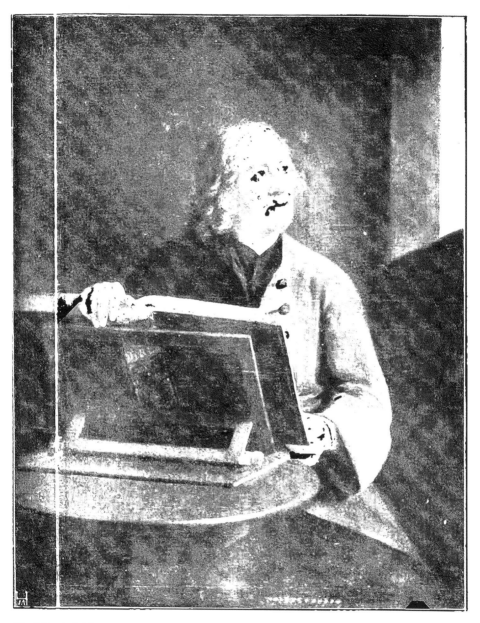

ORPIN, PARISH CLERK OF BRADFORD, WILTS

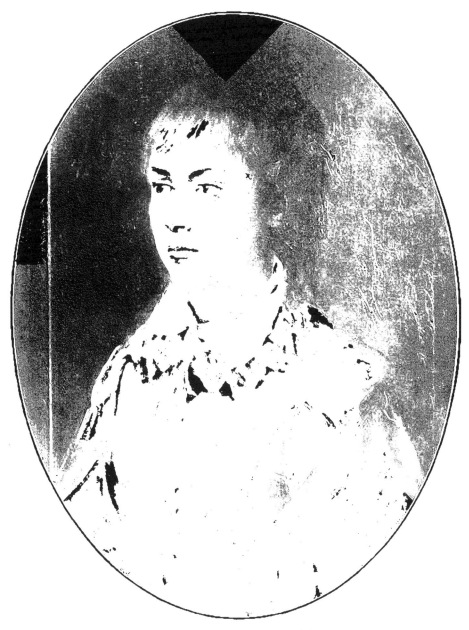

GAINSBOROUGH'S NEPHEW

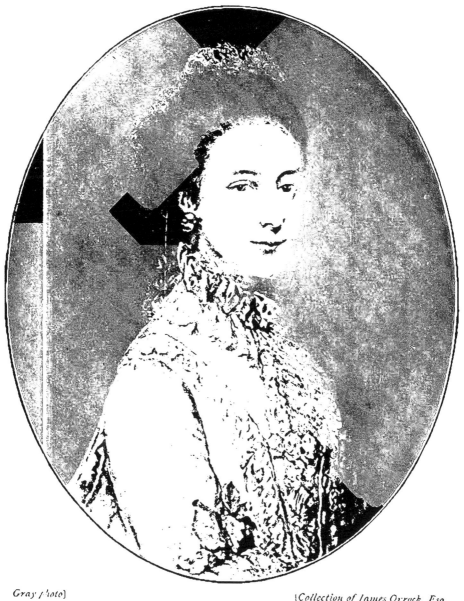

MRS. FREER

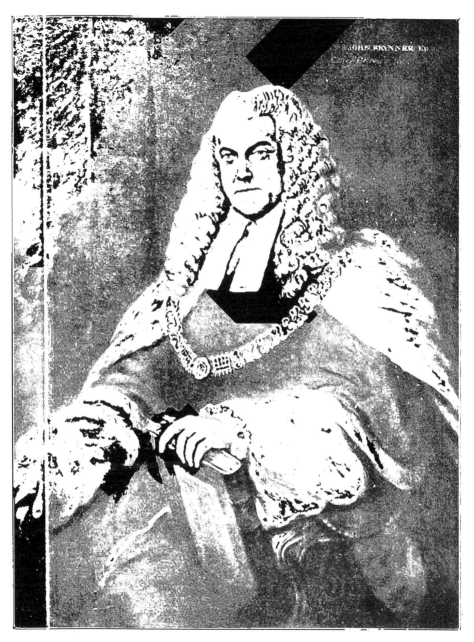

SIR JOHN SKINNER

(CHIEF BARON)

is supposed to have been exhibited in the Academy of 1770. Reference is made in the text to the probable reason for Gainsborough painting the youth in a blue dress. *The Blue Boy* hangs in the same room at Grosvenor House as Reynolds's *Tragic Muse*.

Anne Luttrell, Duchess of Cumberland (p. 80). The eldest daughter of Simon, first Earl of Carhampton. She married, first, Christopher Horton, and, secondly, Henry Frederick, Duke of Cumberland, a brother of George the Third. She died in 1803. Gainsborough painted the Duchess on several occasions. This is a life-size sketch in oils, and belongs to the Royal Collection at Windsor Castle. It is interesting as showing the artist's method in beginning his life-size portraits.

George, Prince of Wales (p. 82). This is the portrait painted for Colonel St. Leger. It was formerly at Brockett Hall, Lord Melbourne's.

George, Prince of Wales (p. 82). This portrait forms one of the series painted by Gainsborough of George the Third, his Queen, and all their children, with the exception of the Duke of York. When the Prince sat to Gainsborough he was in the heyday of his youth, before his fine features had become bloated from drink and dissipation, and when he was still known as " Prince Florizel."

George the Third (p. 82). This very excellent likeness of " Farmer George " belongs to the series of portraits of his family in the late Queen's Council Chamber at Windsor Castle.

Charles Frederick Abel (p. 84). Born in Germany in 1725, Abel came to London in 1759, and became chamber musician to Queen Charlotte. He was famous for his playing upon the viol-di-gamba, and was one of Gains-

borough's greatest musical friends. This fine portrait was in the Academy in 1777, and Horace Walpole thought it "very like and well."

The Cottage Children (p. 86). This scene of rustic life is taken from the mezzotint by Henry Birche, on the plate of which is scratched "Gainsborough Pinx. The Cottage Children." It was published in 1792 and the fate of the original is unknown beyond the fact that it is no longer in existence.

Girl and Pigs (p. 88). Gainsborough painted this subject on two or three occasions. The best I know is at Castle Howard, and formerly belonged to Sir Joshua Reynolds. He also painted one for Lord Gainsborough which perished in a fire. The mezzotint from which this was taken is a rare one, and is the work of Dickinson. There is also an engraving of this picture by Richard Earlom, published in 1783.

The Woodcutter's Home (p. 90) is one of Gainsborough's best landscapes, and is one of the great art treasures at Belvoir Castle.

Colonel "Jack" St. Leger (p. 92). Gainsborough also painted another full-length of this handsome young officer standing by the side of his charger, which was given in exchange for the full-length of the Prince of Wales, and was formerly at Hampton Court Palace.

Drawing for a Transparency (p. 94). This is one of Gainsborough's rare seascapes which he repeated on glass for one of the slides in his camera. He made twelve of these paintings on glass, which were movable and lighted at the back by candles in the back of a box, which he called his show-box. Gainsborough would show these illuminated slides to his friends at Schomberg House. "We were frequently," wrote one of his friends, "favoured

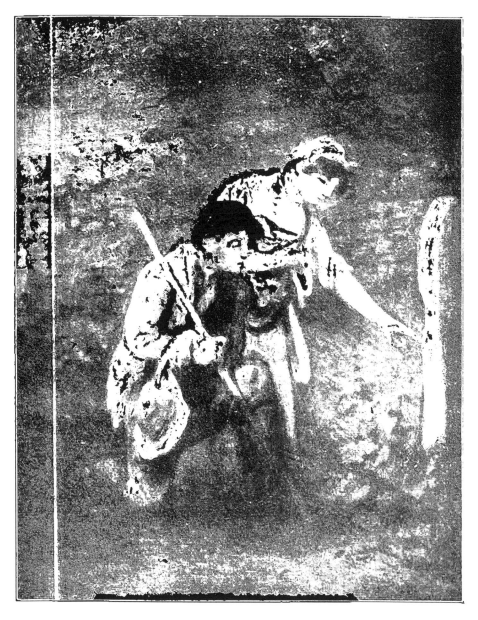

Hollyer photo)　　　　　　　　　　　　　(*Collection of Lord Ronald Sutherland Gower*

AN IDYLL

AN IDYLL.

FROM THE EXCESSIVELY RARE ENGRAVING IN MEZZOTINT

(Belonging to Lord Ronald Sutherland Gower

LARGE DRAWING IN COLOURED CHALKS AND WASH

CHALK DRAWING

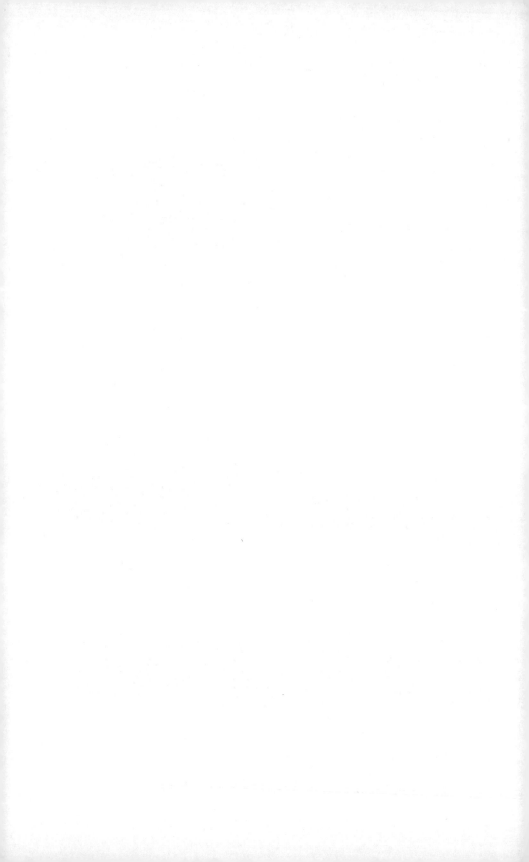

with a peep at the little theatre of transparencies and always with a new pleasure, for by varying the lamps a great variety of effects could be rendered on the same subject." Sir Joshua Reynolds is said to have admired this artistic toy which is now (1903) to be seen quite complete in the Stafford Gallery in Old Bond Street.

The Royal Princesses (p. 96). This is the group of the three eldest daughters of George the Third, the hanging of which in the Exhibition of the Royal Academy led to Gainsborough's quarrel with that institution. The Princesses are the Princess Royal, Princess Augusta, and Princess Elizabeth. This picture hangs at Buckingham Palace in a room full of full-lengths of the other members of the Royal Family by Gainsborough.

Mrs. Robinson as Perdita (p. 98). This is one of Gainsborough's masterpieces. Poor Perdita Robinson looks as sad as sorrow. She holds a miniature of her faithless Prince Florizel in her hand. All the world seems to have deserted her, but she has one faithful friend left, the beautiful Pomeranian which sits on the bank beside his mistress.

Lord Mendip (p. 100). This is a fine portrait, and looks well amongst its surroundings of bishops and heads of houses in the Great Hall of Christ Church, Oxford. Wellbore Ellis, Lord Mendip, was a well-known Minister of State. This portrait was at the Manchester Exhibition in 1857.

Mrs. Moodey and Children (p. 106). A charming group of a mother and children, and the finest Gainsborough in the gallery at Dulwich, to which it was presented by Captain Moodey, but we do not know who Mrs. Moodey was. The delightful children wear pink sashes over their muslin dresses, and little red shoes. The landscape is

superb, the sky gray and cloudy, and tall wild plants in the foreground.

Mrs. Fitzherbert (p. 108). Mrs. Fitzherbert was the youngest daughter of Mr. Walter Smythe of Bambridge, Hampshire, and was born in 1756. She first married Edward Weld of Lulworth Castle, who died within a year, and secondly Thomas Fitzherbert of Swinnerton, Staffordshire, who died in 1781. Later she was supposed to be secretly married to George, Prince of Wales (in 1785); she died at Brighton in 1837. She was a Roman Catholic by religion. The latter part of her life was saddened by the difficulty of her position, but she was universally respected.

Girl at a Window (p. 110), from Trentham. I have no knowledge when this work of Gainsborough's first came to Trentham. It was probably one of the many pictures acquired by my grandfather, the first Duke of Sutherland, an ardent and catholic collector of pictures of all schools and countries. The prevailing tone of this picture is somewhat green, and so unlike Gainsborough is it in colouring that were it not an undoubted work of his, I should have guessed that it had been painted by Cotes.

Robert Grosvenor, Viscount Belgrave (p. 110). A delightful portrait of an attractive-looking youth. Robert Grosvenor was born in 1767, becoming Viscount Belgrave in 1784. He succeeded his father as second Earl Grosvenor in 1802, and died in 1845. It was his grandson, Hugh Lupus, who became first Duke of Westminster in 1874. This portrait is at Eaton Hall.

Thomas Coke, Earl of Leicester (p. 110), at Holkham, Norfolk. This fine full-length of Lord Leicester is one of Gainsborough's most spirited portraits; the youth and

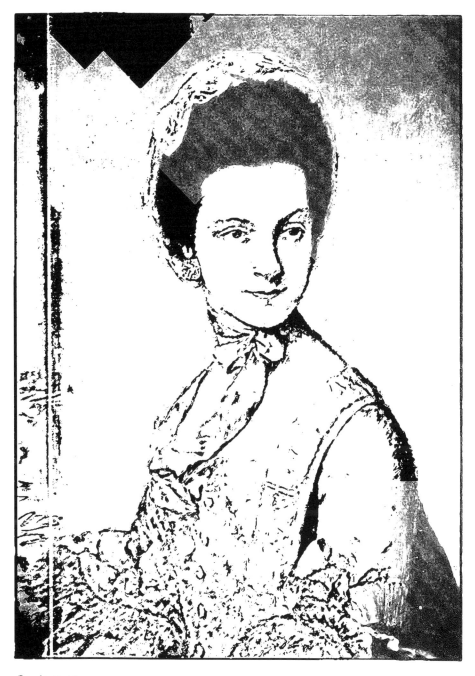

Bourke photo] *[Collection of the Duke of Westminster, Eaton Hall*

HENRIETTA, COUNTESS GROSVENOR

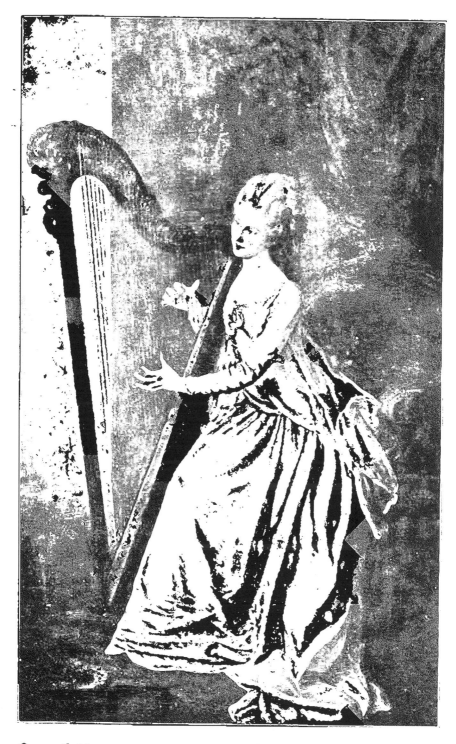

[*Collection of the Duke of Newcastle*

ANNA, COUNTESS OF LINCOLN

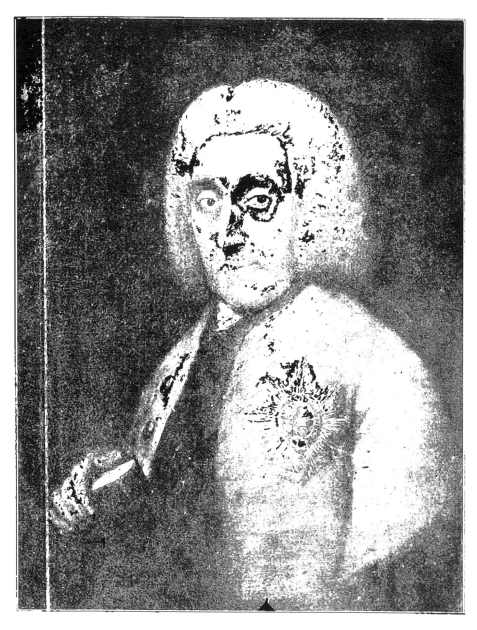

PHILIP, FOURTH EARL OF CHESTERFIELD

(THE ONLY PORTRAIT EVER SIGNED BY GAINSBOROUGH)

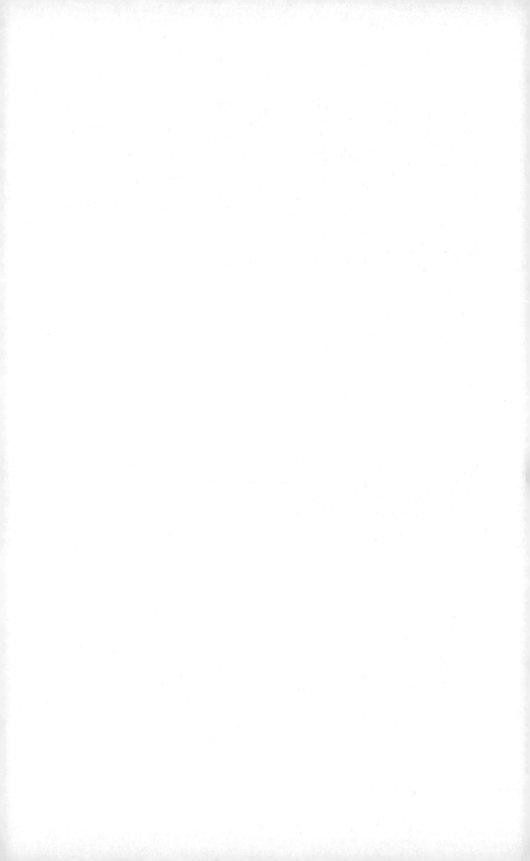

MARIA, LADY EARDLEY, AND HER DAUGHTER, AFTERWARDS
LADY SAYE AND SEALE

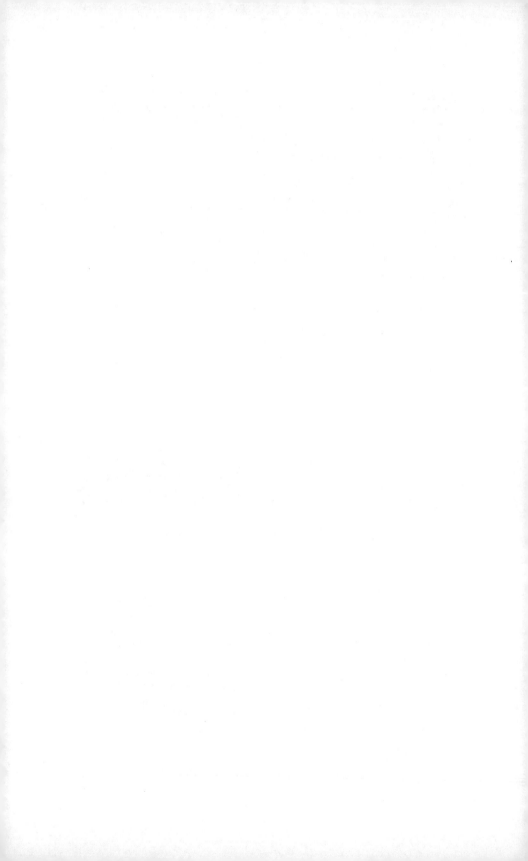

his dogs are full of life. Born in 1754, Thomas Coke was famous throughout Norfolk as a keen sportsman, an excellent landlord and a noted agriculturist. He sat in the House of Commons between 1807 and 1832, and was created Earl of Leicester of Holkham in 1837. He died in 1842. Writing of this portrait, Lady Leicester (to whose kindness and Lord Leicester's permission, I owe the photograph from which this block was made) says, "The dress Lord Leicester's father was painted in has a somewhat historical interest, as he wore it when he went to petition King George to consider the interests of the American Colonies before the war. The mixture of brown and buff in the costume is very effective."

Mrs. Grace Elliott, born Dalrymple (p. 112). Grace Dalrymple was said to be related to the family of Stair. Brought up in France, she married, when very young, Dr. John Elliott, a man old enough to be her father. She ultimately left him and led a very adventurous life in Paris and London. She was in Paris during the worst days of the Revolution, living under the protection of Philippe Egalité, Duc d'Orleans. She wrote a diary of her experiences of that time, which was published in 1859 under the title of "Journal of my Life during the French Revolution." It is of thrilling interest. This portrait is at Welbeck Abbey.

Musidora bathing her Feet (p. 112). Only one other nude beside this is known to have been painted by Gainsborough. This picture, for which Emma, Lady Hamilton may have sat, illustrates the lines from Thomson's "Summer," beginning

"Thrice happy swain !
A lucky chance, that oft decides the fate
Of mighty monarchs, then decided thine."

Study of a Dog (p. 112). This is an admirable study in coloured chalk of a little spaniel, and shows Gainsborough's talent as a painter of dogs. Landseer himself could not have given more life and character to the little creature, which is watching what is going on out of the corner of its eye, and seems ready to spring up at a word.

The Morning Walk (p. 114). This is a masterful sketch of Squire Hallett and his wife, in red chalk, a preliminary study for the well-known portrait group which belongs to Lord Rothschild. The portrait is a superb painting, and one cannot help regretting that the actors on this noble canvas are not of greater interest.

Mrs. Leyborne (p. 114). This lady's portrait is interesting as an example of the early and somewhat stiff style of Gainsborough's portrait painting.

William Pitt (p. 114). One of the six or seven portraits painted by Gainsborough of "the pilot who weather'd the storm," and one of the best. It is at Montreal, Lord Amherst's house near Sevenoaks.

The Duke of Buccleuch (p. 114). A fine portrait of Henry, third Duke of Buccleuch, who was born in 1746 and died in 1812. It was engraved by Dixon in 1771, and again by Every in 1868, and was at the Grosvenor Gallery Exhibition of Gainsborough's works in 1885.

Edward Orpin (p. 116), parish clerk of Bradford-on-Avon. This is one of the finest of the Gainsboroughs in our national collection. The original was one of the many pictures bestowed by Gainsborough on Wiltshire, the Bath carrier, who took his canvases to London. Ruskin, in his " Modern Painters," has referred to Gainsborough's " charm of pathetic tenderness and tinge of melancholy," which he noticed in many of his portraits, but there is

THE DUKE AND DUCHESS OF CUMBERLAND

HEN AND CHICKENS

nothing but gladness in the beautiful old face of the parish clerk.

Gainsborough's Nephew (p. 116). This portrait is supposed to be that of the artist's nephew, Gainsborough Dupont.

Mrs. Freer (p. 116). A charming portrait of a very intelligent-looking woman, which belongs to the well-known collector Mr. James Orrock.

Sir John Skinner (p. 116). Gainsborough painted Sir John twice; one of his portraits is in Lincoln's Inn. The other, of which this is a reproduction, is in the Hall of Christ Church, Oxford. Sir John Skinner was born in 1773, and became Chief Baron in 1777. He died in 1805.

Large Drawing in Coloured Chalks and Wash (p. 118). This beautiful drawing in wash and coloured chalks represents the wooded lane called after Gainsborough near Ipswich. It is one of the most beautiful in Mr. Arthur Kay's beautiful collection of studies by the artist.

An Idyll (p. 118). This appears to have been cut out of a large landscape representing a wood with the ruins of a church in the foreground. Two peasants are reading the inscription on a tombstone. The large painting has disappeared, but there exists a very rare mezzotint of it by M. C. Prestal, inscribed to Sir Joshua Reynolds by Robert Pollard, and dated 12 May, 1790. The first two verses from Gray's Elegy are inscribed below the engraving. The small painting was found at Lillieshall Hall, Salop.

Anne, Countess of Lincoln (p. 120). Anne Stanhope, daughter of the second Earl of Harrington. She married Thomas Fiennes-Pelham-Clinton, second son of Henry, Duke of Newcastle and Earl of Lincoln.

Henrietta, Countess Grosvenor (p. 120). There is a tradition that after the famous divorce case in which this lady and the Duke of Cumberland were the principal actors, the erring lady's husband cut the portrait in half—at any rate this is all that remains at Eaton Hall, of Lady Grosvenor's portrait by Gainsborough. Henrietta Vernon married Lord Grosvenor in 1764, and after his death in 1802 married a General Porter. She died in 1828.

Lady Eardley and Daughter (p. 120). Until the year 1884, when the group was purchased by the late Lord Wantage, it was at its original home, Broughton Castle, Oxon. The mother is Lady Eardley, wife of Sampson, Baron Eardley, and the little girl, her daughter Maria, married William, eleventh Baron Saye and Sele in 1794. Lady Eardley wears a pink " sacque " gown, and her dark brown hair is slightly powdered.

Lord Chesterfield (p. 120). The celebrated statesman and author of " Letters to his Son." Philip Dormer Stanhope was the son of Philip, third Earl of Chesterfield and Lady Elizabeth Savile, daughter of the Marquis of Halifax. Born in 1694, he succeeded to the title in 1726. In 1745 he was made Lord Lieutenant of Ireland. He married Melusina de Schulenberg, a natural daughter of George the First, and died in 1773. This was the last portrait painted of him and is inscribed, "Aged 76, date 1769."

The Duke and Duchess of Cumberland (p. 122). This charming picture, which is at Buckingham Palace, represents the Duke and Duchess walking in a garden; the lady on the right in the background is the Duchess's sister who ended her life so miserably. Anne Luttrell looks a head-taller than her royal spouse, but although this may be owing in a measure to her high heels and

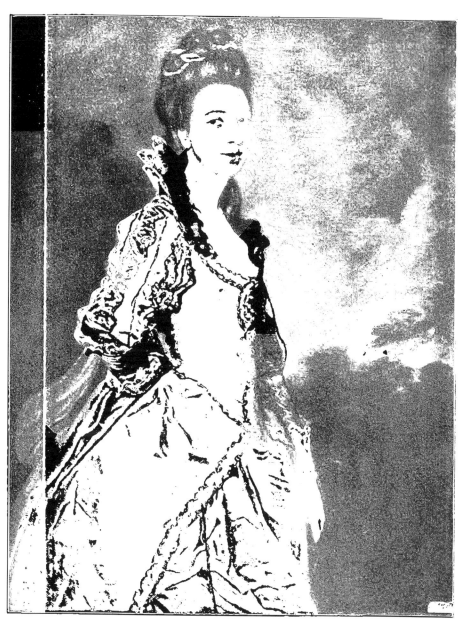

MISS SUKEY TREVELYAN

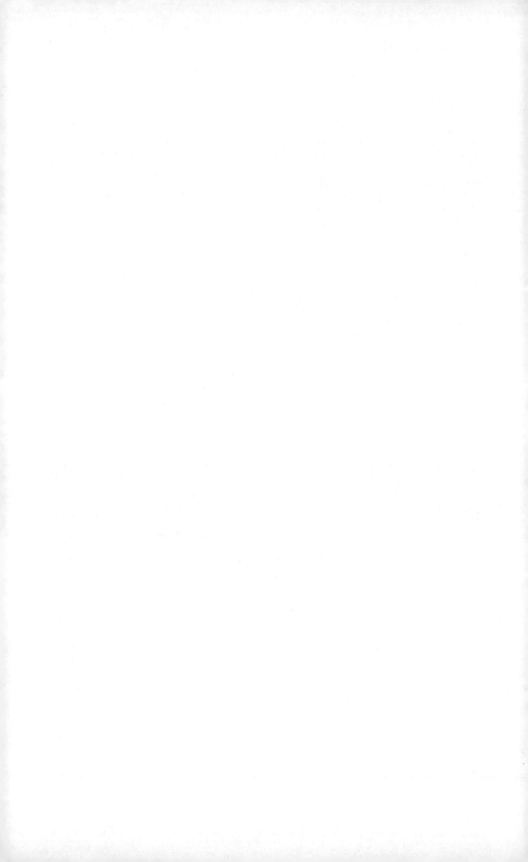

head-gear, she was a tall and stately dame, whilst the Duke was small and insignificant in form and features.

Hen and Chickens (p. 122). A clever oil sketch of a barn-door fowl with her brood, which is said to have been painted in an hour.

Miss Sukey Trevelyan (p. 124), was the great-aunt of Sir George Trevelyan. This portrait was painted in 1761; in 1764 Miss Trevelyan was married to Mr. Hudson, of Bassingly, Yorkshire. In a letter to me Sir George Trevelyan says, "The face is as Gainsborough left it, beautifully painted, and also the white and gold dress. The neck is a daub, and the left hand; and the hair and curls are all painted over. The picture, I suppose, was painted at Bath. I think Gainsborough's price was then eight guineas. The seat of Sir George Trevelyan, the girl's father, was Nettlecombe in Somersetshire. Sir George died in 1768, and he likely enough left the picture to his brother-in-law, Sir Walter Blackett, who had made his son, Sir John, heir to Wallington." In a note to Fulcher's "Life of Gainsborough," the picture is thus described. "The costume of this portrait has been altered. Like Chaucer's 'Wife of Bath,' Miss Trevelyan was originally arrayed in a hat 'as broad as is a buckler or a targe.' Her ruffles also were of gigantic dimensions; the picture was, indeed, styled by a humourist, 'A Portrait of a hat and ruffles.' Sir Walter Blackett, its former proprietor, had the dress painted out by Reynolds, who it is said did not improve the picture by disrobing the lady of her finery." Lady Trevelyan most kindly sent me a sketch in pencil she had made of Miss Sukey's portrait in which she has outlined the shape of the hat and ruffles as they appeared under the fresh coat of paint placed over them by Sir Joshua. This is certainly the

only portrait in existence painted by Gainsborough and repainted by Reynolds.

Lady Sheffield (p. 126). Sophia Charlotte Digby was the daughter of Dr. Wollin Digby, Dean of Durham, and married in 1784 Sir John Sheffield, second baronet, of Normanby. He died without children in 1815, his widow survived him until 1835.

Four of our pictures come from the remarkable collection of the works of Gainsborough which Mr. Charles Wertheimer has from time to time gathered together. The chief one perhaps is the latest which he has acquired, the superb portrait of a lady, which is, I should certainly say, Mrs. Sheridan, in the heyday of her beauty, which he bought at Christie's for the sensational sum of 9,000 guineas.

It is a lovely picture, and having had all the dirt and dust which had accumulated upon it carefully removed, it shines out with glorious light as one of the most exquisite portraits of that always fascinating lady which Gainsborough ever painted. I am favoured in being able to present to the public this newly-discovered treasure; a picture almost unrivalled in beauty. Other works from the same collection are the portraits of Dorothea, Lady Eden, wife of Sir John Eden, Bart., which was shown at Burlington House in 1878 and in 1887; Nancy Parsons, the famous *demi-mondaine*, a great beauty who lived under the protection of the Duke of Grafton, and whose portrait was unknown when Sir Walter Armstrong wrote his book on Gainsborough; and a charming portrait, also newly discovered, which represents the two daughters of the artist, Margaret and Mary, with sketching materials before them. There is also to be found amongst the illustrations a portrait of the Earl Fitzwilliam, which now

LADY SHEFFIELD

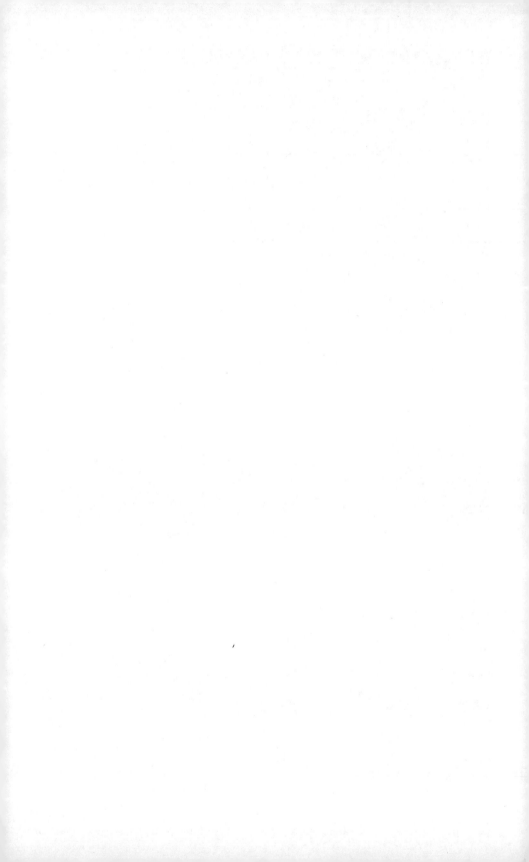

[Fitzwilliam Library, Cambridge

EARL FITZWILLIAM

adorns the famous gallery which bears his name at Cambridge, and a representation of the very rare mezzotint called *An Idyll*, which gives the whole of a picture, a part only of which remains to show its beauty. I am fortunate in myself possessing the small piece of the larger picture which gives the children at the grave, and also a fine impression of this very rare mezzotint, which shows what the whole work was before some wanton person cut it up.

It will be apparent from the illustrations in this volume that Gainsborough loved to paint landscapes as much, if not more, than portraits. He may be said to have lived by portrait painting, and to have painted landscapes for his own personal pleasure. The sale of the latter was extremely small during his lifetime, and we know that hundreds of these delightful paintings were stacked away on either side of the passages at Schomberg House and were left unsold at his death.

Those who have visited his birthplace, Sudbury, and Ipswich, where he lived for fourteen years, and where he worked at landscape painting with greater freedom than in the later years in Bath and London, will be able to judge the truth of his transcripts of the surrounding woods and valleys.

We can still observe his singular fidelity to nature when in the wooded lane near Ipswich, called after the painter's name, with its noble old oaks and distant glimpses of the broad expanse of the Orwell, and although we no longer find the beautiful groups of peasants which the artist introduced into such paintings as *The Harvest Waggon* and *The Cottage Door*, so unchanged are the surroundings he immortalized that we should not be surprised if such models suddenly appeared and gave

what alone is needed to complete the living realization of one of his pictorial triumphs.

Gainsborough loved best to paint the woods and pastures of his native Suffolk when they were flooded with sunshine, and never cared to perpetuate the weird or angry aspects of weather, save when he portrays a woodman caught in a storm, or a peasant lad taking shelter from a deluge of rain. Like his own temperament, his pictures from nature are all brightness and sunshine; and he loved to catch the effect of a passing cloud, of the wind blowing through the branches of some old elm or oak; of the dappled shade on the bracken, and of the setting sun casting its slanting rays over the fields and woodlands, and throwing a silvery sheen on the distant waters in the background.

INDEX

Abel, Charles Frederick, Portraits of, 84, 85, 117.

Amherst, Lord, Portrait of, 99, 100.

Argyll, John Campbell, Duke of, Portrait of, 51.

Astley, " Beau," 71.

Baillie family, the, Portrait group, 94.

Barker, Thomas, 100.

Bath, Society in, 37; beauty of, 40.

Beaumont, Sir George, 103.

Belgrave, Robert Grosvenor, Viscount, Portrait of, 120.

Blue Boy, The, 5, 77-79, 108, 116.

Buccleuch, Duke of, Portrait of, 122.

Burke, Portrait of, 48.

Burr, Margaret, 23. *See* Mrs. Gainsborough.

Burroughs, Rev. Humphrey, 19.

Buttall, Master. *See The Blue Boy.*

Canning, George, Portrait of, 6, 99.

Campbell, Lord Frederick, Portrait of, 51, 112.

Charlotte, Queen, Portraits of, 81, 82, 111.

Chesterfield, Lord, Portrait of, 124.

Constable, John, 7, 11, 33.

Conway, Field-Marshal Seymour, Portrait of, 51.

Cosway, Richard, 71.

Cottage Children, The, 118.

Cottage Door, The, 7, 89, 127.

Cottage Girl, The, 88.

Cumberland, Duchess of, Portraits of, 80, 117.

Cumberland, Duke of, Portrait of, 81, 111.

Cumberland, Duke and Duchess of, Portrait group of, 4, 80, 124.

Cunningham, Allan, his " Lives of the Painters," 10, 11.

Devonshire, Georgiana, Duchess of, study for Portrait of, 9; Portraits of, 42, 65-67, 114.

Devonshire, Elizabeth, Duchess of, the " Lost Duchess," a Portrait of, 67, 114.

Dogs Fighting, 89, 90.

Dog, Study of a, 122.

Dupont, Gainsborough, 14, 15, 65, 100, 111; Portrait of, 123.

Eardley, Lady, and daughter, Portrait group of, 124.

Eden, Dorothea, Lady, Portrait of, 126.

Edgar, Mr., 25; letter of Gainsborough to, 29.

Elliott, Mrs. Grace, Portrait of, 121.

Fischer, J. C., Portrait of, 59, 84, 96; marries Gainsborough's daughter, 91; death of, 92.

Fitzherbert, Mrs., Portrait of, 120.

Fitzwilliam, Earl, Portrait of, 126.

Foote, Portrait of, 47.

Forgeries of Gainsborough's works, 100, 102.

Freer, Mrs., Portrait of, 123.

Frost, William Edward, 101.

Fulcher, G. W., his "Life of Gainsborough," 10, 11.

Fuseli, Henry, criticism of Gainsborough by, 85.

Gainsborough, Thomas, compared with Reynolds, 1-3; his admiration for Vandyck, 3; compared with Rembrandt, 3; and Watteau, 4; as a colourist, 5; distinction of his portraits, 5-6; *portraits of himself*, 6, 28, 110; his landscapes, 6; his sketches, 8; his defects, 9; his birth and family, 12; account of his brothers and sisters, 13, 14; his birthplace, 15, 16, 18; at school, 19, 20; sent to London, 20; life in London, 21; his marriage, 24; removes to Ipswich, 24; portraits painted at Ipswich, 27, 28; letter to Mr. Edgar, 29; Hingeston's description of, 32; his daughters, 33; his love of music, 33; his acquaintance with Thicknesse, 34; goes to Bath, 36; his success, 40; copies of Vandyck by, 45; portraits painted at Bath, 41, *et seq.*; contemplated imaginary picture of Shakespeare, 49; his passion for musical instruments, 54-56; account of his quarrel with Thicknesse, 57-60; Portraits of Miss Linley, 61-63; wax busts modelled by, 63, 64; his method of painting portraits, 65, 86; return to London, 69; his relations with Reynolds, 79; portraits of the Royal Family by, 80-82; little known of his home life, 82, 86, 87; landscapes and pictures of children by, 87-90; visit to the Lakes, 94; transparencies on glass by, 95, 118; visit to Sudbury, 96; his quarrel with the Royal Academy, 96, 97; his imitators, 100-102; his sketches and studies, 102; his last illness, 104; letter to Reynolds, 105; his death, 106.

Gainsborough's Daughters, Portraits of, 33, 126.

Gainsborough, John, father of the painter, 12, 18, 19.

Gainsborough, Humphrey, brother of the painter, 13, 14, 82.

Gainsborough, Mrs., 24; Portraits of, 28, 111; visit of, to Suffolk, 83.

Gainsborough, Mary, 33; marries Fischer, 91; becomes insane, 92.

Garrick, Portraits of, 46, 53, 84, 112.

George III., 80, 81; Portrait of, 82, 117; Portrait of the daughters of, 96, 119.

George, Prince of Wales, Portraits of, 93, 117.

Girl at a Window, 120.

Girl with Pigs, 88, 118.

Gloucester, Maria, Duchess of, Portrait of, 116.

Graham, Dr., 73.

Graham, Mrs., Portraits of, 5, 6, 75-77, 108, 115; as *The Housemaid*, 75, 116.

Gravelot, 20.

Great Cornard Wood, 43, 112.

Green, Mary, 101.

Grosvenor, Henrietta, Countess, Portrait of, 50, 124.

Grosvenor, Robert, Lord Belgrave, Portrait of, 120.

Hallett, Squire, and his wife, Portrait group of, 122.
Hamilton, Colonel, story of Gainsborough and, 87.
Hamilton, Lady, 73-75, 121.
Hamilton, Alexander, Duke of, Portrait of, 6, 109.
Hamilton, Lord Archibald, Portrait of, 111.
Hart, Emma. See Hamilton, Lady.
Harvest Waggon, The, 52, 113.
Hayman, 20, 21, 43.
Henderson, letters from Gainsborough to, quoted, 21, 47; Portrait of, 47.
Hervey, Captain Augustus, Portrait of, 51.
Hill, Jack, 90.
Hingeston, Rev. James and family, Portrait group of, 27, 28.
Hingeston, Mrs., Portraits of, 28.
Hingeston, John, 28; letter from, quoted, 32.
Hogarth, 21, 22.
Honywood, General, Portrait of, 48.
Hoppner, John, his landscapes often ascribed to Gainsborough, 101.
Housemaid, The, 75, 116.

Idyll, An, 123.
Imitators of Gainsborough, 100-102.
Interior of a Cottage, 89.

Jackson, William, account of Gainsborough's passion for musical instruments, 54-56.
Jackson, William (of Exeter), 101.
Johnson, Dr., supposed Portrait by Gainsborough of, 98; Opie's Portrait of, 99.

Kemp, Mr., of Sudbury, 16, 18.
Kirby, Joshua, 25, 26, 101.
Kirby, William, 26.
Kirby, Sara (afterwards Mrs. Trimmer), 26.

Landguard Fort, View of, 35; engraved by Major, 35.
Landscapes, Gainsborough's, 6-8, 52, 53, 88, 89, 113, 127, 128.
Landscape with Figures, 53.
Leicester, Thomas Coke, Earl of, Portrait of, 42, 120.
Leyborne, Mrs., Portrait of, 122.
Ligonier, Lord, Portrait of, 54.
Lincoln, Anne, Countess of, Portrait of, 123.
Linley, Elizabeth, 60; married Sheridan, 61. See Sheridan, Mrs.
Linley, Maria. See Tickell, Mrs.
Linley, Samuel, R.N., Portrait, 113.
Little Cottagers, The, 89.
"Lost Duchess," The, 67.
Loutherbourg, Philippe de, 95.
Luttrell, Anne. See Cumberland, Duchess of.
Luttrell, Elizabeth, 80.

Medlicott, Portrait of, 43.
Mendip, Lord, Portrait of, 119.
Molyneux, Isabella, Lady, Portrait of, 53.
Moodey, Mrs., and Children, Portrait group of, 119.
Morning Walk, The, 122.
Musidora Bathing her Feet, 121.

Normandale, Rev. W. G., 19, 111.
Nugent, Robert Craggs (afterwards Earl), Portrait of, 41.
Nuthall, Portrait of, 54.

Orpin, Portrait of, 52, 122.

Parsons, Nancy, Portrait of, 126.
Peartree, Jack, Portrait of, 16, 17, 25, 110.
Pink Boy, The, 79.
Pitt, William, Portrait of, 122.
Poyntz, William, Portrait of, 41.

Quin, Portraits of, 43, 44; Hayman and, 43.

Rembrandt, 3, 8.
Reynolds, Sir Joshua, compared with Gainsborough, 1-3; his description of Gainsborough's "model landscape," 64; his dictum on the use of warm and cold colours, 77, 78; relations with Gainsborough, 79; Gainsborough's letter to, 105; last interview with Gainsborough, 105, 106; portrait by Gainsborough repainted by, 125.
Richardson, Portrait of, 48.
Rivers, Lord, Portrait of, 53.
Robinson, Mrs., Portrait of, as "Perdita," 98, 119.
Romantic Landscape with Sheep at a Fountain, 53.
Royal Academy, Gainsborough and the, 41, 45, 53, 96, 97; Letter from Gainsborough to Reynolds in the possession of, 105, 108.
Royal Princesses, Portrait group of, 97, 98, 119.
Ruskin on Gainsborough, 9, 122; his description of a landscape painter's life, 30, 31; his criticism on the Baillie family group, 94.

St. James's Park, 4, 28, 115.
St. Leger, Colonel, Portrait of, 93, 118.
Schomberg House, 69.

Schomberg, Dr. Ralph, Portrait of, 94.
Sheffield, Lady, Portrait of, 126.
Shepherd's Boy in the Storm, The, 89.
Sheridan, R. B., Portrait of, 48; married Miss Linley, 61, 63; story of Gainsborough and, 103.
Sheridan, Mrs., Portraits of, 5, 6, 61-63, 114; Portrait group of, with her sister, 62, 113; death of, 64; newly discovered portrait of, 126.
Siddons, Mrs., Portraits of, 5, 6, 78, 98, 109.
Skinner, Sir John, Portrait of, 123.
Smith, John Thomas, 11.
Spencer, Georgiana, Countess, Portrait of, 42.
Sterne, Portrait of, 48.
Sudbury, Gainsborough's birthplace, 10 *et seq.*
Sussex, Lady, and her Daughters, Portraits of, 54.

Thicknesse, Philip, his Life of Gainsborough, 10, 11; first meeting with Gainsborough, 34, 35; account of, 34; induces Gainsborough to go to Bath, 36; his portrait, 39; account of his quarrel with Gainsborough, 57, 60.
Thicknesse, Mrs., account of, 57 n.; Portrait of, 57.
Tickell, Mrs., 62, 113.
Transparencies, by Gainsborough, 95, 118.
Trevelyan, Sir George, 125.
Trevelyan, Miss Sukey, Portrait of, 125.
Trimmer, Sara, 26.

Vandyck, copies of, by Gainsborough, 45.
Vernon, Admiral, Portrait of, 35.

Walpole, Horace, 43, 52, 84, 85, 114, 116.

Watering Place, The, 7, 43.

Watteau, Gainsborough compared with, 4.

Wertheimer, Mr. Charles, 126.

Wilson, Richard, 6.

Wiltshire, the carrier, 52.

Wolfe, General, Portraits of, 49, 112.

Woodcutter's Home, The, 118.

Woodcutters, The, 115.

Woodman, The, 88, 89.

CHISWICK PRESS: PRINTED BY CHARLES WHITTINGHAM AND CO.
TOOKS COURT, CHANCERY LANE, LONDON.